How to Select & Use
# Photographic Gadgets

## by Carl & Phoebe Holzman

### ABOUT THE AUTHORS

Carl Holzman has used virtually every type of photographic gadget. His experience in photography began in high school and continued as a working photographer in the U.S. Navy and the U.S. Soil Conservation Service. Owner of a chain of camera shops, a Certified Photographic Counselor and regional executive of the Photographic Marketing Association, he has spent many years helping photographers find hardware that solves problems.

Mr. Holzman teaches classes on many aspects of photography, judges photo shows and gives many slide presentations and talks about photography.

Phoebe Holzman shoots photos for her own advertising agency and uses them in advertising and TV commercials. She has a particular interest in special-effects gadgets and methods of modifying the image.

Frequent travelers, always with cameras and equipment in use, the Holzmans bring years of know-how and practical experience to this book.

Executive Editor: Carl Shipman
Editor: David A. Silverman
Art Director: Don Burton
Book Design: George Haigh
Book Assembly: Lloyd P. O'Dell, George Haigh
Typography: Joanne Nociti, Cindy Coatsworth

Published by H.P. Books, P.O. Box 5367, Tucson, AZ 85703    602/888-2150
ISBN: 0-89586-043-0 Library of Congress Catalog Card No. 80-81592
©1980 Fisher Publishing, Inc. Printed in U.S.A.

# Contents

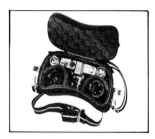
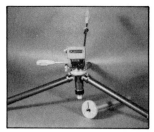
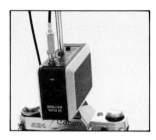

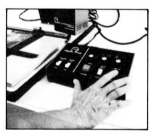

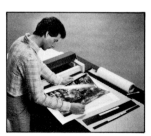

# ABOUT THIS BOOK

Ingenious! That's what a gadget is. There is no better way to describe photographic accessories that solve photographic problems in a clever yet practical way. That's what this book is all about.

This is a sourcebook of the current gadgets for SLR photography. It's also a how-to book because we describe how to use the gadgets and, sometimes, how NOT to use them!

Have you ever bought a new gizmo, rushed home to use it and discovered that you needed a special screw or adapter to make it work? That's frustrating at best. In this book we try to tell you about those additional items before you find out the hard way.

Any book about the gadgets of photography is bound to be partially obsolete by the time it is finished. Examined closely, many of the devices are actually improvements on, or different versions of, gadgets which have been around for a long time.

Others are new answers to new problems. If a specific item in this book has been discontinued, you can probably find a suitable substitute at your camera dealer. If it's not on the shelf, ask for help; they'll probably be able to suggest alternate solutions.

There are many enticing new gadgets for the photographer willing to innovate and try new ideas. For example, there are unusual optical devices like distortion filters and electronic devices like remote-controlled flash. Electronics, computers, microminiaturization and other developments are at the heart of many of our most interesting gadgets—and will probably be the source of incredible items in the future.

Once you have read this book, you will have more than a basic working knowledge of what gadgets are available out there in the photographic world, and how to use them. Then we hope you will put these ideas to work to

solve problems and produce new kinds of photos. After all, what photographer has ever gone out to take a picture and not wished he had the latest gizmo with him to make this image just a little more special?

If you have run into a useful gadget you feel would be of interest to other photographers, drop us a line at HPBooks and tell us about it. It may appear in the next edition. If you have found an interesting use for a standard product, send that too.

Most products mentioned in this book should be available through your local photographic dealer. If a particular item is sold only through mail order or is not widely available, we have given the city where you can find the manufacturer or distributor. We have not given street addresses or phone numbers because they change often—and this can be frustrating to everybody.

---

## USE OF BRAND NAMES

We have used brand names freely in this book, and we've done it on purpose. Here's why: If we ask you to buy a roll of film, you really don't know what we intend for you to buy—there are lots of different kinds. On the other hand, if we suggest buying a roll of Kodachrome 64, 35mm size, with 36 exposures, you know exactly what we are talking about.

You certainly don't have to buy what is mentioned unless you choose to. You can shop around or follow your personal preference in film choice as long as you get something you consider similar or equivalent. Brand names are used

here to *specifically identify* the type of gadget we want you to know about. Is this a recommendation? No! Naturally, we have not mentioned any brands we feel are inferior products. On the other hand, there are usually several manufacturers who supply quality items of the type identified by brand name throughout this volume.

Don't buy the brand we mention unless your shopping convinces you it is the best buy in terms of price and quality for your purpose. You may find another brand you like better for less money. Buy that one!

# 1
# Cases, Straps & Carriers

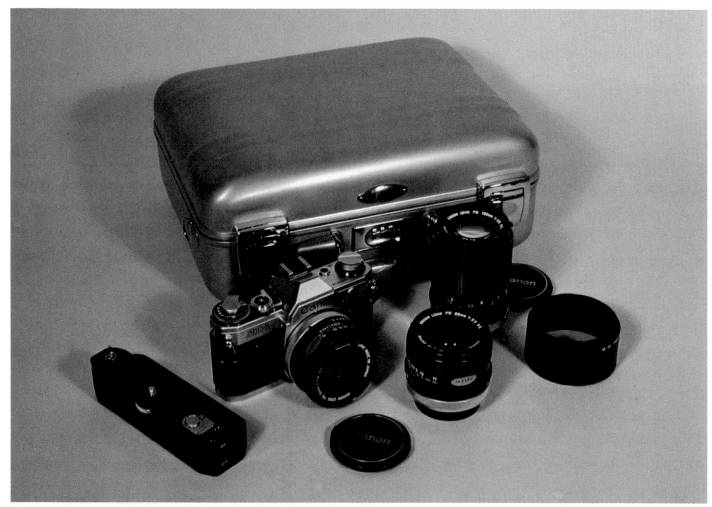

As you'll see in this chapter, there is a dazzling variety of ways to carry your camera equipment, including rugged but stylish aluminum cases. This is a Halliburton case.

## CASES, STRAPS & CARRIERS

How do you carry photo equipment? Select from this smorgasbord of straps, camera and accessory cases, action carriers and handy helpers for transportation without tears! If any of your camera equipment is awkward to carry or if you're overburdened, unbalanced or uncomfortable, you may find one or more really great solutions in this chapter.

Straps for cameras, camera cases, lenses and accessories help keep your equipment from falling, banging, dragging—even from getting stolen if you use them to keep body contact. Some straps have their own accessories!

Cases protect tripods, lenses, cameras and accessories. In camera cases, choose from eveready, compartment, parti-

tioned and custom-cut foam interiors. Your primary camera case should give the greatest protection because that's the one you buy to hold camera bodies and all the accessories you need for a trip or an assignment.

A wild and crazy bunch are those interesting, innovative cases designed to carry long focal length lenses. Well, why not? Toting those big lenses can be a wild and crazy problem without the right case.

Action carriers are a fast-growing group and it's about time. Look for camera restraints and harnesses—even vests with lots of pockets. The photo enthusiast needs all the special attention he can get. Back packs, fanny packs and canvas bags are for general action use and many are designed by hiking and skiing photographers. Highly specialized cases are designed for underwater work. If you snorkel, there's a fairly simple carrier for your camera. If you're a diver-photographer, you need a complete underwater housing system.

Odd-ball problems? Check this collection of handy helpers—a grab bag of miscellaneous gadgets ranging from conservative to unique.

## STRAPS

Buying a strap? There's more variety than you may think. Narrow straps are sometimes uncomfortable after an hour or more of use, especially when worn around your neck. Wide straps are more comfortable but they are bulky and sometimes get in the way when you are using the camera. Two compromises are the tapered strap—wide where it contacts your tender body, narrow where it connects to the camera or whatever you are carrying—and the two-width strap, designed for the same kind of comfort.

Some narrow camera straps

Camera straps are available in bewildering variety—wide and narrow, in leather, plastic and even metal. Try on a couple, to select the style that's comfortable for you. Does it have a non-slip pad or lining? Quality hardware? Is it adjustable?

have a shoulder pad attached, usually made of rubber. These usually don't do much to make the strap more comfortable, but they are essential when wearing the strap over your shoulder rather than around your neck. Their basic purpose is to keep the strap from sliding off your shoulder. Good shoulder pads have ridges or grooves on the underside to give the strap some grip against your jacket or shirt. Some wide straps have a non-slip rubbery lining on the underside to give them a better grip.

Take a close look at how a camera strap attaches to the camera. If there are metal parts on the strap that can rub on the corners of the camera body, they will wear the paint off very quickly. This gives the camera a well-used "professional" look in a hurry, but it also reduces resale value. Some accessory camera straps are made of cloth or leather where they touch the camera body to prevent undue wear, and others use a plastic shield over metal parts.

When Carl wants to be inconspicuous, he doesn't use a camera case at all—just a neckstrap and a coat or jacket. This works great in city streets and other public places. He carries the camera pre-focused and preset for average exposure and sometimes snaps a picture without raising the camera to his eye. He can also button his jacket or coat for additional security. Astonishingly, few people notice the camera.

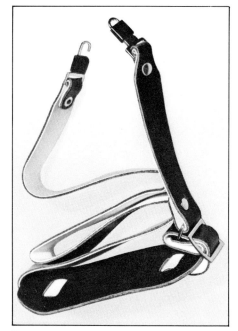

Braun makes a really superior strap. It has a pad that is rubberized and won't slip, yet doesn't damage clothing. It's wide enough not to cut into the neck or shoulder.

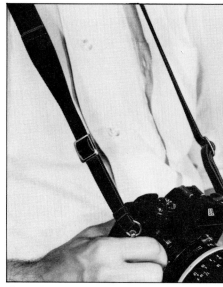

Another type of strap has no metal parts where it connects to O-rings on your camera. The tapered leather ends are less likely to scratch the camera body.

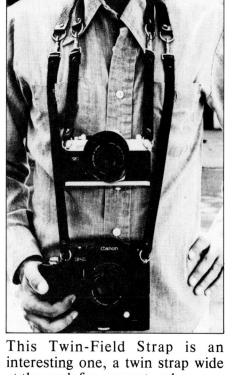

This Twin-Field Strap is an interesting one, a twin strap wide at the neck for support and narrow at the camera ends for freedom of movement. The cameras can be detached quickly and used separately. Also from Greatest Things Mfg. Co. of Beverly Hills California is a Quick Release Strap.

Connectors on the ends of the Braun leather strap are closed by sliding a plastic sleeve downward. The plastic sleeve then protects the camera body from being scratched. When buying a camera strap with end fittings that attach directly to your camera, be sure they fit well.

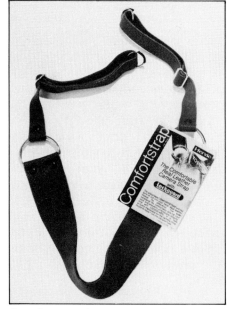

An innovative approach to the photographer's comfort and the camera's safety is the three-part leather strap. The 2'' neck band is wide enough so it won't cut or bind. Large D-rings hold two adjustable narrow straps that attach to the camera.

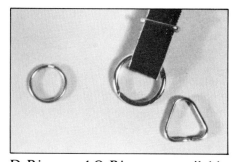

D-Rings and O-Rings are available at camera shops so you can adapt a strap to fit your camera, make your own strap or replace the rings on your camera.

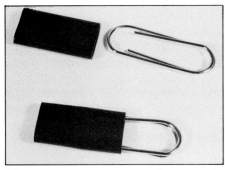

If your camera neckstrap is scratching the camera, replace the end fittings with something that doesn't scratch. You may find replacements like these clips with a protective plastic sleeve.

Also available to help your camera strap do double duty are these individual film-cartridge carriers that fit on a narrow strap of the type that comes with most SLR cameras.

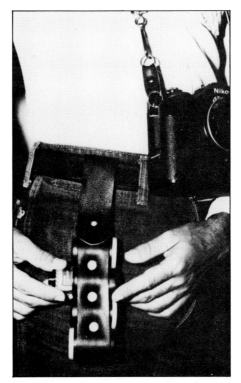

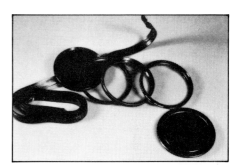

Some camera straps also carry film. This one has three elastic loops to hold three standard film containers. If you are going to be out in the hot sun all day, the film may become too hot, but for short periods in the sun, in the shade or on an overcast cool day, this method of carrying film works fine.

If you don't want your film hanging on the camera strap, your belt will do fine with this film carrier for up to four rolls of film. Temperature is still a concern, but it might be easier to protect the film when it is not on the same strap as the camera.

Another accessory for a narrow camera strap is this filter carrier. The threaded top cap fits on one end of a filter or stack of filters screwed together. The threaded bottom cap screws into the other end of the filter stack. The bottom cap has a slot in it so you can attach it to your camera strap. Filter thread diameters and the thread diameters of top and bottom caps must be the same.

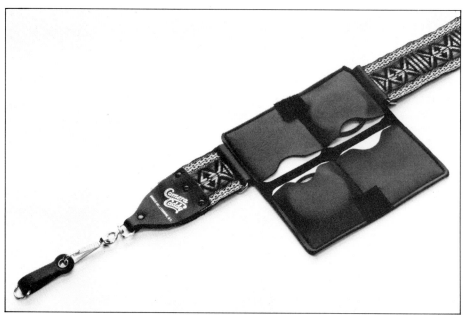

You can carry filters in a compartmented filter wallet. This model has loops to fit a wide camera strap, Velcro tabs to hold it closed and carries four filters of any size up to 62mm. Notice that the camera strap has a short leather extension on the ends to protect the camera from abrasion by metal parts.

## CASES

When people refer to *gadget bags*, they sometimes mean bags made of fabric with soft sides. *Cases* usually are rigid and offer more protection from bumps when the case is carried and handled. However, these are not formal distinctions, and a gadget bag may be a hard case while a hard case may be called a gadget bag. Some fabric equipment carriers are foam lined so they protect the contents about as well as a rigid case.

You will probably end up with more than one way to carry photographic equipment. We suggest you adopt this way of thinking: Have a large *primary* case to carry several camera bodies and an extensive assortment of accessories such as lenses, motordrive, flash and whatever else you may need on a long trip or a major photographic assignment. Also have a smaller *secondary* case for carrying less equipment such as on short one-day trips or assignments requiring only simple equipment. Finally, have an *eveready-type* case that holds just one body with standard lens attached, for casual snapshooting or extremely simple and uncomplicated assignments.

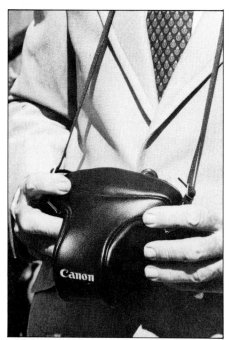

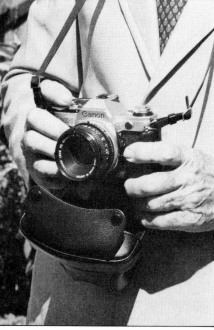

Eveready-type cases give your camera more protection than just a strap, and are fine if you carry only one camera with lens attached. If you intend to carry more than one lens, you won't have much use for this type of case. To use the camera, unsnap the front cover and drop it down out of the way, as shown. Sometimes you can't get the case open fast enough to get the shot; therefore, some people call these *neveready* cases.

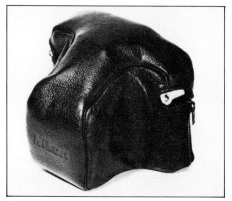

Camera cases are made in several types and styles. Some have a hard, rigid body; some are soft like this zip-on case from Nikon. To get a good fit, buy the case specified by the manufacturer for your camera.

Obviously, you can fill the eveready case from the secondary case and you can fill the secondary case from the primary case.

Don't buy all of these cases at once. Buy them when you need them, according to the plan outlined above. None of these cases is really interchangeable. When you need to carry a lot of equipment, an eveready case won't do the job. When you need only a small amount of equipment, a large case is an unnecessary burden and is generally unsuitable.

When shopping for a case, there are several important things to consider. How are you going to carry it? Usually a shoulder strap is the best way, but sometimes you just want to pick up the case and move it a few feet. In that situation, a handle on the case is very convenient. To cover every possibility, both shoulder strap and handle should be on the case, but not all cases are made that way. Some have a detachable shoulder strap that may appeal to you.

Your equipment should be protected from external bumps caused by banging the case against something while you are carrying it, and from internal damage caused by items inside the case rubbing against or bumping into each other. Protection from the outside is achieved by rigidity or padding while protection from the inside is provided by pockets, partitions, or "nests" for individual items of equipment. Each type is illustrated in this chapter.

You will want flexibility in use so you can carry various assortments of equipment. Adjustable partitions are convenient, but a bag with many pockets of different sizes will usually be about as convenient. Cases with foam liners that you cut out to make nests for your gear are not changeable quickly, but you can buy new foam inserts so you can tailor the case for a different assortment of equipment items.

Carefully examine the case for quality and defects in the manufacture: Is it well stitched and made of strong materials? Does the metal hardware really work, including the locks and zippers? Check the edges and corners of metal items. Sharp edges can scratch you or something else.

Appearance is important in more ways than one. If you prefer a nice looking expensive case and your budget allows it, that's what you should buy. However, some photographers prefer grungy or inexpensive-looking cases so thieves are less likely to steal them. Some camera cases look like camera cases and thereby disclose the contents while some look like luggage or brief cases and tend to conceal the fact that valuable items are inside.

Black or dark colors may be attractive to you, but they also get warmer inside when in direct sunlight. Film can be damaged by excessive heat, so if you will be using the case in a hot, sunny climate, a light color may be best.

Don't forget to allow space for small accessories and film. If you go on a photo trip with everything you need in a case, you will be carrying a lot of small items besides camera hardware. You need a way to carry film—sometimes lots of it—filters and lens attachments, a lens cleaning kit, pencil and notebook, and other small things you will find important to you and the way you use your equipment. Get a case with space for these small items—they may look insignificant, but actually take up quite a bit of room in your bag.

The standard eveready case usually has room for the standard lens on the camera—or any lens that is shorter. To accommodate telephoto lenses, some makers offer a variety of different cases. These Pentax cases have interchangeable "snouts" to fit a variety of lenses.

The Safari case uses screw-on extensions for the part where the lens goes. To carry a longer lens, add another extension. This case is sturdy plastic, foam lined and fits most 35mm SLR cameras. It comes with belt clips which can be replaced by a strap you can put over your shoulder or around your neck.

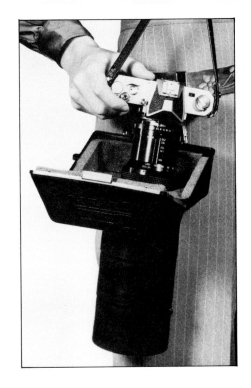

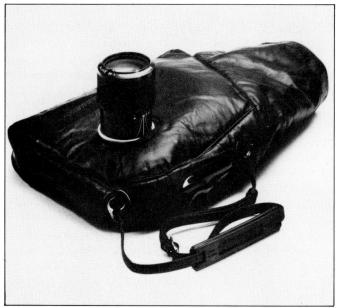

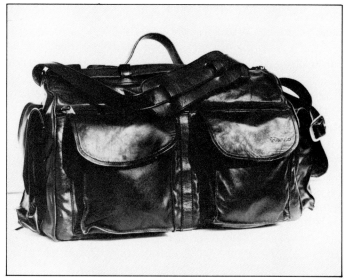

Bothered by shutter noise or motor-drive noise? Nikon has the answer in this padded noise-reducing CS-13 Blimp Case that's big enough to hold any Nikon 35mm SLR complete with motor drive installed. The lens can be any length because it fits through the hole in front. Your right hand goes inside, through the elastic cuff, so you can operate camera controls, and a clear plastic window in the top lets you see control settings. The case will also help keep camera and motor drive batteries warm in cold weather so they don't lose power.

Obviously elegant, here's a soft leather case with hidden organizational abilities! Six interior compartments, three of them adjustable, hold cameras and lenses. Six outside flap pockets carry accessories. Padded and lined, 10" x 15-1/2" x 7", with handles and carrying strap, it weighs just two pounds.

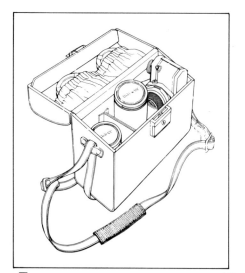

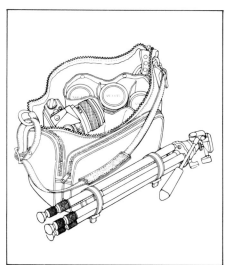

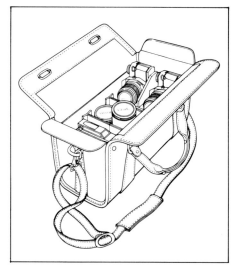

To carry one or more cameras with lenses and accessories, there is a variety of cases with compartments such as these sold by Olympus dealers. The small case at left is for a single camera with lens attached, plus two more lenses. Filters fit in pouches in the top, and film and other small things fit in spaces around larger items. A soft case, shown at center, has room for one or more camera bodies, several lenses and possibly a flash. Accessories and film can be carried in the side pockets. A large hard case, at right, holds two cameras, lenses, flash and possibly a motor drive. Small items fit in the crannies.

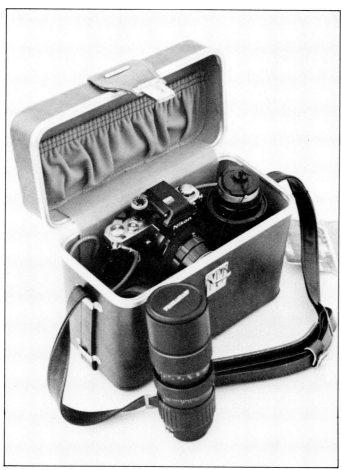

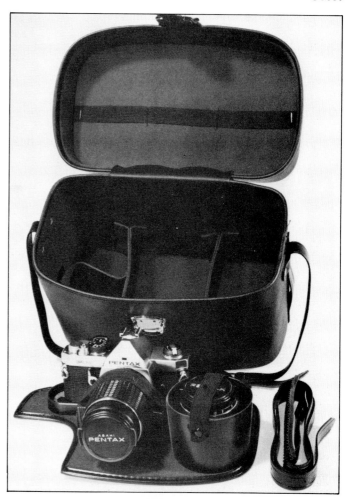

A selection of small cases for a single camera plus accessories is available at your camera store. Many hold the camera securely on a tray along with a lens or two. In some models, the tray lifts out to give access to additional compartments in the bottom of the case.

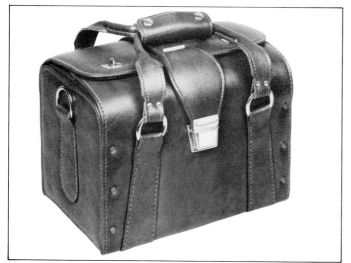

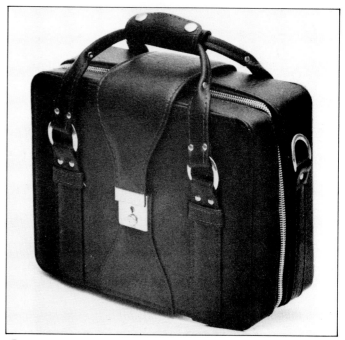

A leatherette case, such as this model by Coast, is attractive and durable. A shoulder strap can be snapped onto the D-rings on the ends of this case to make it easier to carry when loaded—especially important at the end of a long day.

Luggage styling lessens the risk of theft. This doesn't look like a camera case, yet rolled handles with snap fasteners and a shoulder strap help you keep body contact with it, and the lock provides some additional security.

# HOW TO CUSTOMIZE WITH CUBE-CUT FOAM

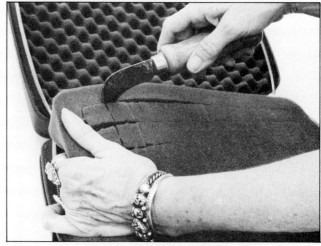

Custom-cutting the foam liner: When preparing to custom-cut a new liner, lay out your equipment and experiment with different arrangements. Then, mark before cutting. Phoebe uses ordinary blackboard chalk. Though not as durable as solid foam, cube-cut was developed because it is much easier to work with. Use a paring knife, an old linoleum knife as shown here or a razor blade (very carefully!) to separate the cubes.

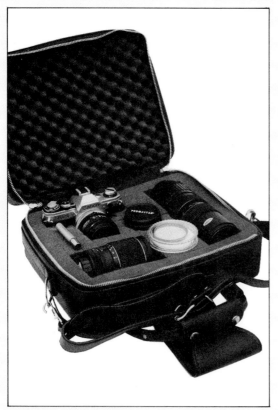
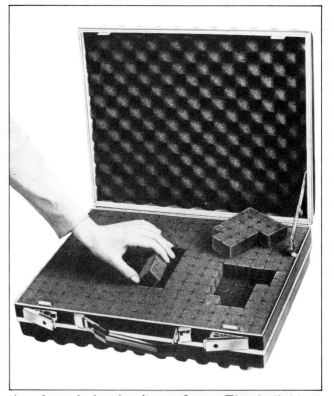

Some camera cases offer the option of solid foam, cube cut foam or pre-cut foam liners. Measuring 13" x 10" x 5-1/2", this case is large enough to hold a camera, three lenses and assorted gadgets.

Another choice is *die-cut* foam. The individual pieces can be separated by hand and lifted out to form spaces for your equipment. Begin by placing your equipment on top of the foam to get the most efficient arrangement. Then remove the foam to provide recesses for your gear.

# HOW TO CUSTOMIZE WITH SOLID FOAM

Solid foam is more durable than pre-cut cubes, but it's harder to work with. The best way is to tape cardboard to the foam and mark your equipment layout on the cardboard. Then use a saber saw, as shown here, to cut out the pattern. If you don't have a saber saw, mark the pattern directly on the foam and cut it out with a razor blade. It will be difficult to get smooth edges and straight lines with the razor blade, however.

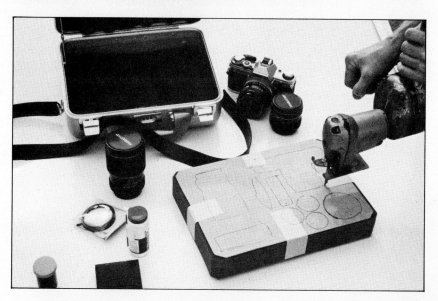

Using a saber saw is quick and easy. You don't need one as powerful as is illustrated here. This heavy-duty saw from our workshop is designed for woodworking. You'll need a helper to hold the foam, and you should work on a surface that you don't mind cutting or scarring with the saw.

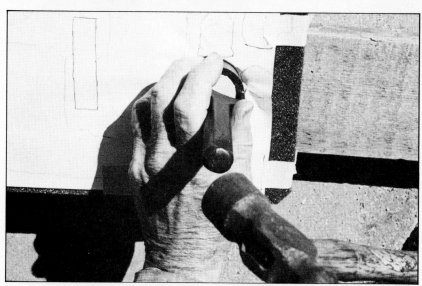

To make openings for film canisters, we borrowed a leather punch which makes holes about 1'' in diameter. Press the foam against a wood block, put the punch exactly where you want the hole and strike sharply with a hammer.

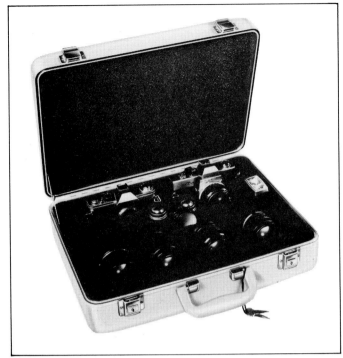

Customized cases look nice and do a good job of protecting your equipment. Replacement foam liners are available at camera shops so you can change the interior when you change your equipment.

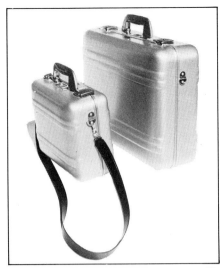

Eight sizes are available in the Halliburton aluminum case line, ranging from 12" x 9" x 5" to 24" x 18" x 7". When you select a case, check all edges and corners for rough spots which can really tear up your clothing. Check the handle—is it comfortable? Don't overlook the convenience of a shoulder strap. Are the case fittings strong? Is the lid closure positive? Photographers traveling with camera equipment and lighting systems may use several of these cases.

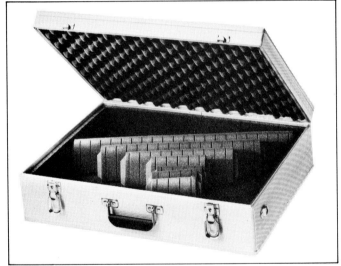

Cases with adjustable partitions include the Fiberbilt Adapt-A-Case line. These are made with exteriors of molded plastic, fiber sheet material or aluminum, and are available in several sizes. This model has a one-piece continuous hinge, tongue-and-groove closure with a rubber gasket, and padding on all interior surfaces.

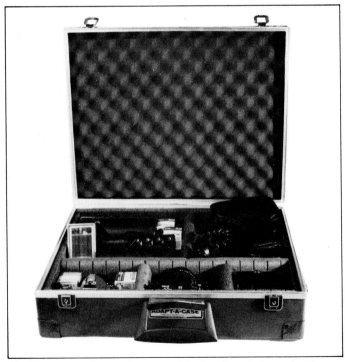

You can adjust the partitions in Adapt-A-Case equipment carriers to fit whatever you intend to carry. Additional partitions can be purchased separately, if needed. This case has a fiberboard exterior.

If you're really a filter fan, the handiest way to carry a bunch of them is with end caps as you see at left. Then put the entire stack in your gadget bag. Or, put a few filters in a filter wallet. Earlier we showed you a wallet that fits on your camera strap. This one goes inside your gadget bag.

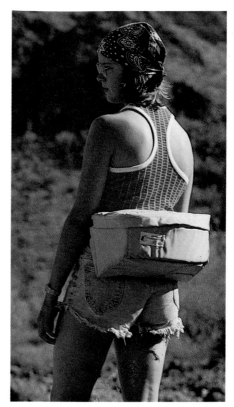

## ACTION CARRIERS

Whether you hike, cycle, ski, fish or ride horseback, you'll find many of the action carriers interchangeable. With back packs and fanny packs, hard contoured carriers, belt gadgets, totes, vests, canvas bags, there's a greater choice than ever before! Water sports—on, in or under—require specialized equipment ranging from plastic bags and rubber bands to protect equipment while boat-ing, to underwater bags for the snorkeling photographer, and rigid housing systems like those from Ikelite for the serious diver.

Pick your sport, then choose appropriate gear. Look for padding and specially-sized compartments when selecting a back pack; sturdy straps and closures are very important for the active photographer. You'll find that most of the bags, totes and vests are relatively inexpensive.

Hike with your hands free! This version is sometimes called a fanny pack, and is just right for a camera with a couple of lenses, filters, film, a good book and a picnic lunch. Wrap your sandwich in plastic so you don't end up with mustard on your lenses.

What has a hide so tough it's named after those bouncing beasties from Down Under? The Kangaroo, that's what! It's an 18" x 9" x 8" photo field bag constructed of a nylon fabric that looks like cotton duck but is more durable, and is waterproofed and mildew resistant too. The removable equipment organizer insert holds two 35mm camera bodies, up to six lenses and accessories—and has adjustable partitions. Two zippered end-cap pockets hold 20 boxed rolls of 135 film each.

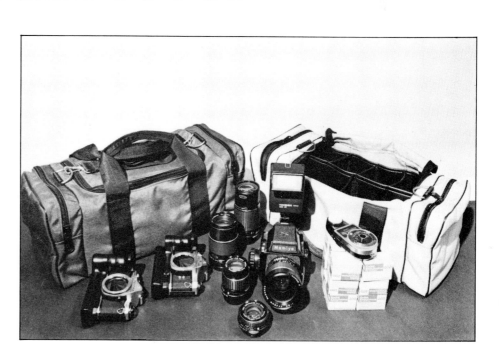

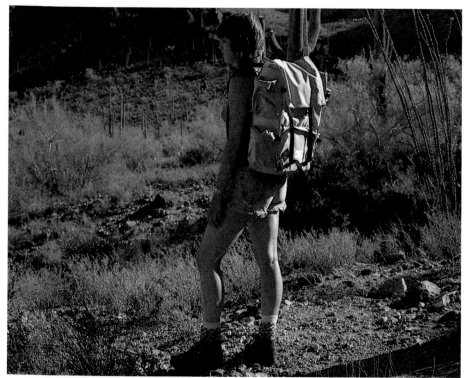

Pentax offers this belt clip for the ME camera. It attaches to the camera by screwing into the tripod socket. The camera can be used with the holder in place—just slip it off your belt and start shooting.

Designed by photo enthusiasts, Shutterpack back packs are compartmented to carry 35mm camera equipment. Constructed of 7.5 ounce nylon pack cloth with 1" foam padding, they have double-slide zippers and padded shoulder straps. Larger models have A-shaped aluminum frames and external straps to carry a tripod.

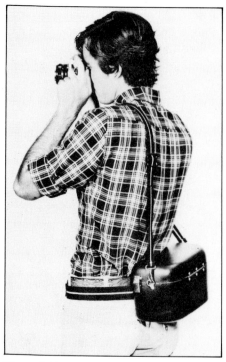

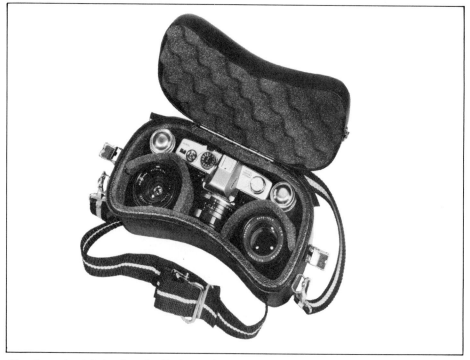

For bikers and other active sportspersons, a hard-shell case like this one protects camera and lenses in case of spills. It's contoured to fit the waist, and has foam-lined partitions.

Equipped with both a built-in waist belt and a shoulder strap attached to D-rings on the case, this is especially well-designed for cyclists.

This simple piece of rubberized fabric fits on your belt and holds a camera so it's out of the way but quickly accessible.

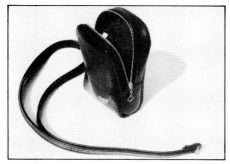

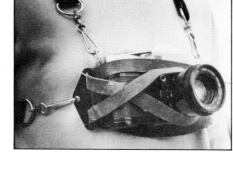

Look around in your camera store and you'll find things you didn't know about. This Kodak Pocket Tote is made for pocket 110 cameras. It has a carrying strap, a belt loop *and* a metal belt clip. We use it as a small gadget bag— sometimes to carry items that overflow from the larger bag. It's low in price and high in usefulness.

If you've ever smashed a lens against a rock as you scrambled uphill, no doubt you bought an inexpensive camera restraint the next day. This style has two straps that cross in back and come over your shoulders like suspenders. The straps attach with snap fasteners to plastic holders, which in turn attach to giant rubber bands that hold the camera body next to yours. Slip the camera out and shoot.

Another popular restraint, which fits all 35mm cameras, has a rubber holder that fits over the lens and holds the camera body. The waist strap keeps it snug against your tummy. Neck strap is not included.

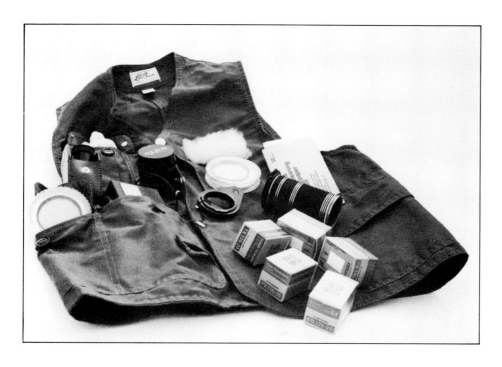

Several manufacturers offer photography vests with an abundance of pockets to carry film and accessories. These appear to be inspired by fishermen's vests because they serve the same general purpose. If you have a retired trout fisherman in your family, check to see if there is a photographer-fishermen's vest in the closet. This is actually a fishing vest from L.L. Bean.

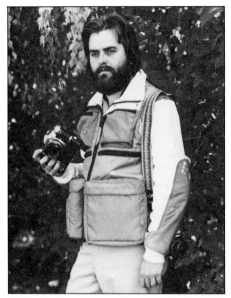

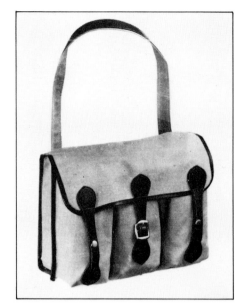

The Prinz Cycler bag is made of canvas, has a main compartment plus three side pockets, and measures a roomy 14-1/4" x 12" x 3-3/4". The adjustable strap fits over your shoulder or you can convert it to a small back pack which is the way most cyclists use it. We're glad to see camera cases designed for use in active sports— it lets us combine our hobbies for more enjoyment of each.

Designed specifically for photographers, the nylon oxford cloth Quest Vest out of Bozeman, Montana has foam-lined waterproof pockets. In front, there's a camera strap harness, strap keepers, waterproof divided lens pockets, two film pockets holding up to ten rolls each, and miscellaneous storage. In back, there's a large zippered pocket for extra photo gear or clothing, and cinch straps for snug fit. When you get a number of gadgets out, you may be concerned about losing or forgetting one. A vest with many accessible pockets allows accessory changes without putting the equipment on the ground.

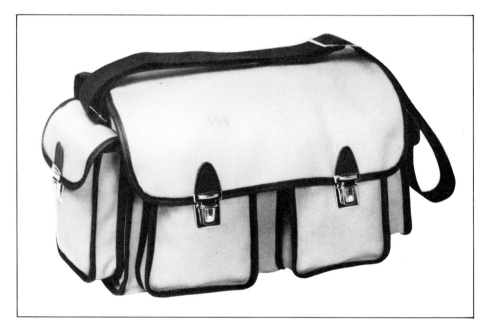

There are many styles and designs of canvas camera bags. Some have internal foam padding to protect your gear from minor bumps. These designs are made by Coast and are available in many camera shops, along with other similar bags, some of which look like canvas fishermen's creels; we *do not* recommend using the same bag for both purposes!

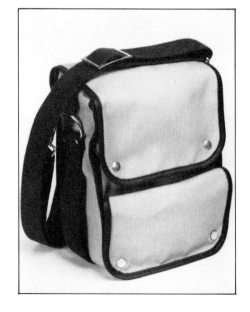

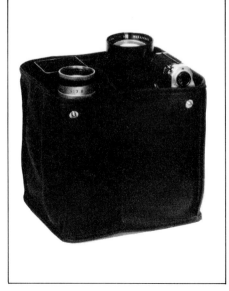

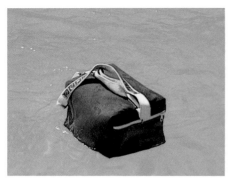

The Float Tote floats if dropped overboard, protects photo gear from shock and acts as a cooler for film or whatever. The 10" x 10" x 15" bag has two outside pockets, one inside, sailmaker's nylon zippers and a padlock. It looks like a good rig for river rats, power boaters and sailors.

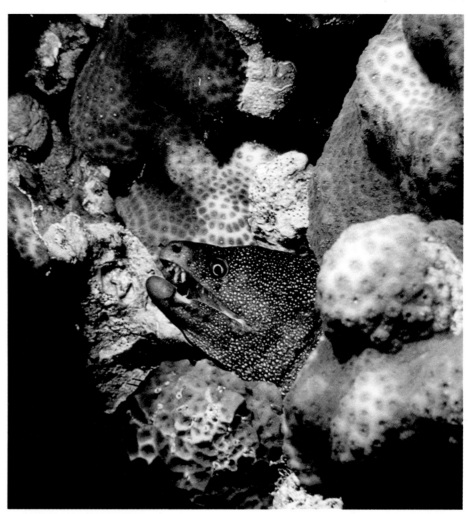

Underwater photography allows you to meet new friends. These photos by J. Thomas Kepler were made at Riding Rock Inn, San Salvador Island.

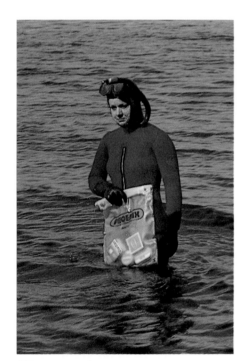

Waterproof bags are great to protect photo equipment from moisture and spray when you are boating or engaged in other top-of-the-water activities. We tested this one by dunking it briefly and the equipment stayed dry, but they *are not* recommended for underwater use. L.L. Bean sells these by mail order in three sizes.

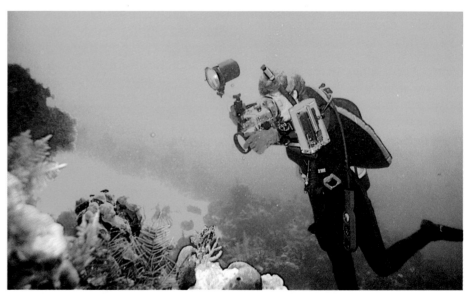

For serious underwater photography, you need specially-designed underwater housings for your equipment.

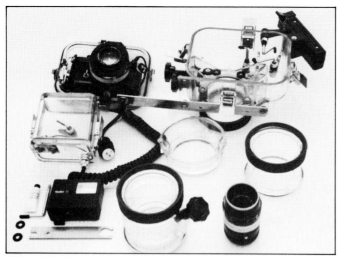

The Ikelite company manufactures underwater housing systems for most popular brands of 35mm SLR cameras. These operate safely to depths of 300', according to the manufacturer. Front sections secure to rear sections by means of four quick-release clips.

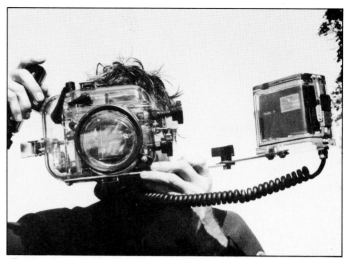

Both the transparent contoured underwater housings and the ports are molded of G.E. Lexan plastic. Interchangeable dome ports accommodate a variety of lenses. Gaskets help make a positive, water-tight seal, and grease is included to prepare the initial assembly. You need a regular screwdriver for assembly and a Phillips screwdriver to change lens ports.

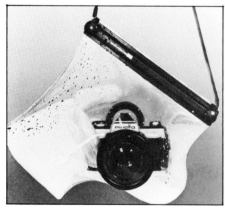

If you're not quite serious enough for Ikelite equipment, this protective camera housing by Ewa is claimed to be water-tight to a depth of 30'. It has an optical-glass port for the lens and a built-in glove for your right hand. It also keeps sand and water away from your camera even if you don't go near the water. Not only that, Ewa says, if your camera falls overboard in this housing, it floats!

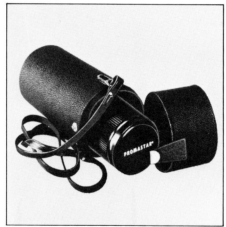

Standard 50mm lenses that you buy with your camera usually don't come in a case. Other focal lengths usually do because the manufacturer considers the lenses to be accessories. The conventional lens case is rigid, bulky and heavy, but it does the job. Most are equipped with rings for a shoulder strap so you can carry them outside of your gadget bag if you have strong shoulders.

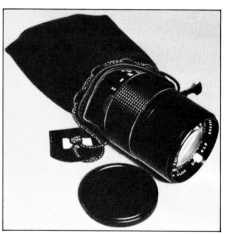

If you intend to carry lenses inside your gadget bag, you may want to give them some protection, but without the weight and bulk of a rigid case. Soft pouches weigh less and protect less. Note the identification tag on the drawstring.

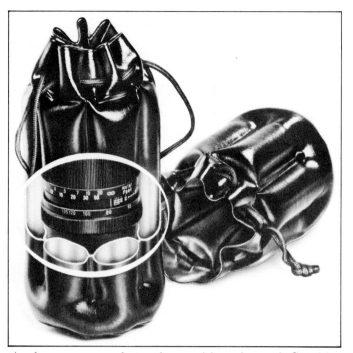

A clever approach to the problem is an inflatable carrying bag such as these AirShield models. When inflated, air forms a protective cushion to absorb shock and protect from scratches and dents. The cases fit inside larger bags or cases. When deflated, they pack flat and don't weigh very much.

Mike says it's a cinch to blow up AirShield inflatable pouches. Check the airtight seal in the store before purchase.

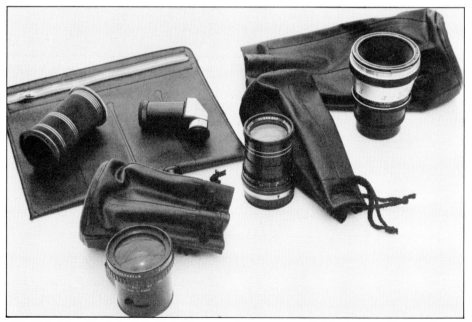

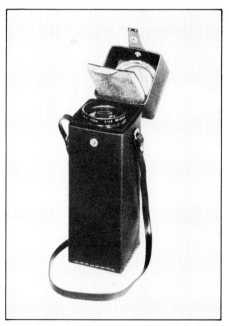

AirShield cylindrical inflatable pouches are available in small, medium and large sizes to hold lenses up to 400mm focal length. There are also rectangular pouches for other equipment such as camera bodies and flash units. Backpackers love 'em!

A square lens case that won't roll when you put it down? Now why didn't we think of that! It features velvet lining, a built-in concealed compartment for a lens shade or filter, belt loop and carrying strap, and comes in four sizes ranging from 3-1/2" to 9-3/4" in length.

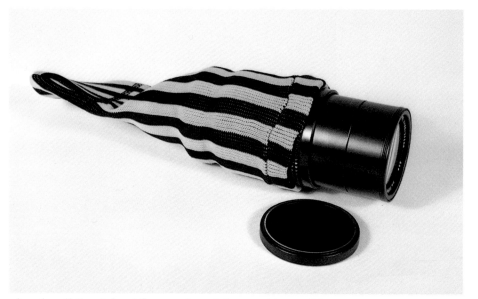

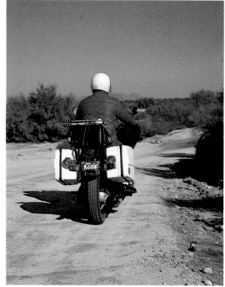

A splendidly striped Lensock weighs next to nothing, protects your lens from scratches and lightens the mood with its cheery colors.

## HANDY HELPERS

There is an old joke that goes: "If that's the solution, whatever can the problem be?" Some photographic gadgets evoke that response until you discover the problem. Then you feel both gratitude and sympathy for the hardy photographic pioneer who encountered the problem before you did and invented the solution. There is a great variety of such problem solvers: Some endure in the market place and are available for years while some appear and then disappear because not many people have the problem that fits the inventor's solution. We call these gadgets *handy helpers*. If you don't see the solution to your special photographic problem here, first identify the problem so you can describe it exactly. Then tell your friendly local photo dealer what it is. Chances are, he'll show you a handy helper you didn't know existed. If it isn't on the market, invent it yourself.

It's no trouble to take along a tripod if you strap it to your case. Any kind of strap will do. Motorcyclists often use elastic bungee cords which are usually available at motorcycle, bicycle and auto supply stores. Some gadget bags have sewn-on straps to hold a tripod.

What do you do with your tripod when you aren't using it? Lean it in a corner? You can be neat and get the tripod out of the way by using this nifty tripod hanger. It screws into the camera-mounting screw on the tripod head, and has an O-ring to fit over a hook on the wall.

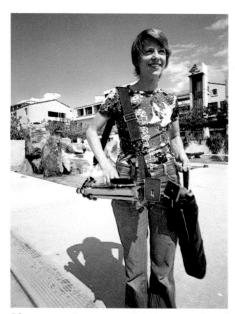

If you end up carrying your tripod with muscle power, there are some handy helpers for that, too! Here, Adele illustrates a tripod strap and a tripod case. The cases give better protection if you ship your tripod as luggage, and are available with one end open, or with both ends closed so the tripod can't fall out.

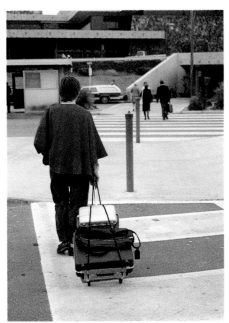

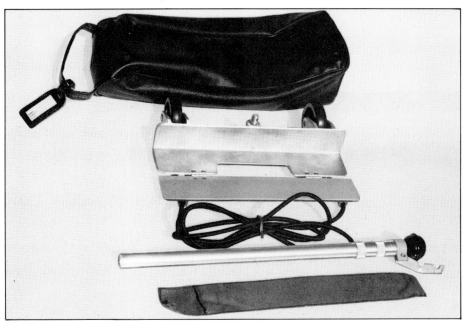

A great anti-hernia device—the photo cart! In European train stations and airports, public carts are almost always available, but rarely in the U.S.A. The solution: buy your own. Look for a strong, wide base; wheels large enough to go over curbs, and clear and understandable assembly directions. This model has a cast aluminum base, and it's of adequate size. The telescoping handle has a knurled locking collar, elastic cords hold your cases firmly, and the cart has a carrying case with name tag. It's a good buy.

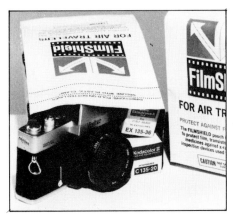

Sima manufactures lead-lined protective pouches in several sizes, and in rolls for lining camera cases. This protects film against fogging by *low-dosage* X-ray, and is the only product we know that does this. If your photo dealer doesn't stock FilmShield, have him order it for you. It's good insurance. Nothing will protect undeveloped film against *high-dosage* X-ray inspection machines which are still used in some parts of the world. The best solution is to ask for a hand inspection of your carry-on luggage.

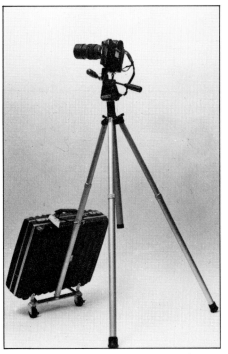

Just when we think everything has already been invented, Welt/Safe-Lock, Inc., announces the Welt Tri-Caddy. It's an accessory set of wheels and parts that fits on one leg of Welt tripods. When you have finished shooting, put the camera in the case, collapse the tripod and use it as a luggage cart.

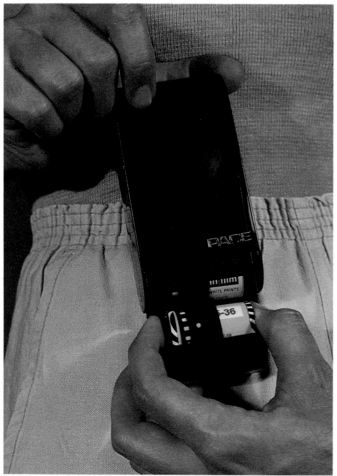

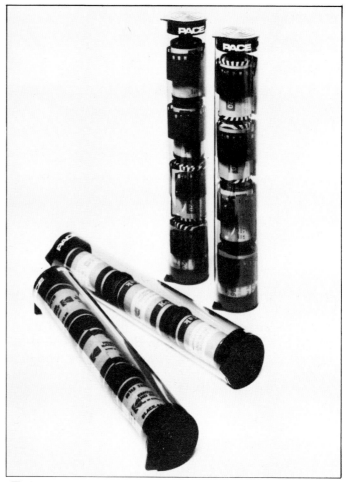

A transparent film dispenser from Pace holds four rolls of 35mm film. Click open and take fresh film from dispenser bottom, slip exposed roll in top. Instant, one-hand access! Smoked, rigid plastic protects film from dust, rain, sun. Clip to belt, pocket or camera strap.

This smoke-colored tube from Pace holds four rolls of 35mm film. It provides instant, visible film inventory. The tube can be shortened to fit small spaces, and the snap-on caps will still fit. This container is handy at airport X-ray inspection stations. Ask for a visual inspection and hand the inspector your tube of film.

# Camera Supports

## CAMERA SUPPORTS

You can hold your camera steady with a variety of aids, such as a lens rest for long telephotos, clamps, straps, mounts, grips, pods and an incredible all-purpose gadget that we'll show you in this chapter.

Tripods and tripod systems are discussed here—what they are and how to select the right one for you. Components, high and low tripods, the revival of the ball head and platforms for two-camera use are all part of a complete tripod system.

It's an art to get good pictures in a variety of settings and conditions, and there are a lot of fascinating and fun-to-use gadgets to make it easier. When shopping, test the gadget for stability when locked, and consistent, smooth, easy movement when unlocked. Any instability will cause jerks, jumps and blurred pictures. Check the locking mechanism for ease of use and positive handling.

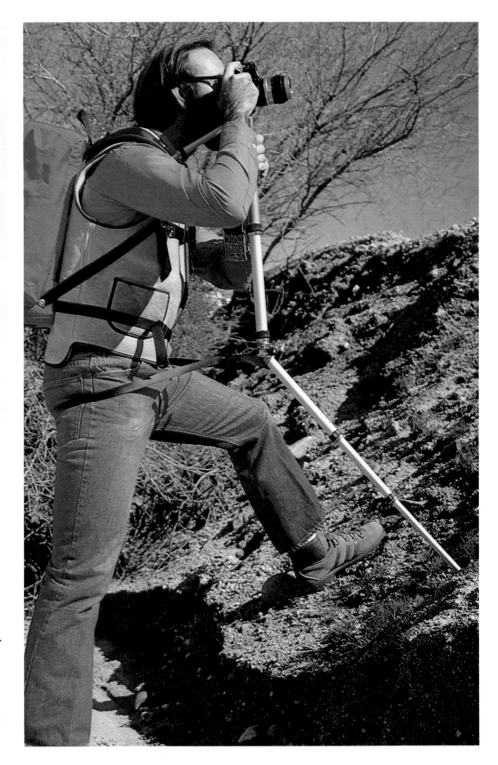

Sometimes, supporting the camera and holding it steady is not simple to do, but there is nearly always a way. This tripod has three legs, but two of them are the photographer's. He is using a Gitzo Multi-Pod, an astonishing foldable "pod" you can use on your chest, shoulder, knee, table or the side of a stream bed as shown here. It has a swivel head, shoulder support, straps to hook it onto your body and to carry it. It adjusts to a variety of heights and its use is limited only by your ingenuity.

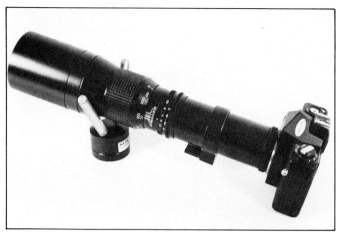

This V lens support for medium telephoto or zoom lenses is useful for sports and action photography. Fabricated in two sections, the upper part of the base swivels on the lower part. The mechanism works smoothly for vibration-free pans. The lens can be supported with or without a tripod. On a tripod, it allows the sports photographer to follow anything in motion, from a flight of geese to a racing car, with a smooth, shake-free motion, while keeping the subject centered in the viewfinder.

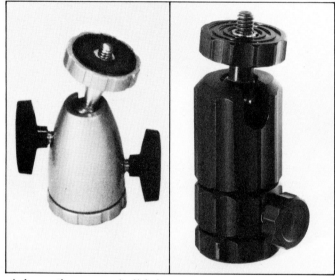

A long time ago, ball joints were very common and Leitz made the best one. After virtually disappearing, they are back on the market again from several manufacturers because they are very useful. The ball joint fits between camera and tripod, and rotates and tilts for quick and easy camera positioning. The one at left is by Osawa; the other one is from New Ideas, Inc.

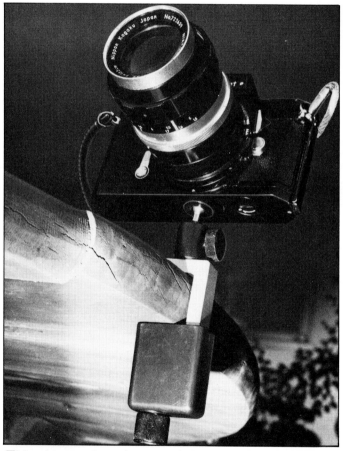

This tiny pocket clamp weighs only 5-1/2 ounces. The jaw opens to 1-1/2" and adjusts by turning the knurled knob at the bottom. At the top is a ball joint with a screw to fit into the tripod socket of your camera. It allows tilting and rotating the camera and is locked by the clamp knob on the side. This camera support is very handy; it can be fastened to tables, fences, tree limbs, chair backs, or anything not more than 1-1/2" thick.

## CAR MOUNTS—WITH VERSATILE VARIATIONS

Car mounts have a special fascination for some photographers. Some even use them to take pictures when the car is in motion, although we haven't seen many successful pictures made that way.

However, a car mount offers easy opportunities for steady shots with telephoto lenses, and can also help in making time exposures at night. The best way is to stop the car and sit very still or even get out when you make the exposure, because the slightest movement will blur your picture.

When shopping, check to be sure the car mount won't scratch your car window or the paint on the car body. If you're using a long focal length lens, be sure the mount is sturdy enough to rigidly support the camera with lens attached.

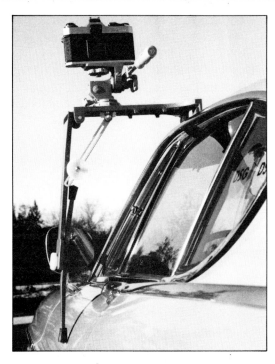

Cambrac is an all-purpose attachment for clamping your camera onto cars, ladders, doors, tables, chairs, fences, trees and more! We tend to retreat into our conservative nature when we hear the words "all-purpose"—too often this indicates that the object is mediocre for a lot of things, really excellent for none, but not in this case. The Cambrac by Gitzo is a carefully-designed and beautifully made ingenious device which attaches a camera to an astonishing number of things, in addition to serving as a tabletop tripod. C-clamps and pan, ball or socket heads are recommended accessory gadgets for use with the Cambrac. Folded length is 12", and it weighs 1-1/2 pounds.

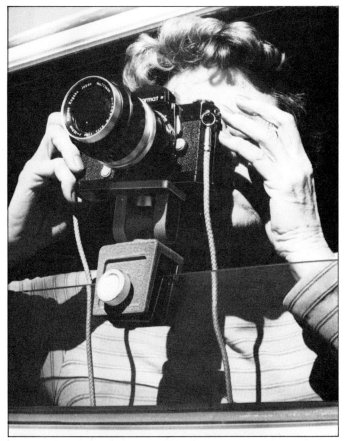

This car window mount is padded with rubber so it doesn't damage the glass.

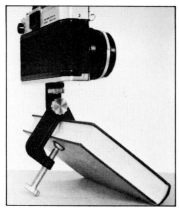

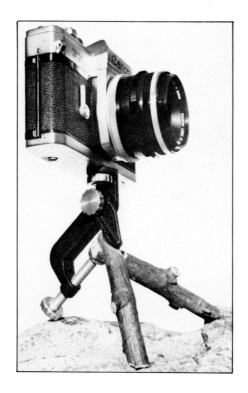

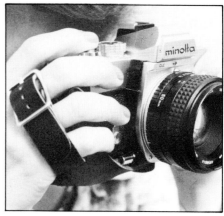

Another small gadget for fastening your camera or other photographic equipment anywhere is this Clampette from High Sierra Mfg. Co., Midpines, California. It weighs 2 oz. and can support a 500mm lens or 4x5 camera.

A hand grip makes it easier to hold your camera steady, allowing you to S-Q-U-E-E-Z-E the trigger softly. Many grips are inexpensive, lightweight and do the job well. Here, an angled leather strap surrounds the three lower fingers, leaving thumb and index finger free to operate camera controls. The strap attaches to the camera tripod socket.

## HOLD IT STEADY WITH A GRIP

Camera grips are essentially substitutes for a tripod. Smaller and lighter, they are easier to pack and carry, and do indeed help you keep your camera steady. They're good gadgets to have when you're using electronic flash, too.

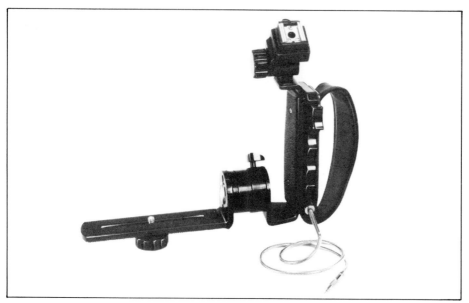

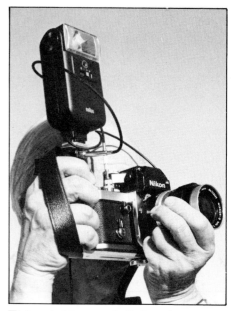

With this Soligor camera mount and flash bracket, you push the trigger with your forefinger. This operates the flexible cable release and trips the shutter. The angle between camera and handle is adjustable for user comfort and preference. On top of the handle is an accessory shoe to mount a flash which can be tilted and locked for direct or bounce flash. The handle, with flash attached, can be removed from the camera quickly when desired.

This rigid metal L-bracket supports a camera on one end and a flash on the other. The camera platform is covered with rubber and has a 2-1/2" slot so you can adjust camera position. The shaped plastic handle has a strap to steady your grip and a built-in thumb-operated plunger for a remote cable release.

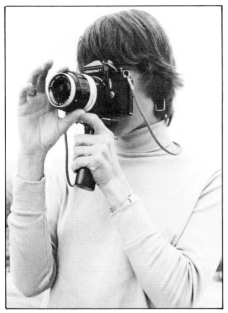

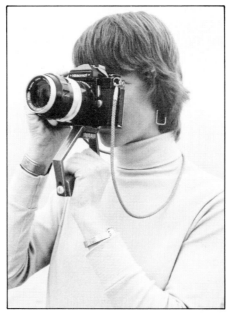

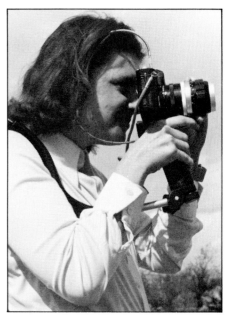

Pistol grips provide a positive way to hold a camera. Your camera shop probably has several to choose from. The grip at left has a built-in cable release with a plunger located so you work it with your trigger finger. The grip at right has a different angle for the handgrip and can also be used with a cable release if desired.

A shoulder support with grip and cable release is smaller and more flexible in use than the old gunstock mount. The curved molded plastic shoulder piece is comfortable and has an adjustable strap. Debbie says the adjustable strap and the extendible rod permit her to work with longer exposure times and longer focal length lenses. It has vertical, horizontal and lateral adjustments, and the entire rig packs flat.

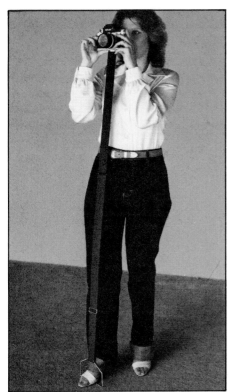

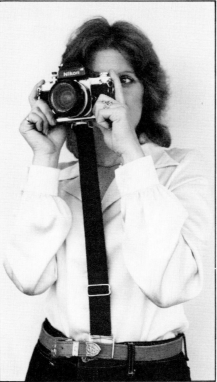

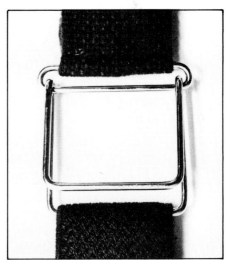

So you've got the shakes and not a tripod in sight? Never fear, Hold Steady Foot Strap is here! Screw this 1-1/2'' wide elastic and webbing strap into the tripod socket on your camera, and hold the other end firmly with your foot. Shoot sharp photos even at 1/8 second, says the manufacturer.

Another Hold Steady version is the Belt Strap. This is also a safety device should you lose your grip on the camera.

Invest in the combination Foot-Belt Hold Steady Strap and you're ready for anything. This gadget is very appealing to those of us who have lugged heavy tripods on extended journeys. This coupling combines the foot and belt straps into one.

# MONOPODS AND TINY TRIPODS

The "one-leg" can be a simple, one-piece metal rod with a threaded mounting screw at one end to attach a camera, or it can be a complex gadget with multiple sections, hand grip, wrist strap, swivel head, shoulder support, and combination rubber or spike tip.

Monopods have been popular in Europe for years, and they're now getting favorable attention in the U.S. Hikers like them because they weigh less than tripods. Some are collapsible and compact enough to fit inside a camera case or pack, or strapped to the outside.

Most pods are made of aluminum tubing. Check for quality, diameter and weight suitable for your use. Weight range is 1 to 2-1/2 pounds. Be sure to test for positive lock and knurled finish on the lock rings. Pods with three, four or five sections range from 18" to 23" telescoped and 60" to 62" extended. Camera platforms, ball socket heads and pan heads are available to fit on top. Look at the foot—some have rubber tip only, others offer the choice between rubber or a metal spike for dirt or grass.

And when it comes to tiny tripods, don't worry about the name—pocket, mini, tabletop—just pick the one you need. Some are so tiny they extend from a very pocketable 7-1/2" to only 12" or 13", and they often do double duty as a hand grip. Others are slender and weigh only about 20 ounces, yet extend to about 40". Unlike the monopod, the tiny tripod stands alone so you can use a cable release. Some have three tiny feet while others have a suction cup or clamp base.

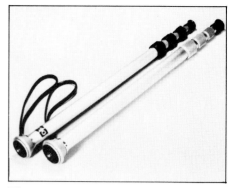

The monopod telescopes for carrying or storage. When you are not using it to support your camera, you can use it as a walking stick. Four-section monopods, such as these by Osawa, telescope to a shorter length and are more likely to fit in a gadget bag or case.

The stubby little Stitz is an example of innovation—a full-size tripod in every way except height. It even has an adjustable center column, and will extend more than you see here.

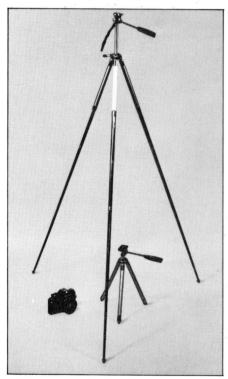

This Asanuma tripod can be used at 11-1/2" or 50"! Because it has a minimum height of under 12", it can be called a pocket tripod.

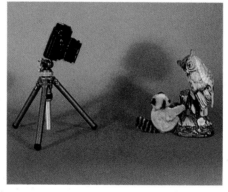

This tabletop setup shows the advantages of such a short tripod in photographing small items, jewelry, miniatures, flowers and other collectibles.

Two-in-one—a tabletop tripod that doubles as a handle. Release the lock lever at the top, shake the unit sharply, and the three small legs pop out. The lock lever also locks the ball head in any position, whether you place it on a table or use it as a hand grip. Note that there is no extension on this Prinz Mini Pod.

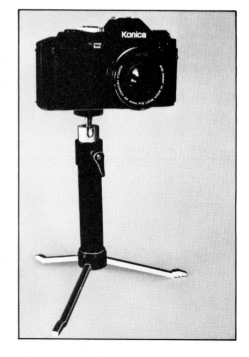

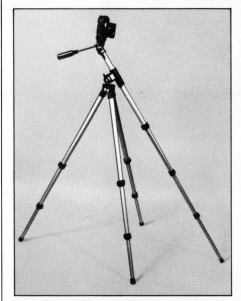

# A QUADRAPOD

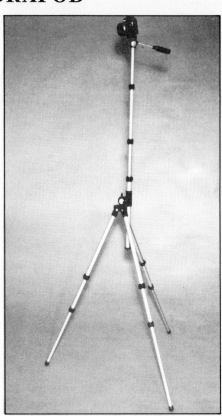

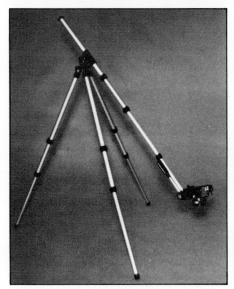

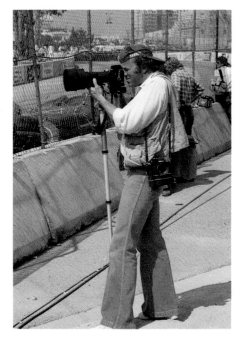

If you're tempted to think of the small tripod as a toy, ask to see the Gitzo Reporter model 226. It's beautifully designed and crafted, especially the solid turn-and-tilt head. Note the center column with collet fastening.

This photographer has both mobility and stability when using a monopod. Without it, he would have a problem hand-holding that long focal length lens.

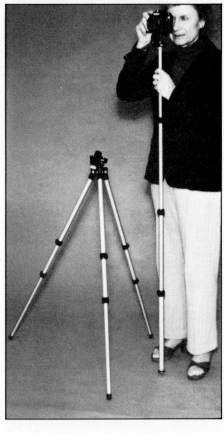

A tripod? No, with four legs we'd have to call it a *quadrapod*. It's actually Slik's 1200G Lightweight Compact Tripod. You can use the fourth leg as an extended center column for a maximum extension of 100'', or swing it down for a low-angle shot close to the ground. Folded, it's only 22-7/8''. The center column also doubles as a monopod, with a maximum height of 61-3/8''. A grand traveling companion!

## TRIPOD SYSTEMS

Camera tripods evolved from the surveyor's transit tripod. Early models were big and heavy because the cameras they supported were also big and heavy.

During the 1920s and 1930s, many view cameras were mounted on folding wooden tripods. The legs could be attached to a tripod head which was usually very simple, consisting of two boards with a piano hinge at one end so the camera could be tilted. Small brass brackets at the edge permitted locking. To turn the camera, just loosen the head screw.

Lighter weight metal tripods had telescoping round or oval legs that locked when fully extended. They were not very sturdy, and most were sold without a head. The buyer selected a ball head or other type as a separate purchase.

Tripods with handles to control camera position were generally used with movie cameras. Some of the finest tripods of the 1940s and 1950s were movie tripods such as the Kodak Cine-Tripod and the Bolex.

Today, most tripods have channel legs and clamp locks, and nearly all come with head attached. Some of the more expensive models still use the tubular legs.

Tripod *systems* are a recent innovation and consist of the basic tripod plus accessories to make it more versatile. Several of these systems feature dollies or wheels which are very useful. Widely used by motion picture photographers and in some well-equipped still studios, they are now being used by adventurous amateurs. We predict that dollies will be in common use by the amateur in the near future.

Because an ordinary tripod does not fit our definition of a photographic gadget, we're going to help you explore the world of the *tripod system*.

The terminology used in describing the parts of a tripod—head, arm, leg, foot—is the same as we use for parts of the human body. Phoebe says that, because the tripod is so similar to the body of a person, it's like having a twin or clone to help solve your photographic problems.

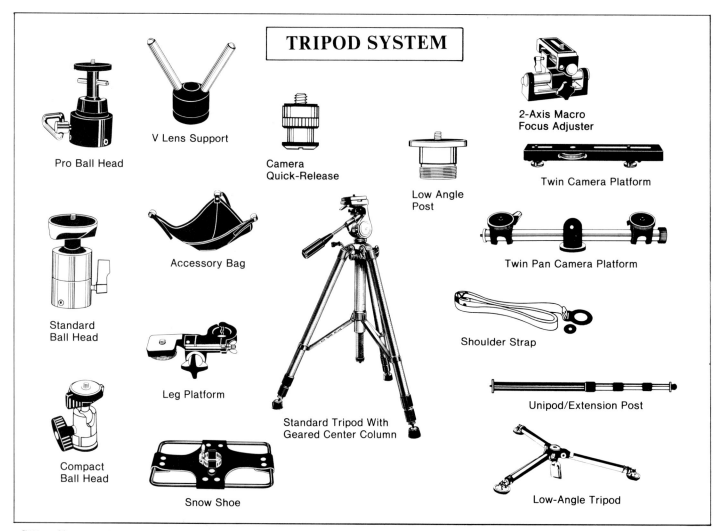

**TRIPOD SYSTEM**

Pro Ball Head

V Lens Support

Camera Quick-Release

Low Angle Post

2-Axis Macro Focus Adjuster

Twin Camera Platform

Standard Ball Head

Accessory Bag

Twin Pan Camera Platform

Leg Platform

Standard Tripod With Geared Center Column

Shoulder Strap

Compact Ball Head

Snow Shoe

Unipod/Extension Post

Low-Angle Tripod

Slik offers an interesting tripod *system* because of its wide range of accessories which help you solve problems. Examples include a platform that fastens to the tripod leg so you can attach a second camera for low angle shots, snow shoes for the tripod feet and a dual-purpose center post that also serves as a unipod.

# TRIPOD SYSTEM COMPONENTS

Now that you know you can buy more than just a simple tripod, here's what to look for. Every one of these is a great problem-solver!

## TRIPOD TYPES

Pocket, tabletop, copy stand, low-angle, regular, high extension, ladder.

Heights: 4" to 135".

## TRIPOD HEADS

Post, pan, ball, macro-focus, twin, V-rest.

2-heads: one for pan, one for tilt.

Heads for extra-large lenses.

## HEAD ACCESSORIES

Offset bracket for light cameras with grip, or with large lenses.

Plate for cameras with large lenses.

Quick-release gadgets.

Accessory tray.

Handles—right or left hand —with cable-release fitting.

## TRIPOD ARMS

Short, medium, long.

Slide or gear adjustment.

Cut-out for counter-weight.

Double extension.

360° pan capability.

## CENTER COLUMNS

Single, double, split, reversible, with post at both ends.

5" to 19" length, plus multiple-section columns to 35" to extend length.

Slide or gear adjustment.

Interchangeable camera platform with extra-low position at bottom of column.

## TRIPOD LEGS

Extensions: usually 3, but available with up to 9.

Leg spread: all together, or individual locking mechanisms.

Diameter: 3/4" to 1-1/2" is the usual range. Smaller and larger specialty types available.

Leg locks: lever, ring, knob.

Tips: rubber, rubber with screw, spike.

## LEG ACCESSORIES

Camera platform.

Accessory bag.

## TRIPOD FEET

Snow and sand shoes.

Dolly—a wheeled platform.

## TRIPOD STRAPS AND BAGS

Carrying strap.

Open-end bag.

Closed-end case.

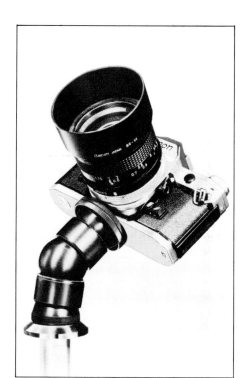

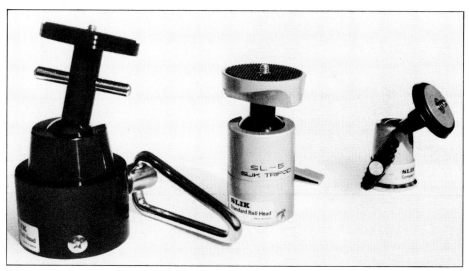

Each of these ball heads has a lever to quickly release the lock on both pan and tilt at the same time. Each also has a U-shaped notch into which the ball neck fits, so the camera can be tilted to a 90° angle.

Pan-and-tilt and ball tripod heads have been made in almost every variety—and here's one from Ewa of West Germany which allows the friction to be adjusted to the need so the camera can be changed from vertical to horizontal instantly. The swivel will bend to 90°. Model TR 1 is for equipment under 4 pounds—a compact 35mm camera, for example. Model TR 2 is a heavier version for equipment over 4 pounds, such as a 35mm camera with auto winder, flash and telephoto lens or other combinations of lenses and accessories.

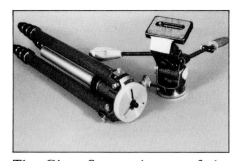

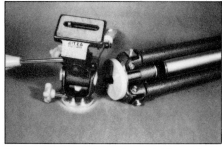

The Gitzo System is one of the most complete tripod systems in the world, with a selection of about 60 different tripods plus copy stand, ladder tripod, multipod and monopods; more than 25 interchangeable heads; interchangeable columns, side-arms, platforms; accessory heads; dollies, and more! The cost is rather high, but the useful life is long. Add components as you need them, but be sure to specify European or U.S. post and socket—there's a difference in the size of threads.

Tripods vary in adaptability. One of the more versatile ones is the model 226 Gitzo Reporter. In this French-made tripod line, tripods and heads are sold separately—contrary to the trend in the U.S. Select from a large group of heads; some photographers need two or three. This tripod extends to 69" in height, and to the ground for low-angle photography. The #235 short column accessory makes low level photography a pleasure.

Note the special leg locks, each with four positive positions, which permit the legs to be adjusted straight out for low-level photography, yet lock solidly for less spread at higher positions.

The Gitzo push-button cable release is unique.

Degree-marked pan heads help in making a panorama—from just two shots to be joined together, to a series of shots encompassing the 360 degrees. There is a special problem for those desiring to do a really good job—matching the details in the distance and foreground of each successive photo. If the camera is attached at the usual tripod socket on the bottom, the near and far details won't match. If you attach the camera to the tripod so it turns with the optical center of the lens over the axis of the tripod head, you can get a much better match. This, of course, is for the perfectionist—or when the near and far details are distinctive.

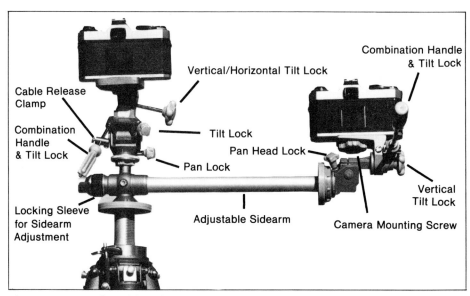

An accessory for this tripod is a separate, adjustable sidearm to hold a second camera. Some photographers like to shoot the same scene with two different films or two different lenses. This makes it easy.

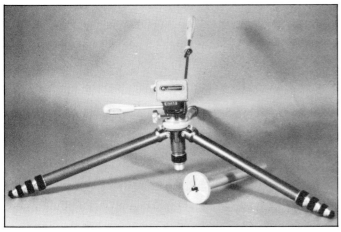

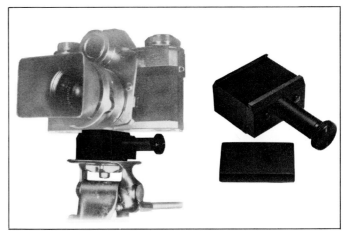

To get even closer to ground level, select a tripod with a split center column. This means that the column is in two pieces so you can remove the lower piece for ground clearance. With other tripods, we've had to dig holes to do what this tripod accomplishes with ease.

Frustrated by having to remove your camera from a tripod repeatedly during a photo session? Instant-on, instant-off when you use a clever Quick Release! The Universal Tripod Quick Clamp attaches to the tripod and Adapt-a-Plate mounts on the camera. The camera then slides on and off easily, yet is clamped securely when in use. The Quick Clamp and Plate is also a safe release on hand-held flash brackets and light stands, and can even be mounted in the equipment carrying case.

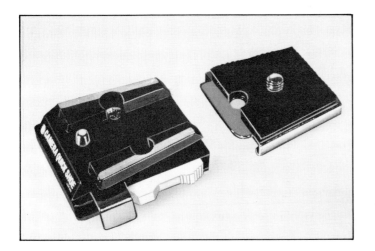

This small, compact quick tripod release has a bottom plate that screws onto the tripod. The top section is mounted on the camera and slides on, snapping into position. A lever releases the camera.

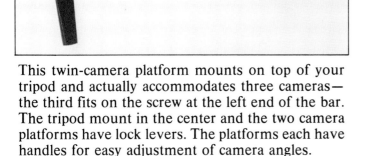

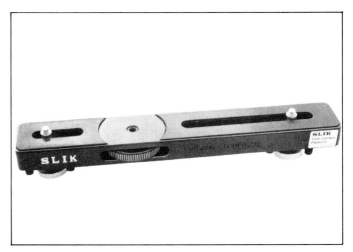

This twin-camera platform mounts on top of your tripod and actually accommodates three cameras—the third fits on the screw at the left end of the bar. The tripod mount in the center and the two camera platforms have lock levers. The platforms each have handles for easy adjustment of camera angles.

Another kind of twin-camera platform has sliding camera posts for precise camera positioning. For a low-angle setup, use a tripod with threaded post on the bottom of the center column, and screw this platform into the post. Length: 11.4". Weight: 19.4 ounces.

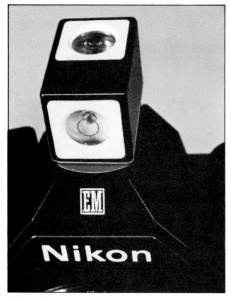

No tilted pictures when you use this camera level. The square case houses both vertical and horizontal levels, has a tripod thread, and a foot that fits the camera accessory shoe.

A camera side arm solves the problem when the top of your tripod is not where you want the camera. Set up the tripod on clear ground and then extend the camera to get the view you want. If it's extra height you need, turn the side arm vertical so it serves as an extension of the tripod center column. Rule one: Don't fall off the stepladder.

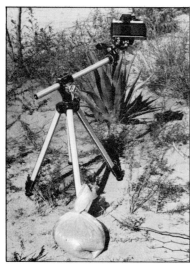

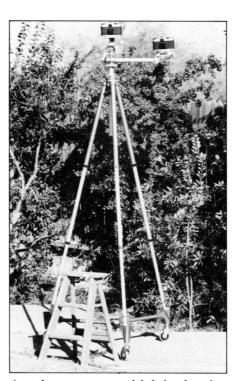

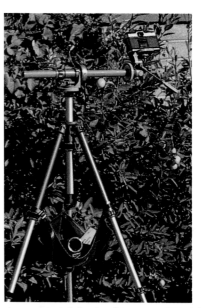

When tripod legs are collapsed to their shortest length, the base of the tripod isn't very large. Add a camera extended on a side arm, and the whole arrangement may become unstable because of the off-center weight of the camera. Stability is improved by extending the camera so it is directly in line with one of the tripod legs. If that doesn't do it, fill a plastic bag with sand or dirt and tie it to one of the legs on the opposite side.

Another way to get high in the sky and take pictures to prove it is by using a tripod with very long leg extension. A wheeled dolly for the tripod legs adds maneuverability and also tripod stability by holding the legs firmly in position.

An old trick to increase stability and reduce vibration of a tripod is to hang a weight on it. Some photographers hang a gadget bag on one of the knobs of the tripod head for this purpose. A tripod sling does essentially the same thing, attaching to the three legs and providing a handy tray for temporary storage of lenses and accessories.

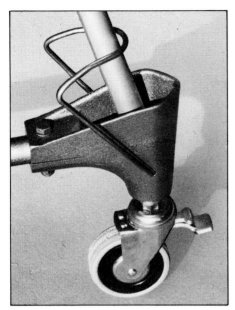

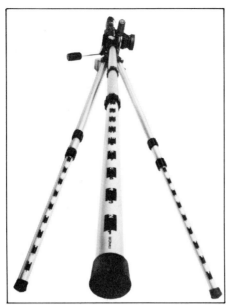

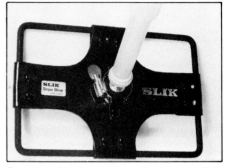

The U-shaped spring holds the tripod leg securely in a recess above the dolly wheel. A good dolly should lock at least one wheel. This wheel has two levers you work with your toe. One locks the wheel, the other unlocks it. It's a good idea to lock the dolly even when you think it isn't necessary—otherwise an accidental touch causes the whole operation to roll away from you.

Tripod leveling tape is a low-cost gadget for helping you extend each tripod leg to precisely the same length. Each package contains three 1/2" x 20" strips of self-adhesive vinyl tape which apply easily and stay on a long time. The numbers are large and easy to read.

Snow shoe or sand shoe—this really innovative gadget keeps tripod legs from sinking into soft surfaces and fits 17 to 24mm diameter tripod legs.

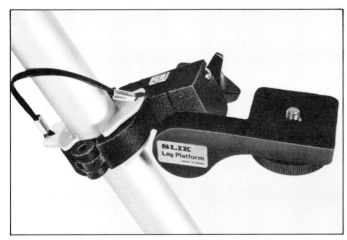

A tripod-leg platform is another way of mounting a second camera, and a way of solving camera-mounting problems for special situations. This Slik model fits tubular legs of 28mm or 26mm with a size adapter. The camera platform pivots and has a lock knob. For more versatility, you can use a ball head between camera and camera platform. The size-adapter is two pieces of plastic, connected together by a thong so you can't lose just one.

## COPY STANDS

The name understates the utility of the item. Copy stands are gadgets to hold a camera pointing straight down toward a flat surface. If you want to copy a photograph, a drawing, a page of a book or any flat object, the copy stand is made for that purpose.

However, once you use a copy stand, you may decide that copying things is the least important use. They are great for close-up and photomacrography using extension tubes or a bellows. A copy stand is very handy when photographing many types of small objects, including product photography for commercial use such as catalogs.

The basic parts of a standard copy stand are the base, a vertical pedestal and a camera holder which travels up and down the pedestal to vary distance between the camera and the object being photographed. Some tripod systems have parts that can be assembled to do a similar job, but usually without the operating convenience of a genuine old-fashioned copy stand. In addition, you need some way to light the object. Some copy stands have gooseneck lamps that also fit on the pedestal, while some use lamps on separate stands beside the base. You can also use ordinary studio lights on stands, or improvise.

When shopping, wiggle the pedestal to be sure it is rigid. If the camera moves during exposure, the resulting photo will be blurred. A conventional copy stand should have two ways to adjust the height of the camera. A coarse adjustment is just the clamp that locates the camera holder on the pedestal. This is fine for large movements or imprecise settings to get the camera in approximately the correct location, but it will not work very well to make the small adjustments necessary to find focus under high magnification. The second adjuster should be part of the camera holder and should allow you to move the camera smoothly up and down in small increments with complete control.

The camera is attached to the camera holder using a screw into the camera tripod socket. The holder should have a locating ridge or projecting tabs so the film plane is parallel to the base of the copy stand when the camera is pressed against the locating ridge or tabs. However, the mounting arrangement should not *force* you to mount the camera parallel to the base if you don't want to. Check to see if you can tilt the camera by loosening the mounting screw and not placing the camera against the locating ridge or tabs. This adjustment is handy when you are photographing objects in three dimensions, rather than copying flat objects.

Some copy stand bases are wood; some have an 18% gray surface which is handy to set exposures; some are ruled with lines and squares to help you set rectangular objects so they are parallel to the bottom and sides of the film frame; some are metal so you can use magnets to hold papers in place while being copied—some even supply the magnets.

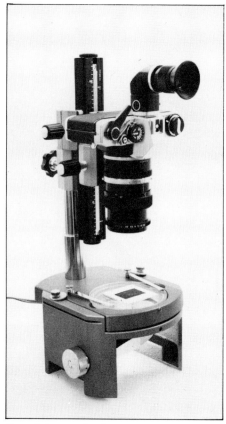

Special stands for photomacrography, such as this Olympus model, are available from several manufacturers. The specimen or slide can be illuminated from above or below.

Four-legged "tripods" like this Olympus model collapse to fit in your briefcase or gadget bag. Used with extension tubes, they make a quick and easy setup for copying documents and photos. These are sometimes called handy stands and are offered by several manufacturers.

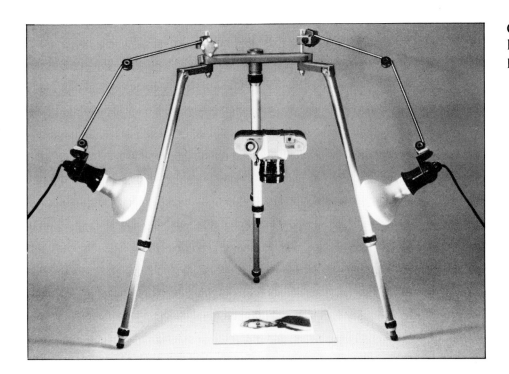

Gitzo uses tripod components plus lights to assemble this unique portable copy stand.

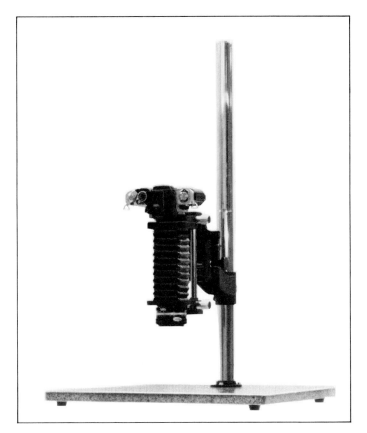

This is a standard copy stand. Most are available with accessory lighting sets to illuminate the subject.

# 3
# Remote Control

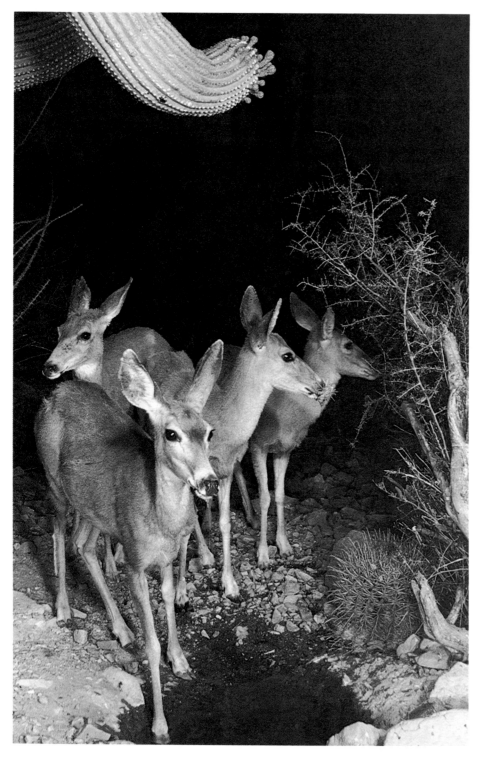

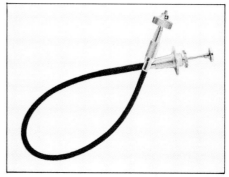

Here's two gadgets in one cable release—a release lock and a soft-release shutter button! The knurled lock under the cable-release plunger has two positions: Unlocked, it causes the plunger to stay down for a time exposure. When locked, it releases the plunger when you remove your finger. The soft shutter button *screws* into the *camera* shutter release, and the cable release then *plugs* into it. The soft shutter button can be left on the camera and used without the cable release.

Setting up for good wild animal pictures usually involves the use of a blind. If the blind is near a water hole or food, the opportunities for good shots are increased. This picture was made with electronic flash on a camera hidden in a blind at the Arizona Sonora Desert Museum near Tucson, Arizona.

## REMOTE CONTROL GADGETS

There are many reasons to operate your camera from a distance, and many ways to do it.

The simplest reason is to avoid shaking the camera when you depress the shutter button and thereby avoid blurred pictures. One easy way to do this is to put the camera on a tripod and use a cable release which screws into the shutter button, allowing you to operate the camera remotely; because the cable release is flexible, you are not likely to transmit movement to the camera when you depress the operating plunger on the far end of the cable release. Another way is to use the camera's self-timer, if it has one. The advantage of using a cable release is immediate operation of the shutter without waiting for the self-timer to run through its cycle.

Obviously it doesn't make much sense to use a cable release when you are hand-holding the camera—but you should consider using one every time you have the camera on a firm support such as a tripod.

Cable releases are available in several styles and lengths. Some camera models use releases with special design features unique to that brand and model—your camera manual will state if a special cable release is needed. Most use the ordinary cable release found in any camera shop. Because of mechanical friction inside the cable, the maximum length of cable releases is limited to about five feet.

Another use, in formal or informal portraiture, endears it to us. Try setting up your camera on a tripod, add a cable release of adequate length, and get a foot or two away from the camera. Note how much better control you have of the subject. It's the portrait of the subject that becomes of foremost importance, not the camera itself.

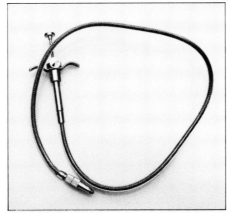

The special tapered thread of this standard cable release screws into a threaded hole in the center of the shutter button on most cameras. When you depress the plunger at the opposite end, the camera shutter operates. You can make time exposures with a *locking* cable release by setting the camera shutter speed control to B, depressing the plunger on the cable release and locking it in that position for the desired length of time. This cable release locks with a set screw on the side of the plunger housing. Notice the large comfortable finger grips which give you good control when using the release.

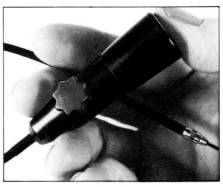

This is a unique cable release featuring a "handle" big enough to fit the large hand comfortably.

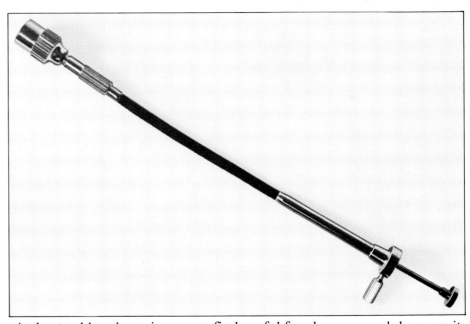

A short cable release is one we find useful for close-up work because it doesn't dangle in front of the lens. It has a screw lock for time exposures, cloth covering for flexibility and a removable Leica cup or adapter which is also used by some models of Nikon cameras.

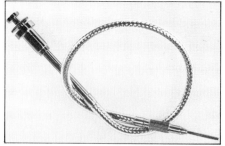

Braided metal ensures long life. Other interesting features are the extra long plunger which is required by some cameras and the unusually long knurled section just above the threads which makes it easier to attach to the camera. Try a cable release before you buy it—you may need these special features for your camera.

When the plunger is pushed in, the ring locks the shutter open for a long exposure. The B setting on the camera is used with this gadget.

A few years ago there were several kinds of cable-release threads in use. Today, this universal tapered type is used by virtually every camera.

## REMOTE RELEASES

For longer operating distances than the cable release can provide, there are many ways to operate the camera. Several types are available commercially, and for special needs some people build special remote control devices to fit the need.

**Air Releases**—An air release is simply a squeeze bulb at one end connected through a small rubber tube to a cylinder at the other end. The cylinder screws into the tapered threads of the shutter button on many cameras. When you squeeze the bulb, air pressure in the cylinder causes a piston to move and a small-diameter rod emerges to depress the shutter button on the camera. The pioneer maker of these is Rowi, with models capable of releasing a shutter at distances from a few feet up to 165' with special extension tubing between bulb and cylinder.

An air release kit includes the bulb and shutter release unit along with rubber tubing to interconnect them. Except for the shortest types, the rubber tubing is wound on a spool for storage. You can operate the bulb with your hand, or you can step on it—a way of taking the picture while you are in it without the squeeze bulb being in view. If you want a photo of yourself driving your car, try running a

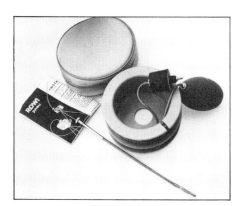

wheel over the rubber bulb.

This is one of the few photographic gadgets that may help handicapped persons enjoy photography—it can be squeezed with any kind of body pressure, even in the mouth!

**Electronic Releases**—Electronic remote releases are a natural spin-off of the miniaturization of electronic gear. Radio remote control of model aircraft leads to remote control of your camera by radio signals.

Another electronic remote control gadget uses a beam of infrared light. You hold the sender and use it like a flashlight. When the beam falls on the receiver, which is near the camera, it operates the shutter.

Your needs will probably be specialized, such as nature photography or sports—perhaps the ability to get your camera into a place that would be dangerous or even impossible for the photographer to go! Adventurers intrepidly dangle cameras over cliffs and out of high-rise building windows, or set them up so close to racing autos, horses and such that they would be in real danger if they themselves photographed from that position.

In all these situations, and also as a key part in some security systems, remote control units are a necessity.

A remote air release will trip almost any mechanically-operated shutter, from as far as 75' or more. An exciting use is for bird and animal photography. Place your tripod and camera in the appropriate location and focus the lens on the spot where you hope the bird will perch or the animal will feed or drink. Then go some distance away and wait. When your subject is in the right place, operate the remote air release.

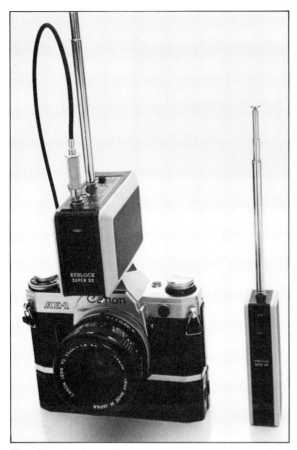

The Kenlock radio remote release works like a charm. The transmitter, receiver, two antennas and shutter release are packed in a felt-lined case with hand strap. The transmitter uses one 9-volt battery and the receiver uses four 1.5-volt penlight batteries. Weight including batteries is 430 grams. The receiver will operate the camera shutter button mechanically. It also has a switch for cameras with motor drive, which use electrical remote control.

We recommend using an auto winder or motor drive so you can shoot an entire roll without approaching the camera. Otherwise, you must dash out to the camera after each shot, which can disturb the wildlife.

Nikon's ML-1 Modulite remote control system uses a hand-held transmitter and a receiver mounted on or near a camera equipped with a motor drive. The receiver is connected to the motor drive by a cable. The transmitter produces modulated light signals and has a dual channel selector so you can control two cameras individually or simultaneously. The receiver must be able to "see" the light beam from the transmitter; it won't work around corners or through bushes. Maximum operating range is 200'. Other camera makers also offer remote controls using light beams.

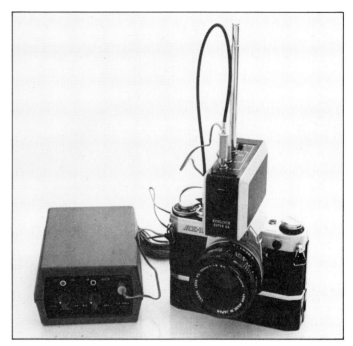

Ultra-S is a directional ultrasonic motion detector and camera trigger for unmanned photography— wildlife, candid, or surveillance. When something moves in the detection zone, it triggers. It runs on battery or AC and has a trigger-on time adjustable from 0.25 to 60 seconds. We used the Ultra-S with the Kenlock radio remote control, and it worked like a charm. Use it with a motorized camera or auto winder.

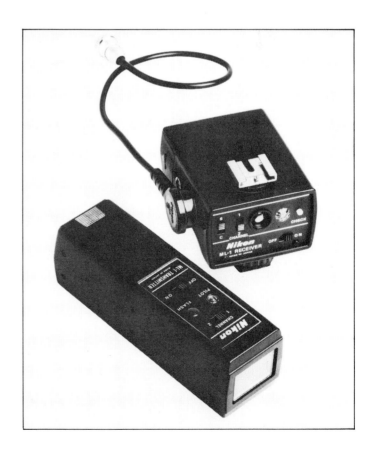

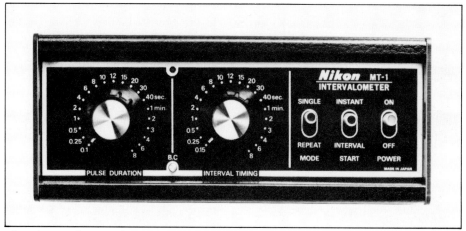

An *intervalometer* is more commonly known as an interval timer. This Nikon model will control a motor-drive camera for unattended time-lapse photography using single frames or multi-frame bursts. Time interval between firings is adjustable from 0.15 second up to 8 minutes.

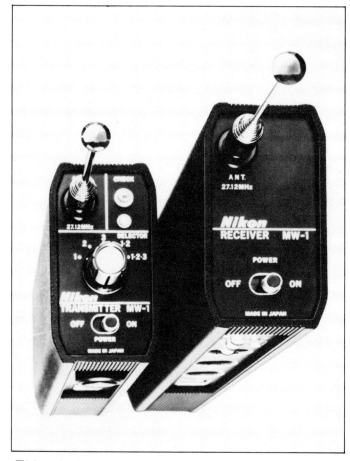

This wireless remote control set MW-1, also from Nikon, uses a radio signal in the CB band to control up to three motor driven cameras which can be operated individually or simultaneously. No radio operating license is required.

# Camera Care & Protection

Some people don't know that lenses have both front and rear caps, and SLR camera bodies have caps for the place where the lens isn't.

## CAMERA CARE & PROTECTION

Sun, rain, snow, excessively high or low temperatures, sand, dust, spray, humidity and water can ruin cameras, lenses and film. Just being aware that heat can ruin film should keep you from leaving film or a loaded camera in the glove compartment or on the dashboard of your car. There are a few simple and inexpensive ways to take care of your photographic equipment to keep it in top shape.

Body caps are used to protect the lens opening of your camera if the lens is off for any appreciable time—for example, if you send the camera body for service without the lens, or you habitually carry a second camera body in your case without a lens attached. They are sold by brand and sometimes by model designation of your camera.

Rear lens caps are essential when the lens is off the camera.

They fit on the back of the lens and must be purchased to fit the brand. Accessory lenses are normally sold with both front and rear caps.

Front lens caps are easily lost or misplaced, so there is a brisk trade in replacements. Size usually conforms to the lens filter-thread size. Common sizes are 49mm, 52mm, 55mm and 58mm, but they are available from 15mm to 90mm.

After you lose the originally supplied front lens cap, you become wary. One solution to the lost cap problem is a flip-cap like this. It screws into the lens filter threads and you don't remove it to make an exposure—just flip it open! Before buying, install the gadget and look through the camera viewfinder to be sure the screw-in ring doesn't vignette the image and the opened cap is not visible in the picture. This is more likely to happen with short focal length lenses than with long.

To use this gadget, you don't even have to wait until you lose the original lens cap. This Sima CapKeeper sticks to the standard lens cap for any camera. The other end attaches to the camera-strap lug or metal loop on the end of the strap.

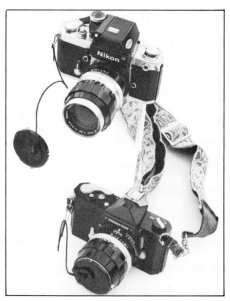

Another Sima CapKeeper model uses an elastic band that fits around the lens body. The cord is attached to the band, making lens and cap one unit. When you change lenses you also change caps which is often necessary anyway because the lenses are different diameters.

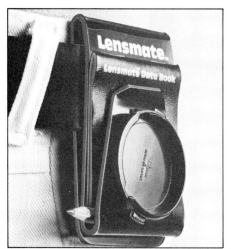

Another way to avoid losing your lens cap—and to keep a notebook handy at the same time—is with Lensmate, a lens cap holder and film data book from Kalt. With this smoked plexiglass holder clipped to your pocket, belt, gadget bag or camera strap, you can concentrate on the image, and can record each shot on the pad. The cap is secured using Velcro fasteners, supplied with the Lensmate.

Common household equipment can help solve problems. The Swiss army knife has small tools for minor repairs like tightening screws. Plastic kitchen bags protect equipment from rain or spray, and a hair dryer can come in handy to dry out damp equipment. Masking tape has a hundred uses! Stash film and equipment in a cooler bag to protect them from heat. Use a short stepladder for overhead shots, and dig with a trowel to make a level spot for the ladder, or to make a depression so you can get the camera lens at ground level.

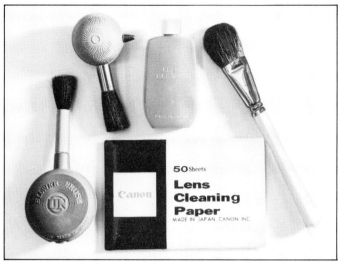

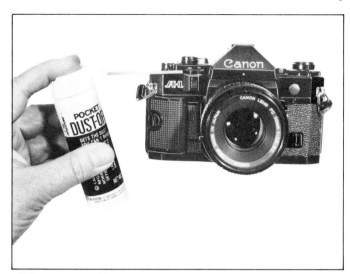

Assemble a cleaning kit for your gadget bag. You need special lens cleaning fluid and lens cleaning tissue, both available at camera shops. Don't use any other kind of fluid or tissue! You don't need three brushes, but you do need two—one to clean camera and lens bodies, the other to clean glass surfaces. The long-handled brush at right is fine to clean bodies; it's actually a ladies' cosmetic brush. Be sure to lift grit off the lens surface with a puff of air, before brushing it. Two styles of blower brushes are shown so you can blow first, brush later. One sends a puff of air out through the bristles, the other out through the metal nozzle on the side of the squeeze bulb.

"Canned air" comes in several sizes, one small enough to carry in your gadget bag. It's fine for blasting dirt out of corners and crevices. Be careful using it near the focal plane shutter in an SLR camera or you may blast it out too!

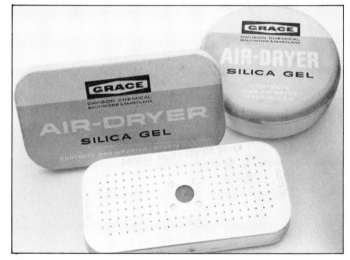

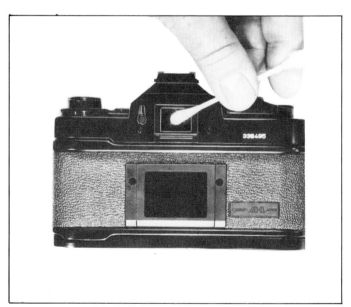

Wrap a few cotton swabs in plastic and add them to your cleaning kit. When the viewfinder window gets so greasy and dirty that you are taking a dim view of the situation, clean it like this, using lens cleaning fluid sparingly on the cotton. Don't use a cotton swab on lens surfaces.

Cameras and lenses usually come packed with a small cloth packet of silica gel which absorbs moisture to keep the equipment comfortable and happy. When the silica gel has absorbed all the moisture it can, it changes color, but you can't see the color change in a cloth bag. If you want to be sure, buy a small air dryer like one of these. The indicator dot changes from pink to blue when it is saturated with moisture. To dry it out and use it again, just bake it in the oven at 350°F (175°C) until the dot turns pink again. If your photo dealer doesn't have these, he can order them. They are valuable protection in damp climates.

These two pliable, lightweight plastic wrenches will loosen jammed lens accessories when threads bind. The wrenches fit filter sizes from 48mm to 58mm and are serrated on the outside edges so you can get a good grip on your problem.

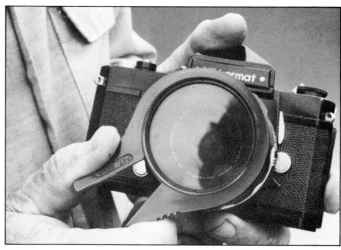

No matter how careful you are, it's possible to get a filter on so tight it won't come off by hand. A single wrench is often all you need to loosen it.

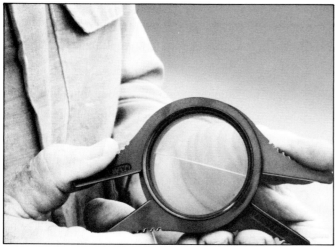

Use two wrenches to separate two accessories. Many times, two filters or a filter and a close-up lens become jammed, and these plastic wrenches will separate them without scratching.

Emergency tip! If you're without tools and two of your lens accessories become jammed, use masking tape to get a grip on them. Fold two pieces of tape with the sticky side out. This gives the friction you need. Other kinds of tape will do in a pinch, too.

When you and your equipment are out in freezing weather for a long time, efficiency drops. People don't work well with cold fingers and battery-powered photo equipment doesn't work well with cold batteries. New Ideas, Inc. offers these catalytic heaters with adjustable temperature to keep your gadget bag toasty warm. Buy a spare for your pocket and keep fingers warm, too!

# Lens Accessories

There are dozens of ways to modify the image by using lens accessories. These photos show the effect of using a Chromofilter on the lens to change color in part of the image. You'll see more on Chromofilters and many other image-modifying gadgets in this chapter.

## LENS ACCESSORIES

There are two basic categories of lens accessories. Those which serve to protect or care for the lens were discussed in Chapter 4.

In the second category, there is a wild and wonderful variety of lens accessories for changing the image made by the lens. We think of this as *modifying* the image.

Why should you modify the image you get in your camera? Even if you are a photo purist, you may want to focus closer than your normal camera lens permits. This requires an accessory such as a close-up lens, which makes the image larger.

Contemporary artists develop new concepts in painting and

sculpture by experimenting with new techniques and approaches—these are other types of image modification. Contemporary photographers tend to be innovative, too. They look for different kinds of images—and these modifying gadgets offer ways to innovate.

When Carl goes out to take a picture, he usually decides on

49

some kind of image modification to make that image more dramatic. It's a whole new problem to go out with a gadget in hand and try to find a suitable subject. We are not basically gadget-oriented photographers, so our approach is conservative, but these gadgets are exciting nonetheless, and open up lots of opportunities—especially in color photography.

Some "new" items are really old gadgets revived—sometimes with modifications, but still essentially the ones used years ago. Half-colored and half-clear filters serve as a good example: About 1930, Kodak made a half-yellow and half-clear filter, with the yellow part used at the top to bring out clouds without changing the foreground—using black-and-white film, of course. Turn that filter upside down, use it with color film, and you'll get the effect shown at the beginning of this chapter.

Modifying the image includes modifying its size. Macro or micro accessory lenses, close-up attachments, extension tubes, bellows systems, reversing rings, microscope and telescope adapters, and wide-angle and telephoto gadgets all change the size of the image on film.

Softening the image includes the use of a diffusion filter for diffusing the entire image, or a spot filter for diffusing just edges of the image. The matte box is no longer used only by professional photographers; we illustrate two amateur 35mm systems here.

Modifying color can be done with a dazzling array of full color filters, filter combinations, diffraction filters for spectacular work with light, and half-color and bicolor filters! Color modification also includes the use of infrared film, using indoor film outdoors and vice-versa.

## MAGNIFICATION

There are several ways to state magnification but these methods *always* compare the size of the image in the camera to the size of the subject in the real world.

$$\text{Magnification} = \frac{\text{Image Size}}{\text{Subject Size}}$$

For example, if the image is 1" tall and the subject is 4" tall,

$$\text{Magnification} = \frac{1}{4}$$

If you perform the indicated division, the decimal answer is 0.25 which means the image in the camera is 0.25 times as tall as the subject. This can also be stated as a percentage: The image is 25% as tall as the subject. Some authorities don't do the indicated division and say the magnification is 1:4, where the colon indicates a ratio or division.

In this book, we will always complete the division and state magnification as a decimal or whole number.

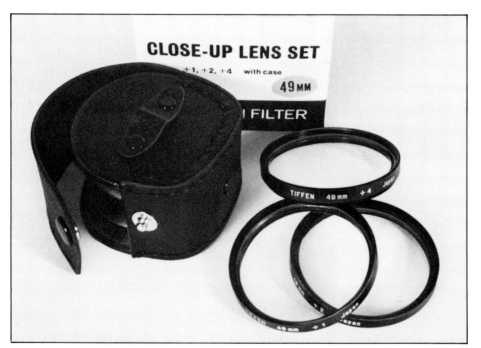

If you use close-up lenses often, you may find it more convenient to have a single unit with variable power. This one "zooms" by rotating a control on the lens.

Close-up accessory lenses screw into the filter threads on the front of most interchangeable lenses. When purchasing close-up lenses, be sure they match the filter-thread diameter of the camera lens you intend to use. Common thread diameters are 49mm, 52mm and 55mm. You can use accessories of one diameter with lenses of a different diameter by placing a step-up or step-down adapter between them—as you'll see later in this chapter.

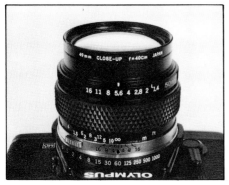

Close-up lenses look like filters and mount on the lens like filters, but they are clear and serve to magnify the image.

Close-up lenses increase image size as illustrated here, but they don't change exposure settings and your camera works the same way with or without the close-up attachment on the lens.

## HOW TO USE CLOSE-UP LENSES

Most accessory close-up lenses are marked with the thread diameter and an identification number such as 1, 2, 3, 4 or 10. The identification number actually states the "strength" of the lens in *diopters*. Higher diopter numbers magnify more.

To figure magnification with close-up lenses, you must first convert the diopter rating of the close-up into its focal length in millimeters (mm). This is easy to do.

$$\text{Focal Length (mm)} = \frac{1000}{\text{Diopter Rating}}$$

It's even easier if you consult the table on page 52 where we've done the arithmetic for you. For example, a close-up lens with a diopter rating of 2 has a focal length of 500mm.

Then use this formula:

$$M = \frac{\text{Camera Lens Focal Length}}{\text{Close-up Lens Focal Length}}$$

Where M is magnification and both focal lengths are stated in millimeters. Example: Suppose you are using a 50mm lens and attach a 2 diopter close-up lens.

$$M = \frac{50}{500}$$
$$= 0.1$$

Thus, the image in the camera will be one-tenth as tall as the subject.

This formula applies *only* when the cameras lens is focused at infinity. When the lens is focused closer than infinity, the distance from lens to subject decreases and magnification increases. Therefore, magnification as figured by the formula is the *minimum* for the combination of camera lens and close-up lens.

To select a close-up lens, first estimate the amount of magnification you need. The 35mm film frame is 24mm tall and 36mm wide, which is about 1" x 1-1/2". Example: If your subject is 1/2" tall and you want to fill the 1" dimension of the frame, you need a magnification of 2.

Find a combination of close-up and camera lens resulting in the desired magnification. Using the same close-up lens, camera lenses with longer focal length give more magnification.

When you have set up to make the shot, adjust the focus control on the camera lens for the desired amount of magnification, then move the entire camera toward or away from the subject to find best focus. No special exposure adjustment is needed. Firm support for the camera is necessary when using higher than normal magnifications to avoid blurring the photo due to camera movement.

You can combine close-up lenses to get more magnification, but image quality will be reduced and the edges of the frame may be dark due to vignetting. When combining, put the close-up lens with the highest diopter number nearest the camera. The diopter rating of two lenses combined is the sum of the individual diopter ratings.

Most authorities agree that image quality deteriorates noticeably when close-up lenses are used at magnifications larger than about 0.5. However, if you need high magnification with a close-up lens, you can get it easily by using a diopter rating of 10. With a 50mm camera lens *minimum* magnification will be 0.5 and it will go higher as you focus the lens closer than infinity.

| ACCESSORY CLOSE-UP LENSES WITH A 50mm CAMERA LENS | | | | | | |
|---|---|---|---|---|---|---|
| | MINIMUM MAGNIFICATION | | | MAXIMUM MAGNIFICATION | | |
| | | Subject Distance | | | Subject Distance | |
| Close-Up Lens | M | mm | inches | M | mm | inches |
| 1 | 0.05 | 1000 | 40 | 0.21 | 277 | 10.9 |
| 2 | 0.10 | 500 | 20 | 0.26 | 217 | 8.5 |
| 3 | 0.15 | 333 | 13 | 0.32 | 178 | 7.0 |
| 4 | 0.2 | 250 | 10 | 0.38 | 151 | 6.0 |
| 1+3 | 0.2 | 250 | 10 | 0.38 | 151 | 6.0 |
| 2+3 | 0.25 | 200 | 8 | 0.44 | 131 | 5.2 |
| 1+2+3 | 0.33 | 167 | 6 | 0.5 | 116 | 4.6 |
| 1+2+4 | 0.35 | 143 | 5 | 0.55 | 104 | 4.1 |
| 10 | 0.5 | 100 | 4 | 0.73 | 79 | 3.1 |

Accessory close-up lenses are often labeled with their diopter ratings. This table shows approximate minimum and maximum magnifications M with various combinations of close-up lenses and a 50mm camera lens. To use different camera lenses, doubling focal length will double minimum magnification; it will not double maximum magnification, although it will increase.

| FOCAL LENGTH OF CLOSE-UP LENSES LABELED IN DIOPTERS | |
|---|---|
| Diopter Rating | Focal Length mm |
| 1 | 1000 |
| 2 | 500 |
| 3 | 333 |
| 4 | 250 |
| 3+2 | 200 |
| 4+2 | 167 |
| 4+3 | 143 |
| 4+3+1 | 125 |
| 4+3+2 | 111 |
| 10 | 100 |

Close-up lenses generally have their diopter ratings indicated, but to figure magnification you need to know their focal lengths. This table converts diopters into focal length in millimeters.

## MAGNIFICATION BY EXTENSION

If you look at an ordinary lens on a 35mm camera while focusing it, you'll see that the lens moves away from the film to focus at closer subject distances. Then look through the viewfinder while doing that and you'll see that the image becomes larger as you move closer to the subject and focus on it.

With an ordinary 50mm lens, the closest focused distance is usually about 18" and magnification at that distance is about 0.1. The reason you can't focus closer and get higher magnification is in the construction of the lens—it won't move any farther from the film.

That's the clue to another way of increasing magnification: The more distance you put between lens and film, the more magnification you get. Distance between lens and film is called *extension* in photographic language. A small amount of variable extension is built into the focusing control of the lens.

To get more extension and therefore more magnification, you can use *extension tubes*. These are

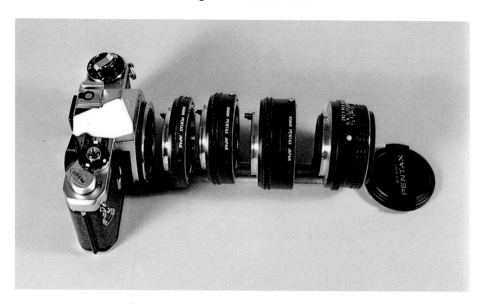

Extension tubes are spacers placed between the camera and lens to increase magnification. They are usually sold in sets of three so you can obtain various degrees of magnification. Individual tubes are marked with millimeter extension—11mm, 18mm, 36mm, for example—and can be used singly or in combination. The term *automatic* means they will operate the diaphragm mechanism of the lens automatically, just as your camera and lens normally operate. Non-automatic extension tubes do not preserve the automatic diaphragm feature of your camera.

simple hollow cylindrical spacers that fit *between* lens and camera. You just remove the lens, place an extension tube on the camera and install the lens on the front end of the extension tube.

Conventional extension tubes put in a fixed amount of extension. Sometimes it is necessary to vary the amount of extension to vary the amount of magnification. This can be done in two ways: Some manufacturers offer an extension tube with a control to change its overall length which can be used alone or in combination with fixed extension tubes. Another way is to use a bellows between lens and camera. A bellows is very convenient and the extension is easy to change—but bellows units cost more than simple extension tubes.

## HOW TO FIGURE NEEDED EXTENSION

Begin by estimating the amount of magnification you need, as already described. Then use this formula to calculate the amount of extension required between lens and camera:

$$X = M \times F$$

where X is extension in millimeters, M is the desired magnification and F is focal length of the camera lens in millimeters.

Example: Using a 50mm lens, you need a magnification of 2.

$$X = 2 \times 50mm$$
$$= 100mm$$

Use extension tubes or a bellows to put a distance of 100mm between lens and camera body, and magnification will be 2.

## EXTENSION TUBES

Using extension tubes is very simple—just put them between lens and camera. However, there are two types. Some have pins and levers which preserve the automatic features of camera and lens. With these *automatic* extension tubes, you usually operate the camera the same way with or without extension tubes installed. With non-automatic extension tubes, it is usually necessary to use a special exposure measuring procedure called *stop-down metering.* Consult your camera manual.

At higher magnifications, the slightest camera movement or vibration during exposure will blur the image. Choose extension length for the desired magnification and then move the entire camera to find best focus.

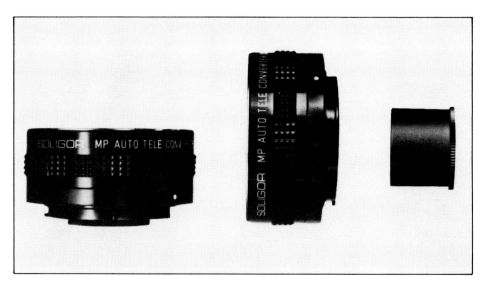

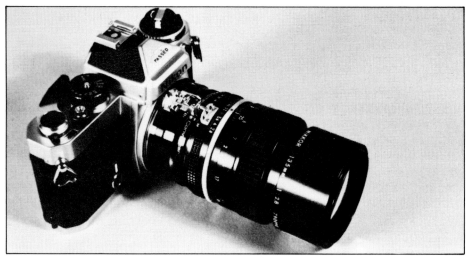

A *tele-converter* fits between lens and camera and multiplies both lens focal length and *f*-number. For example, a 2X tele-converter changes a 100mm lens set at *f*-2 into a 200mm lens set at *f*-4. Tele-converters have glass optics inside the barrel; extension tubes don't.

This clever Multi-Purpose Tele-Converter from Soligor combines both functions because the optics are removable. Remove them and use the barrel as an extension tube. Insert the optics carrier and it functions as a 2X tele-converter suitable for use with 50mm and longer focal length lenses. The unit is available with mounts to fit most brands of 35mm SLR cameras.

Using tele-converters to extend focal length reduces light in the camera and sometimes results in reduced image quality; however, some camera makers are now offering tele-converters designed to work with specific lenses with the claim that image quality deterioration cannot be seen!

A Nikon tele-converter for use with a specified group of lenses is shown at left.

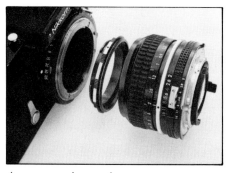

A reversing ring, or reverse adapter, is used to mount a lens backwards on the camera, on extension tubes or on the front of a bellows. Reversing the lens gives better image quality at magnifications greater than 1.

## BELLOWS

In principle, a bellows is just a variable extension and is as simple to use as extension tubes. Just connect the camera to one end and the lens to the other, figure the amount of extension needed and set the bellows for that amount. Typically, a millimeter scale on the bellows is used to read the amount of extension.

The bellows should be designed for your brand of camera because it uses the lens mount on the camera and must fit. The front of the bellows duplicates the camera's lens mount and will accept any lens that fits on your camera.

Typically, a bellows does not make the mechanical connections between lens and camera to preserve automatic features of camera operation. In this case, you may need to use stop-down metering. Your camera manual will tell you how.

The bellows must be firmly mounted on a tripod, copy stand or equivalent to avoid image blur due to camera movement or vibration.

Set extension for the desired magnification, then move the entire camera and bellows assembly forward or back to find best focus.

Some bellows units have three adjuster knobs, one moving the front of the bellows; one moving the back, and the third moving the entire bellows assembly with camera and lens. A "three knob" bellows is desirable because you use the third knob to find focus.

Some have two knobs—one to change bellows length and the other to move the entire assembly to find focus. This is convenient, also. Some have two knobs which change bellows length, one at the front and the other at the back. However, this type has no way to move the entire bellows and camera assembly, so you must do it another way—perhaps by moving the tripod or mounting the bellows on another adjustable mechanism so you can change its position.

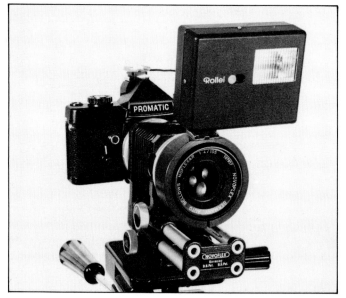

This Novoflex bellows has one knob to control bellows length by moving the front standard. The lower knob controls position of the entire camera and bellows assembly for focusing. It uses a special bellows lens with an accessory shoe to mount a flash.

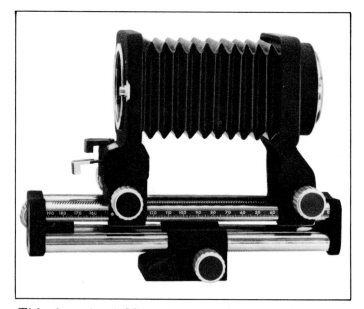

This three-knob Nikon bellows has one adjustment for the front of the bellows, one for the back, and one to move the entire assembly to find focus. The focusing adjustment is the lower set of rails and the lower knob.

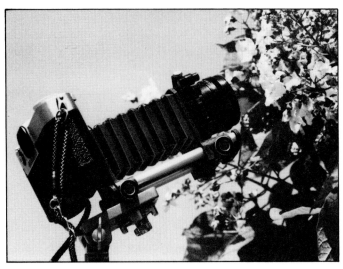

This bellows has two knobs—one to position the front standard and one to position the rear standard of the bellows. There is no adjuster to move the entire assembly, so you have to do it by moving the tripod.

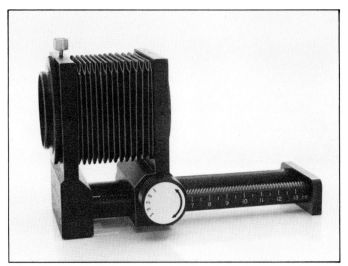

This inexpensive single-track bellows has only one adjustment—position of the front bellows standard which you can read off the calibrated scale on the track. The adjuster knob is labeled "focus" but you actually use it to set magnification. Loosen the set screw on the rear standard and you can rotate the camera for either a vertical or horizontal format. Most bellows units have a way to rotate the camera.

## USING AUTOMATIC EXPOSURE

If your camera sets shutter speed automatically after the lens aperture is adjusted, you can use it for automatic exposure control when shooting through a bellows or extension tubes. This is very convenient. If your camera sets lens aperture after you set shutter speed, check the camera manual for instructions on using it with lens extension devices.

## EXPOSURE COMPENSATION

When you increase magnification by adding lens extension, the amount of light entering the camera is reduced and the viewfinder image may become very dim. If the camera is set so its internal exposure meter is working and if the amount of light is sufficient to get an accurate exposure reading, there should be no problem except compensating for *reciprocity failure* of the film. If you cannot use the camera exposure meter, then the procedure is to measure exposure another way, such as with an accessory meter, and then compensate the reading with an *Exposure Correction Factor*. This is beyond the scope of this book but you can read about both exposure correction and reciprocity failure in *SLR Photographers Handbook* by Carl Shipman, also published by HPBooks.

## REVERSING THE LENS

When magnification is greater than 1.0, ordinary camera lenses produce a sharper image when mounted backwards. One way to do this is with a *reversing ring* which screws into the filter threads on the front of the lens and then serves to mount the lens backwards on the front of a bellows or extension tube. The reversing ring *must* have threads the same diameter as the filter threads on the lens. The opposite side of the reversing ring must match the lens mount, extension tube or bellows—which means it must be made for your brand of camera.

Another way to reverse the lens on some bellows models is to remove the front standard of the bellows, reverse it and reinstall. The lens then fits backwards, between the bellows fabric and the front standard.

## AUTOMATIC DIAPHRAGM CONTROL WITH BELLOWS

Modern SLR cameras allow metering at open aperture and then stop down the lens aperture automatically just before exposure. This is called automatic diaphragm and is done by a mechanical connection between camera and lens. A few bellows designs preserve this mechanical connection so you retain the automatic diaphragm feature. Most do not.

Some bellows units provide automatic diaphragm by using a special cable release with two branches. One branch connects to the front standard of the bellows, the other to the camera shutter button. The dual cable release performs two operations in sequence: First it stops down the lens, then it operates the camera shutter.

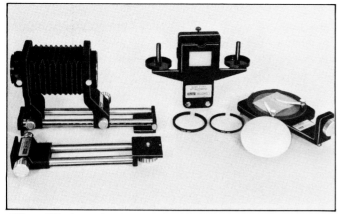

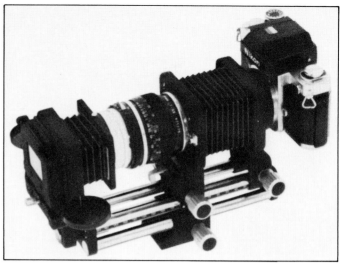

The Vivitar bellows system includes dual-rail bellows with rack-and-pinion adjustment and a camera mount which rotates 90° to permit both horizontal and vertical format pictures. It has three tripod mounting sockets and a T-mount so you can adapt the bellows to use different brands of cameras and lenses. The macro stage mounts the bellows vertically and is a great help in photographing close-up subjects such as stamps, coins and insects. This stage includes a translucent specimen plate for making back-lighted shots.

The system also has a slide copier for mounting in front of the lens. The Vivitar Owner's Manual for this set is complete and well done.

This Nikon slide copying attachment mounts on the front of the bellows and has its own small bellows to exclude light between slide copier and lens. Just drop slides into a slot on top of the copier. Roll film fits in the trays at each side and passes through slots in the sides of the copier. Illumination is through the frosted glass window in the copier unit.

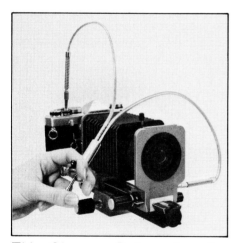

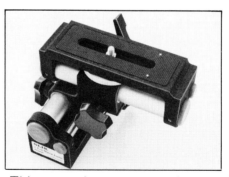

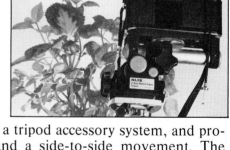

This two-axis macro stage is part of a tripod accessory system, and provides back-and-forth adjustment and a side-to-side movement. The geared center section of the tripod on which you mount the stage makes the third—up and down—adjustment for precise positioning. This gadget solves some of the most annoying problems encountered in critical photomacrography—precise size adjustment and image placement. It's a great help in making perfect compositions.

This Olympus Bellows has the front standard reversed to reverse the lens. Automatic diaphragm control is provided by the double cable release which closes lens aperture before operating the shutter. A set screw on the handle can be used to hold the shutter open for long time exposures.

# MAGNIFICATION RANGES

An artificial butterfly photographed with a 50mm lens on the camera, using no accessories.

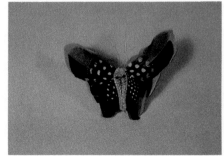

Same subject using close-up lens **1** on the 50mm camera lens.

Same arrangement except with close-up lens **2**.

Same butterfly photographed with 50mm lens and close-up lens **4**.

Switching to a bellows with 50mm lens, we photographed the butterfly at minimum bellows extension.

At a bellows extension near the middle of its range.

At maximum extension of the bellows.

Another way to get high magnification: This shot was made with a 50mm lens reversed, using a reversing ring and mounted directly on the camera. (All illustrations were enlarged the same amount.)

These Olympus macro lenses illustrate available types. At right, on the table surface, is a 50mm macro for use on a camera or on a bellows. It has a focusing mechanism and gives magnification up to 0.5 without any accessories. In the center is an 80mm *bellows* macro lens. It can be used only on a bellows because it has no built-in focusing mechanism. At left, and on the bellows are special microscope-type lenses which use an adapter to mount on the bellows.

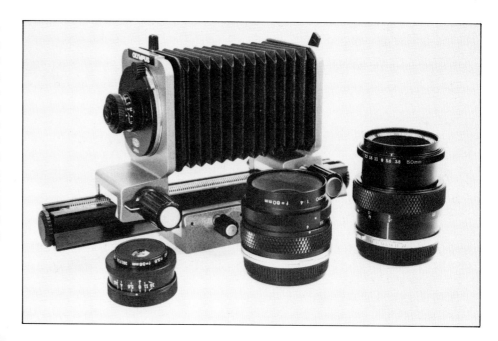

## CLOSE-UP, MACRO AND MICRO

These names generally indicate both the magnification range and the equipment used. Close-up photography is normally done with close-up lenses. For best quality, maximum magnification should be no more than about 0.5, but you can get much more than that if image quality is satisfactory.

Macro takes over where close-up stops, although macro is precisely defined as magnifications greater than 1. Macro work is normally done with extension tubes or a bellows. The practical limits are from about 0.5 up to a magnification of about 10 or 12. Scientists call this *photomacrography*.

Lenses specially designed for good image quality at magnifications greater than 1 are usually called *macro* lenses, although Nikon calls them *micro* lenses.

When you need magnifications greater than you can get with conventional macro equipment, you can do it by shooting through a microscope. Scientists call this *photomicrography*. Some erroneously call it *microphotography*, which is actually the process of making a small image of a larger subject. For example, the microfilming of a check produces a microphotograph. We call it *shooting through a microscope*.

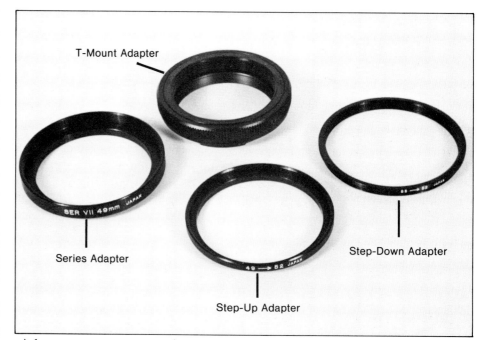

Adapters are connectors between two pieces of camera equipment. They connect lenses to filters, accessory lenses, bellows, microscopes, telescopes, matte boxes and lens to camera when reversed. Step-up and step-down filter adapters are available in many different combinations. To use a 52mm filter on a 48mm lens, you can get an adapter that is 48mm on one side and 52mm on the other.

Series adapters such as Series V, VI, VII, VIII and IX are almost obsolete. In the old days, camera lens sizes were not standardized. If you bought a filter for one lens, you then had to buy several series adapters in order to use that filter on all of your lenses. Today there are still a few gadgets that require a series adapter. T-mount adapters were used to connect the old T-mount lens design to various cameras. This system was developed before automatic lenses were common and is no longer in general use, although a few gadgets still require the use of a T-adapter.

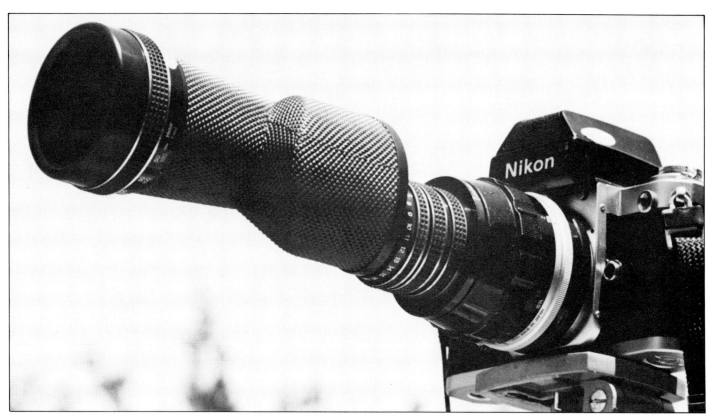

A current version of an old gadget, this monocular has the capacity to zoom! In fact, about ten years ago a whole series of these was marketed; they could be hooked up to almost any camera using an adapter. The monocular's attraction lies in high magnification combined with low weight. The disadvantage is the lower light transmission, vignetting, and an image that is not always sharp to the edges.

Catalpa blossoms photographed through a combination of camera lens and zooming monocular.

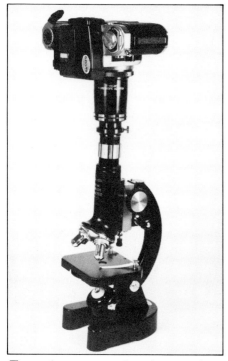

To photograph through a microscope, you don't use any lens on the camera body. Instead, use a microscope adapter which fits the camera at one end and the microscope at the other. Magnification is determined entirely by the microscope lens.

Swift Instrument Company, makers of a line of microscopes carried by some photo dealers, supplied these color shots taken through a Swift microscope. This kind of photography is properly called *photomicrography*, although some incorrectly call it *microphotography*. It is commonly used by scientists. Artists also are fascinated with this field and adapt the patterns and colors they see in highly-magnified objects to the arts of painting, weaving, and even work in plastic and glass.

# PHOTOS TAKEN THROUGH A TELESCOPE

Like microscopes, telescopes work very well with almost all SLR cameras. It's best to remove the camera lens and attach the camera to the telescope by means of a simple adapter. The Celestron shown here is a compact, high-quality telescope with great power and yet is easy to transport and use.

Pay attention to what astronomers call "seeing," namely the clarity and stillness of the air. This is especially important in using the Celestron as a high-power telescope during the day. A distant shot through atmosphere over hot earth hasn't much chance of being sharp. Late at night or early in the morning is better—either time will usually provide better atmospheric and photographic conditions.

The Lagoon Nebula.

The Moon. Photo by S. Reed.

The Moon and Venus. Photo by Dennis diCicco.

The Moon's surface, partly in sunlight and partly in shadow. Photo by Dennis deCicco.

Two hobbies that combine exceptionally well are photography and astronomy. They both require patience and persistence—and the rewards are terrific! The photographer who proudly displays an enlargement of an excellent telescopic shot that he took himself deserves to be congratulated. Celestron International, manufacturer of the telescope you see in this section, furnished these slides which were taken with the same type of Celestron 8 used by the hobbyist.

A Nikon coupled to a Celestron 8 with an adapter available for most camera brands from Celestron International. After focusing the telescope, use a cable release to operate the camera.

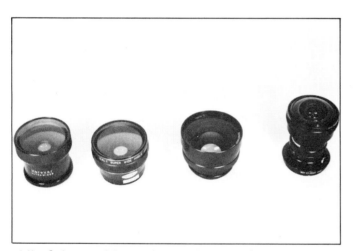

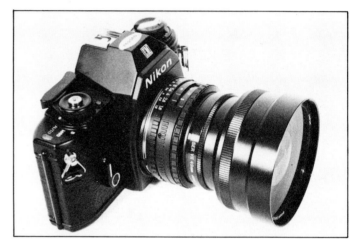

All of these wide-angle attachments fit on the front of an ordinary lens and increase the angle of view. The increase depends on the focal length of the camera lens. For example, with a 50mm camera lens, a typical combination has an angle of view of 113°. With a 35mm camera lens, you get an angle of view of 150°. For best picture quality and sharpness, close down to f-11 or f-16.

We took these shots with a wide-angle attachment on a 50mm lens. At left, the attachment expanded the view and made a pleasing photo. At right, distortion is apparent but the photo may have more impact because of the distortion.

Split-field lenses are close-up lenses with half of the lens cut away. This allows two zones of sharp focus—one at the focal length of the close-up lens, the other with the camera lens focused through the cut-away portion of the attachment.

If you choose the scene or subjects carefully so the composition is not harmed by a blur at midpoint, you can use this lens successfully. It's easy to take a really bad picture with this gadget; difficult to get a shot that really exploits its unique capability. Available diopter ratings of the glass part are $+1$, $+2$ and $+3$.

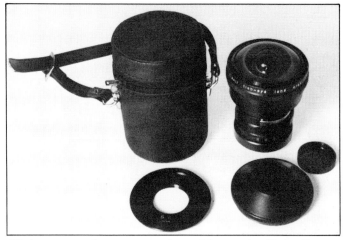

Fisheye attachments, such as this one by Kalt, fit on the front of a camera lens and increase the angle of view. When used with a 50mm lens, the attachment gives a full 180° fisheye angle of view. Image quality is not the best, but it is a very inexpensive way to take a fisheye picture. This lens uses a Series VII adapter, shown at lower left, which fits the filter threads on the front of the camera lens.

With an ordinary camera lens, you often cannot get a nearby subject and a distant subject in good focus at the same time. Add a split-field accessory and the problem is solved! This toy mouse belongs to our dog, Mr. Steele, who is looking all over for it. We know where it is through the magic of a split-field lens. Distance to the nearby subject when using a split-field accessory lens is the same as the distance given earlier in the discussion of close-up lenses. Distance to the far away subject is set on the camera lens. Look carefully and you'll see a blur in the grass which is the edge of the glass part of the accessory.

Fisheye attachments make a circular image that fits inside the film frame, like this. Angle of view is approximately 180°, which is wide enough to include your shadow if you don't watch out!

## MULTIPLE IMAGES WITH SPECIAL-EFFECTS GADGETS

There are several ways to get more than one image of the same subject. One simple way is to use an opaque mask to block part of the frame while you photograph the subject in the other part of the frame. Then mask off the area of the first image and make a second one in the unexposed part of the frame. If you are clever about it and have the right masking technique, you can make more than two images of the same subject.

Another way is to use multiple-image lens attachments which create multiple images of one subject simultaneously during a single exposure.

Still another way is to use flash at night to make several exposures on one frame. Move the subject or the camera so the subject occupies a different area of the frame for each shot.

An assortment of Pentax special-effects filters: On the right is a prismatic multiple-image filter with a center panel surrounded by four additional panels, for a total of five images. Multi-image filters are available with many patterns to put images around the center, or all in a row. They produce 2, 3, 4, 5 or 6 identical images simultaneously.

At left is a spot filter, clear in the center and textured around the edge to produce a diffusion pattern. The dark filter in the center changes color when you rotate the rim—red to blue, for example. We propped up the filters so you could see their shadows.

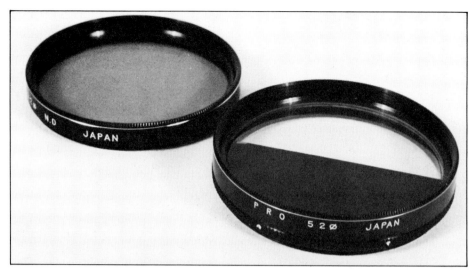

This dual-image blackout mask gadget attaches to the front of the camera lens. Rotate the blackout portion of the filter to the desired position, masking half the frame. The other part usually includes a person or animal which you photograph. Take the first picture. Following the multiple-exposure procedure for your camera, prepare to make another exposure on the same frame. Rotate the mask to a new position and move the person or animal. Take a second picture.

Used with a 50mm or 55mm lens, the dual-image set here has a recommended aperture of f-11. Too small an aperture causes a dark area without image in the center of the picture. Too large an aperture causes a light area and too much overlap of the two images. The neutral-density filter also shown is used in front of the dual-image gadget in bright light conditions to reduce the amount of light so you can use the recommended larger aperture.

Twins? No, Phoebe Gillette is talking to herself, thanks to the double-exposure capability of a dual-image mask. We took the first exposure with Phoebe sitting on the floor. Then we rotated the mask, had Phoebe move to the chair and took the second exposure without advancing the film. Check your camera instruction manual for instructions on multiple exposures.

## MULTIPLE IMAGES

The real problem in getting acceptable and even exciting pictures with multiple-image lens attachments is the need to see pictures differently. We go through much the same process with these gadgets as when we buy a new camera lens. We experiment with them in a lot of different photographic situations until we feel comfortable with them. Also, we need to know each item's limitations so we can work well within those parameters.

For the person who enjoys manipulating the image at the time of taking the picture, as contrasted to darkroom manipulation, these gadgets can become tools for the composition of very imaginative photos.

Some multiple-image accessories come with clear, explicit instructions; others are written in virtually undecipherable language, so check these out before purchase.

You should also be aware that, when used with lenses of different focal lengths, the effects are totally different.

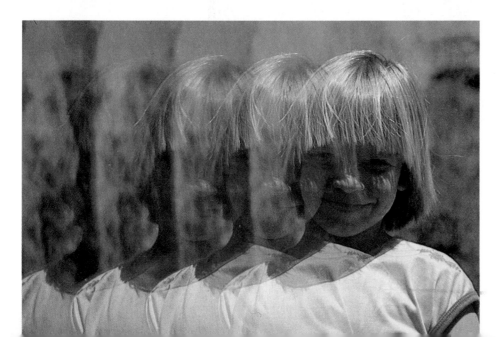

These photos show multiple-image filters used with a single subject in each case. Generally, special-effect gadgets are difficult to use because the end result is often just a demonstration of what the gadget does.

Here's a photo made of a department store window using a *Vario-Speigel-Vorsatz* attachment.

The kaleidoscope lens attachment, the *Vario-Speigel-Vorsatz*, as it is endearingly called in German, is essentially a tube lined with angled mirrors which reflect images much like mirrors in a fun house. It's rotatable for many different effects.

## DIFFUSING THE IMAGE

The entire image area of your photograph may be diffused and given a soft, dreamy focus—or you may diffuse only the edges.

Whatever the term—soft focus, diffusion or fog effect—these "filters" all serve to diffuse the entire image. Early Hollywood photographers reportedly achieved the same effect by placing a nylon stocking over the lens.

To diffuse or *vignette* the edges of the picture, you can use a spot filter or a matte box. Both provide a soft look to the perimeter of the picture and also serve to diffuse or hide a distracting background.

This diffusion filter is lit so you can see light reflected from the front surface. Diffusion filters are usually clear glass etched or molded with lines on an irregular surface like this to create a soft focus effect. Some are numbered or graded, such as from 1 to 5, to indicate that one type will produce more diffusion than the other. You can stack diffusion filters to produce a stronger effect.

Diffusion filters can be used with black-and-white or color film: First, focus the camera lens, then attach the diffusion filter to the front of the lens. No exposure adjustment is needed, but these work best with an aperture between *f*-4 and *f*-8. When shooting in strong sunlight, use a neutral density filter instead of stopping down. Diffusion filters can also be used with color filters and other special effects gadgets.

The decision to use diffusion in portraiture is one which involves the sensitivity of the photographer and how he relates to the subject's self image. Although your subject may state that he has spent a lifetime achieving the character reflected in his face and he likes it the way it is, his mind's "eye" may see it completely different from the camera's "eye." Thus, a little manipulation may be justified. This is a judgment decision; there is no steadfast rule.

Traditionally used to create a delicate softness in portraits of women, the diffusion filter also creates a dreamy, ethereal feeling in landscapes and many other kinds of photos.

This spot filter has a clear center and is heavily diffused over the remaining area. It provides a drastic means of concentrating attention on the center of the picture. Also known as a vignetting lens, it is often used for portraits.

The diffusion of this spot filter is affected most by the aperture of the lens. A small aperture makes a sharply focused spot in the center of the photo and complete diffusion at the edges; a larger aperture causes much less diffusion at the edges.

## THE MATTE BOX—A SPECIAL-EFFECTS LENS ACCESSORY

Simply defined, a matte box attaches to the front of the camera lens and holds mattes, another term for masks, filters, vignetters and montage effect accessories.

Some matte boxes can be used not only with color filters but also with polarizers, diffraction lenses and cross screens, for a fascinating variety of effects.

Some are of bellows-type construction, others are rigid. A few include all masks and blanks, but most are priced for the basic unit, and mask and vignette sets cost extra.

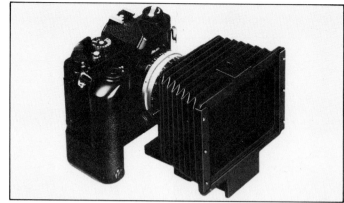

This Shade + holder is both a bellows-type lens shade and and holder for special-effect accessories. It's adjustable and can be used on most lenses. A slot at the rear of the unit holds 3" x 3" filters; one at the front holds the vignette and montage sets. It screws into the lens filter threads using an adapter. 49mm to 77mm adapters are available. An optional accessory is a flash shoe for mounting at the front to accommodate a small electronic flash. The holder collapses to 2" for storage or carrying in a belt pouch. Holder, adapter, vignette set, montage set, shoe and pouch are sold separately.

During much of the year the desert shows very colorful flowers. Judy shot this full-frame.

She used a star mask to concentrate the viewer's attention on the essential part of the subject.

Using a different mask, Judy eliminated conflicting detail from this shot of an unexpected visitor.

The vignette set here has eight masks. Four are made of brown plastic to be used with either color or black and white film. Four are made of slightly fogged clear plastic. When using the clear masks, color can be added by the photographer, either by using glass color filters or standard 3" x 3" gels. The montage set has eight cut-out masks—center circle, star, cross, heart, corner cut-outs and ovals; a half-mask and a blank mask for the user's own design. A belt pouch is available to carry the collapsed bellows-type holder and accessories.

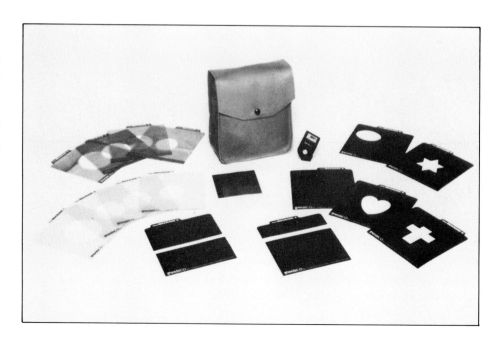

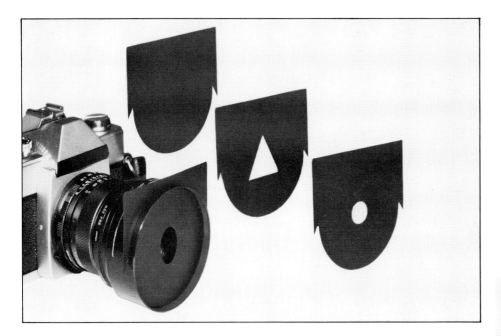

This rigid-frame interchangeable mask system includes the mask holder, adapter to fit your lens—from 49mm to 77mm—and 16 special-effect masks, including a blank you can cut to any desired shape. The maker recommends using normal or slightly telephoto lenses.

## COLOR FILTERS

Conventional filters, used in conventional ways, are not included in this section. We want to show full-color filters used in unusual ways; half-color and dual-color filters; color filters combined with special-effect lenses, and filters and color polarizing filters.

Where is the restraint of yesteryear? Alive and well. Photographers often use color filters with pastel delicacy, but some also use color filters to create artificial-looking, color-manipulated scenes with powerful moods, even supernatural effects.

More and more, photographs are being used as an integral element in interior design, and filters help to produce images with colors which enhance the decor of a particular room or location.

Strongly colored filters such as these will produce dramatic eye-catching effects when used imaginatively with color film.

Deeply colored filters are used to obtain artificial effects in photo imagery, blanketing the entire scene with one color. If the image is prosaic, the statement will be enlivened. If the image is dramatic, the color may emphasize whichever aspect you choose—cold colors for cool or frigid scenes, hot colors for an intense, emotional effect.

If you're at a great picture-taking location at exactly the wrong time of day for good lighting, or in the wrong weather to get anything but a flat picture, take it anyway—but use a filter.

We used a yellow filter to brighten this scene and add visual impact, even though we rarely see yellow clouds.

A mood was created at this location by using a red filter. The photo is definitely not the same as one taken during a natural sunset, but it has a similar quality.

If you enjoy using color filters to add impact to your photos, consider these special filters that change color as you rotate the outer rim. Kolor-Mix is one brand. You can choose ones which change from red to blue, red to yellow, and other combinations. This makes it easy to experiment without the bother of finding and changing a lot of filters—just rotate the rim and the color changes as if by magic. In these photos, a beautiful Utah valley scene was changed entirely by using a Kolor-Mix red-yellow filter.

## HALF-COLOR FILTERS

Grey, blue, pink, yellow—these are just a few of the colors you'll find in the half-color filter—a filter that is 50% clear and 50% color.

A *graded* half-color filter means that the color fades into the clear rather than forming a sharp division. This makes the filter infinitely easier to use. Some offer a choice of densities of the colored part.

Half-color filters are normally in a rotatable mount so you can position the colored part at any angle.

## POLARIZING FILTERS

Sometimes called polarizing screens, these useful gadgets darken blue skies when used with color film, remove reflection from glass and water, and penetrate haze.

Select a polarizing filter to fit your lens, attach it to the front of the lens and point the camera toward the sky at a right angle to the sun. Rotate the polarizer. You'll see changes in the color of the sky.

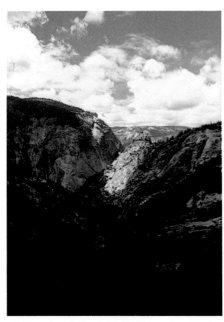

Good exposure of the sky caused the foreground to become too dark and lose detail.

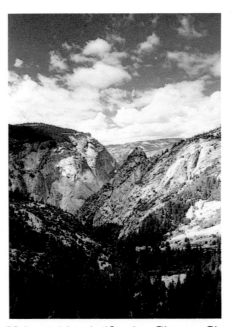

Using a blue half-color Chromofilter, the sky was darkened. This allowed giving more exposure to the foreground for an overall improvement in the photo. Similar half-color filters are available in other brands.

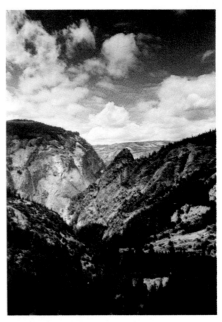

The same scene was given a touch of sunset colors by a red half-color filter rotated to color the top half of the image.

The shimmer of Aspen leaves in the Colorado mountains is not as brilliant a gold as we'd like.

A polarizing filter darkens the blue of the sky and, by contrast, seems to brighten the gold of the leaves. Now one can almost smell the tang of autumn air! When the air is clear, a polarizer can turn blue sky so dark it's nearly black—provided you point it at the right part of the sky.

Diffraction filters cause direct or reflected point light sources to have patterned shapes—stars, circles, horizontal and vertical color light patterns—by means of special grid designs etched into plastic filters. Put a diffraction filter on the front of your camera lens and rotate it until you see the pattern you like; it can be used in daylight as well as at night. Try lenses with different focal lengths—the effects will change.

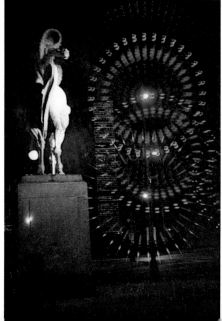

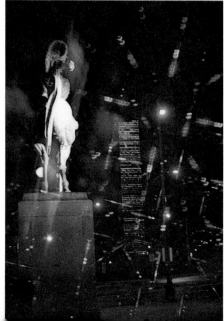

# INFRARED FILM

Along with modifying the image by means of filters comes the subject of modifying it even more with special film. In some cases, the film itself requires filters.

A good example is infrared film. It has enough application to regular subjects to be useful to most of us, at times. As you probably already know, infrared rays are the longer wavelengths of light and they act in a different manner than the light we see and ordinarily use for photography.

The special black-and-white films made with infrared sensitivity are also sensitive to ordinary light, so a filter to exclude ordinary light, such as a red filter, must be used.

Both common kinds of Kodak infrared film, High Speed Infrared black-and-white film and Ektachrome Infrared color-slide film, have general applications to scenic, portrait and special effect photography. The instruction sheet packed with each roll of film tells enough about its use that you can start to experiment at once.

Probably the most perplexing question to most is that of film speed. Because the light used is infrared, your light meter doesn't react in the usual fashion. Don't let this throw you, just follow the film instructions.

Because there are no infrared rays in the sky, infrared film shows the sky as black on black-and-white film. Infrared light penetrates haze very well. Infrared Ektachrome film produces color slides using both infrared and visible light. It makes this unique plant growth appear still more unique. Infrared film, developed originally for camouflage detection, gives an unreal or unearthly effect in many scenes. The recommended "G" orange filter was used for this image.

At left, an outside shot of Rose and her Christmas doll, taken on daylight color film. The colors are natural. At right, the same location, using indoor tungsten color film without a filter. This is a dramatic color change—sometimes useful as a special effect. You can go the other way also: Use daylight film indoors under tungsten lighting and the colors become all warm and yellow looking.

Lens shades or hoods of metal or rubber prevent unwanted light rays from coming into the front of the lens from the side, top or bottom. Flexible rubber ones can be folded back rather than removed when camera and lens go into the case.

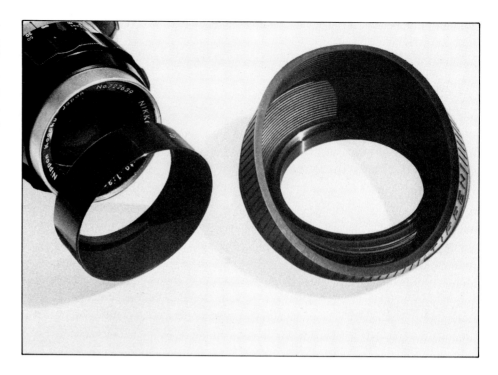

Mirror adapters, also called Right-Angle Scope and Candidar, fit on the front of a lens. They have an angled mirror inside so the camera actually takes pictures "sideways" through the hole in the side of the attachment. This is fine for sneak and peek photography. If you buy one of these, check to see how it fits on the lens; it may require an adapter.

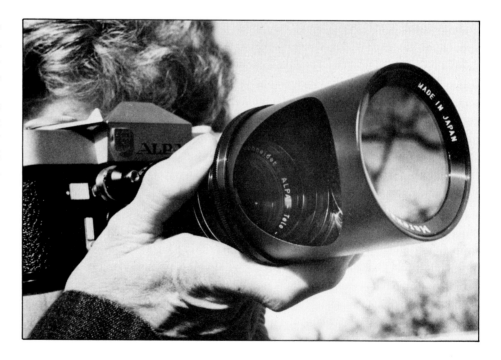

# Artificial Lighting

## ARTIFICIAL LIGHT

Photographers have used artificial light almost since the beginning of photography itself. Some kind of artificial light was essential to obtain pictures inside buildings, especially since the film used by early photographers was slow.

Before 1850, "limelights" were used in theaters to light the performers. A disc of lime was heated to incandescence by a lighted jet of oxygen and hydrogen gas, producing a bright "limelight."

By the 1850s, a burning magnesium wire was used to make light similar to daylight. Marvelous! Photographers adopted the magnesium light. Unfortunately, it emitted choking clouds of white smoke which drove both photographer and subjects from the building.

The 1880s were brilliantly lit with the flash from "photographer's powder"—a combination of magnesium, potassium chlorate and antimony sulfide. This was ignited, and in the ensuing flash of light, photographs were taken. In the interests of safety, the flash was held above the camera, and it

Photographers dressed differently in the "old days," and used different equipment. Now, we are less obvious, and our equipment is a little more compact. The late Harry Rhoads, photographer for the Denver Rocky Mountain News, looked this way when he photographed weddings and conventions, using flashpowder. Photo courtesy of John Faber, NPPA.

gave a beautiful light for portraits. In spite of careful handling, however, unexpected explosions occurred, causing fires and injuries.

Even so, flashpowder was the major source of artificial light until the 1930s when we graduated to flashbulbs held in a holder commonly called a flash gun. Then the electronic flash was introduced, and gradually took over most photography with 35mm cameras. Meanwhile, single flashbulbs became flash cubes and flash bars to produce more flashes from one unit.

Today, flashbulbs in various forms are still popular with 110 format cameras and some instant cameras, but electronic flash is rapidly taking over that application as well.

Electronic flash units have become more powerful and more capable. Some control exposure automatically on behalf of the camera by measuring reflected light from the scene and shutting off the flash when enough light has reached the film. Some even make camera control settings automatically to make flash photography super simple.

Continuous light sources have been improved also. Tungsten floodlamps are still available and widely used because they are handy and economical. Studio photographers and serious amateurs use quartz halogen lamps which burn longer and with a more uniform light output than the simpler tungsten floodlamps.

For studio use, continuous light sources and electronic flash have been combined into one unit, called a *modeling light*. The continuous source is used to illuminate the subject for posing and composition. Then the brighter flash unit is triggered to make the actual exposure.

When Phoebe and I photograph with artificial light, we don't make a major distinction between tungsten floodlights, quartz lights or flash. They are all sources of

Light is the essential ingredient in every photograph you make.

light to be used as the photographer chooses. It really pleases us to see a photographer use all types of lights casually, as tools helpful to the craft rather than part of a mystique.

Ordinary light sources are not gadgets because they are common and well known today. By our definition, a flash *system*—a specialty flash unit, flash brackets and grips, voltage converters and adapter for the traveler, slave units and other special accessories—is a gadget. This chapter is filled with a variety of ways to put light on your subject—and we hope you find it "illuminating!"

You don't see flash guns much any more! This Kodak reflector/holder is from our collection and even has its original instructions! Flash guns with flashbulbs put out more total light than most electronic flash units, although they take longer to do it. The flash duration is about 1/50th of a second, whereas most of today's electronic units are 1/1000th of a second or less! The cost of a simple electronic flash can be regained in a few shooting sessions—paid for by the money you didn't spend for flashbulbs.

A variety of reflector types is available for screw-in tungsten floodlamps. Some are designed to mount on a light stand and some are equipped with a spring clamp for mounting on a chair back or any convenient support.

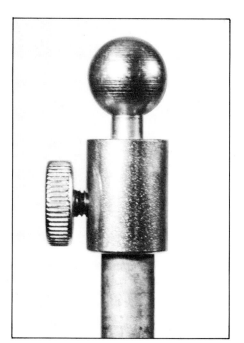

A spring clamp is a versatile tool for mounting on different supports, but they are sometimes unreliable. This type can be removed easily and replaced by a bracket for use with light stands. This is a very simple device, and one few people know about.

This diffusion screen snaps over the reflector, providing a more even and softer light. It's inexpensive—and a snap to use.

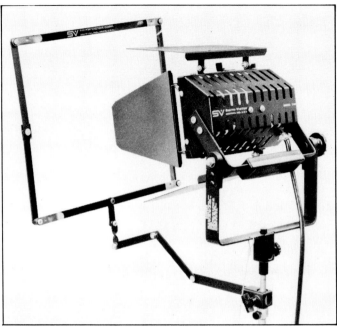

This large adjustable filter holder attaches to a light stand to hold colored gels, polarizing filter sheets or whatever you want to put in it. The material stays cooler because air can flow around it. The flat panels attached to the lamp housing are called *barn doors* and are used to control the spread of the light beam.

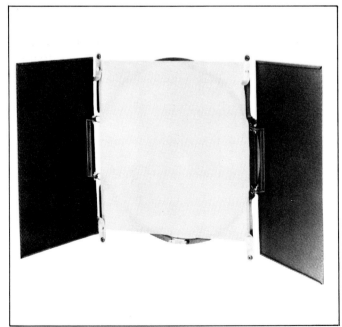

Here's another reflector gadget, barn door and filter holder in one. The entire holder may be rotated. The filter holder holds diffusion, polarizing and special effects color sheets which are purchased separately.

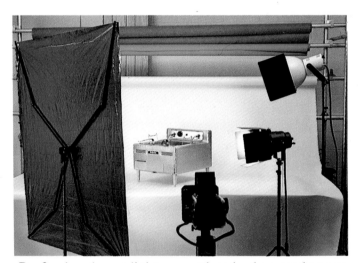

Professionals use lights, seamless background paper and reflectors for studio photography. You can improvise reflectors and use poster board for a seamless background. There isn't any easy way to improvise lights, but some types are relatively inexpensive and your studio work will benefit from the professional approach to lighting.

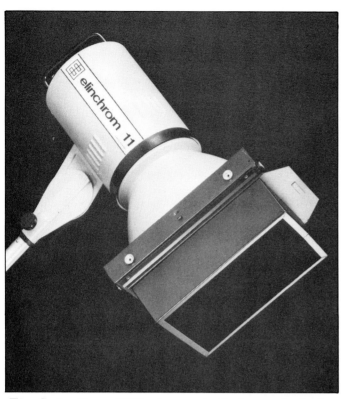

The Swiss line of Elinchrom studio lamps includes both flash and built-in continuous modeling lights, and accepts a wide range of accessories which fit into a holder on the front of each lamp.

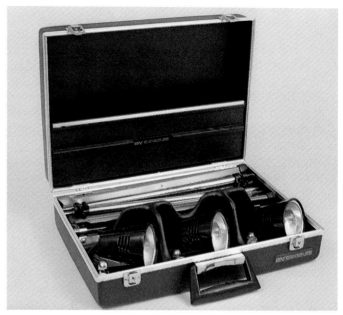

Adequate for some professional use, a quartz light kit is also excellent for the amateur home studio. Lights and stands fit into the case and there is additional room for extension cords, spare lamps and barn doors. Weight: 24 pounds.

Reflectors have been used even longer than people have had cameras. For control of old-time studio skylight lighting, there wasn't much else to throw a little extra light into the shadows. Some photographers still use a handy white cloth or paper for this purpose, although crumpled aluminum foil pasted on a board is more efficient and permanent.

Reflectasol units give a more even light, and are supplied in a variety of shapes and formats. For instance, the umbrella type tends to direct the light as needed. This *Studio I Kit* supplies two different useful reflectors on adjustable stands, complete with modeling light. All you have to do is add your flash unit, camera and subject.

## RED-EYE

When using flash with color film, it is possible for the light of the flash to enter the subject's eyes and reflect off blood vessels in the back of the eye. For obvious reasons, this is called red-eye. So far, no subject has liked photos made that way.

It only happens when the flash is mounted close to the camera lens. Some pocket 110-format cameras had the problem until it was solved by supplying a plastic extender to fit between camera and flash, providing more distance between them. Modern 35mm SLR cameras rarely produce the red-eye phenomenon because there is enough distance between flash and lens, even with the flash unit mounted in the camera's hot shoe.

If you find a flash and camera combination that produce red eyes occasionally, here are some ways to prevent it:

Remove the flash from the camera and hold or support the flash at a greater distance from the lens. This usually makes better pictures anyway.

Ask the subject not to look directly at the camera.

Increase the amount of room light so the iris in each of the subject's eyes becomes smaller.

For close-up shots or photomacrography using extension tubes or a bellows, the lens usually blocks light from a flash mounted on the camera. A bracket to mount flash near the front of the lens solves the problem. This bracket mounts on the lens through a Series VII adapter and holds one or two flash units on movable arms.

A ball-and-socket *bounce head* solves a couple of problems. It increases distance between flash and lens to reduce the possibility of red-eye in portraits. If the flash unit doesn't have a swivel head to allow bouncing the light off the ceiling, the bounce head can be tilted, or even angled to bounce off a side wall. Metal flash mounts like this are designed for use with accessory shoes *without* an electrical contact to fire the flash. If you use a metal mount in a "hot shoe" that has an electrical contact, use a piece of paper or tape to insulate the electrical contact; *otherwise, the camera sync system will be shorted out and damage may result.* Without a sync contact, you must connect the flash to the camera with a sync cord.

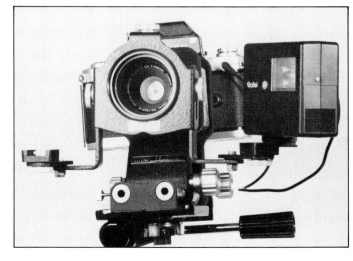

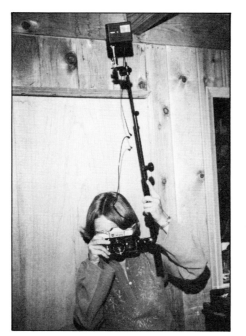

Notice that two sync cords connected together are necessary for this long reach.

Several manufacturers offer brackets to mount both flash and camera so you handle it as one unit. This is convenient but the flash remains close to the camera and may cast strong shadows on the wall behind your subject.

Some camera manufacturers offer "dedicated" flash units to work specifically with a certain type of camera. The advantage is that the flash unit sets exposure controls in the camera automatically, perhaps flashes a ready light indication in the camera viewfinder and, in some brands, even flashes a "correct exposure" indication in the viewfinder. Dedicated flash units have more capabilities than ordinary flash units and require a special hot shoe connection with more than one contact.

A disadvantage is that extension sync cords may not be available for the dedicated flash—which requires you to always use the flash in the camera hot shoe. The Duo-Sync Cord solves the problem. Plug one end into the camera hot shoe, and connect the flash to the other. The end that fits the camera hot shoe repeats the electrical contacts on top, so you can use two flash units, one at the end of the sync cords, one mounted on top of the connector in the hot shoe. Or, you can stack Duo-Sync cords at the camera and use two or three flash units, one at the end of each sync cord. The manufacturer recommends using identical flash units when using more than one.

Here's a clever idea! This flash bracket has a hollow handle for the flash unit so you can store film cartridges in the handle.

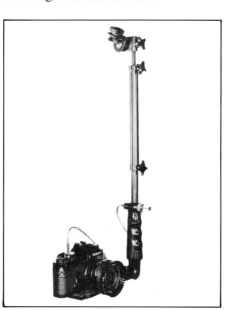

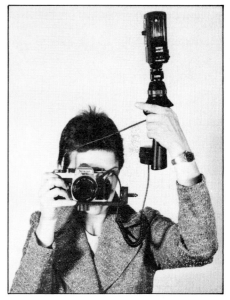

Most flash brackets come apart in a simple way so you can separate flash from camera. This allows you to hold the flash higher, producing more natural lighting on the subject, and moving shadows downward on the wall.

Some flash brackets, such as this Siegelite model, have an extension to put the flash high in the air—even higher than your arm can reach.

## MULTIPLE FLASH

Two, three or more electronic flash units can be mounted on light stands by using adapters, and can be positioned just like flood or quartz lights. Flash can be used for primary, fill, back or side lighting, and the illumination can be direct or bounced off walls or ceilings.

Diffusers and filters are included with some flash systems, and can be bought separately for other lines. The amount of light can also be controlled on flash units with *automatic* exposure by changing the ASA setting on the flash unit, instead of physically moving the flash farther from or closer to the subject. Doubling the film speed setting on the flash causes it to produce half as much light. Dividing film speed by two causes it to produce twice as much light. This applies *only* to automatic flash units set for automatic operation. Some flash unit light output controls work only with the flash set for manual operation.

This photo was made with two electronic flash units—one at the camera location and another out of view at far right to illuminate the subject in the background. With only a single flash at the camera, the background subject would have been underexposed because flash illumination falls off rapidly with distance. Ambient lighting comes from large glass windows at the right in this view, so the second flash looks natural because it illuminates from the same direction.

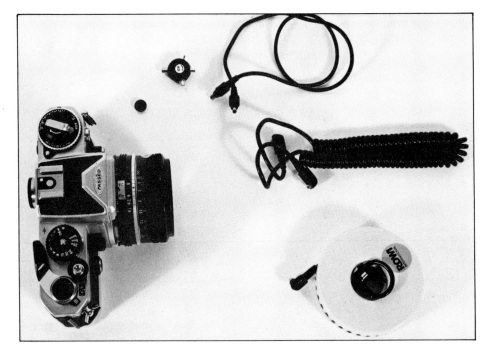

A simple way to use multiple flash is to connect each to the camera with a long sync cord—also called PC cord—which you can buy neatly coiled in reels as shown here in lengths up to around 30'. Cameras typically have only one sync connector, so you need a multiple plug with outlets for as many flashes as you are using. One side of the multiple plug connects to the camera; the other side to your battery of flashes. Disadvantages: You end up with sync cords all over the room; sync cords sometimes are unreliable and fail just when they shouldn't; and camera damage may result from firing more than one flash simultaneously. Some camera makers don't object; some warn against it.

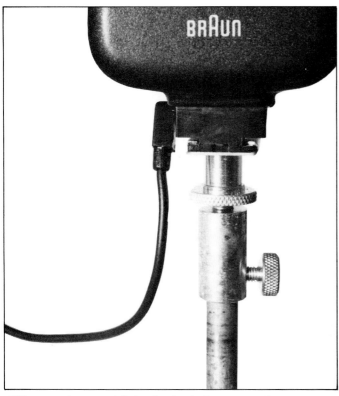

When using multiple flash, it is convenient to use light stands to support electronic flash units. The typical flash is designed to mount in a camera accessory shoe or hot shoe. An adapter such as this fits on a light stand and provides an accessory shoe on top to mount the flash. You need a long sync cord connecting to the camera, or an optical flash slave unit to trigger this flash. When buying gadgets for mounting flash units, test them before leaving the store. Some are difficult to use without a hammer or wrench—which is undignified at best.

Optical slave units fire multiple flash units without any direct electrical connection to the camera. You use the camera to fire one flash, and the light from this flash triggers other flash units, each with its own optical slave unit. Slaves mount in several ways; this model attaches to the remote flash with a rubber suction cup, and the sync cord from the slave unit plugs into the sync socket on the flash. Optical slave units normally will not be triggered by room lighting or sunlight; they are triggered by the flash on your camera, at distances up to 100' for some models. One disadvantage is that they may also be triggered by a flash on somebody else's camera!

Vivitar makes this optical slave unit and calls it a remote flash trigger. You can fire any number of remote flash units by using one of these slaves with each remote flash. Slide the main flash into the hot shoe on top of the camera and the slaves fire one or more remote flash units without any other electrical connection. A PC connector on the side of the slave can be used to make a PC cord connection to a flash if desired. On the back of this model is a HI-LO switch which is a sensitivity control for ambient light; if it is bright, switch to HI, and if it is dim, switch to LO.

## ELECTRONIC FLASH SYSTEMS

An electronic flash *system* consists of an electronic flash unit that accepts a variety of accessories which expand its capabilities. There is an increasing number of systems on the market, although some are not really complete systems. For example, two diffusers just don't expand flash capability all that much, but this is a start.

Others are part of larger systems: One manufacturer not only has a highly sophisticated series of flash units, but an infrared flash system as well.

We anticipate continued miniaturization in this field, with great benefits to the amateur photographer. Items formerly used only by professionals, many times only in the studio, are now compact enough for everyone to carry around.

This Rollei flash features a head which swivels for bounce lighting. It also has a clever reflector accessory for producing less directional, softer lighting. A tiny folding reflector is certainly easier to carry than a full-size reflector with stand.

A kit of four color domes is part of the Rollei flash system. Clip one over the flash window to color the flash. Choose blue, red, yellow or green for dramatic shots similar to using full-color filters over the camera lens. Each part of the Rollei flash system is available separately.

The Rollei Creative Lite-Effects Kit consists of four domes which fit over the flash window, including a close-up dome, warming dome, 2:1 bounce dome and 4:1 bounce dome. The close-up dome is actually a neutral density filter yielding a pleasing light for close-ups; the warming dome warms flesh tones and can be used straight-on, or with bounce flash. The two bounce domes provide two light sources from a single electronic flash—simultaneous bounce lighting and diffused fill light. The 2:1 dome provides stronger fill light, and the 4:1 bounce domes gives more subtle fill.

Rollei Creative Lite-Effects Kit

Close-Up Dome (Neutral Density)

2:1

4:1

Warming Dome

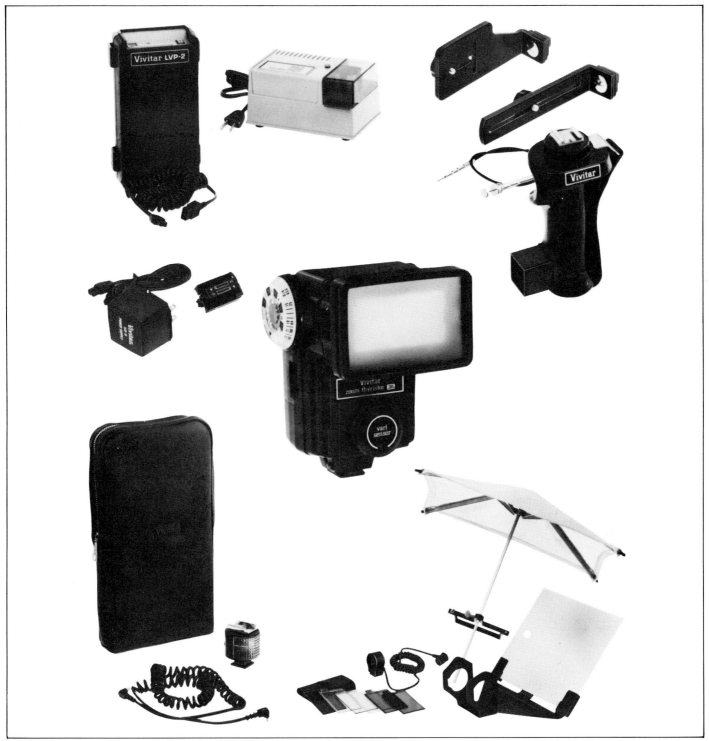

Vivitar's Model 285 zoom electronic flash is actually part of an extensive flash system which includes handles and mounting brackets, umbrellas, diffusers, slaves, AC and low-voltage power packs, and nicad batteries with fast charger. The flash unit itself incorporates many innovative features. It has an optical zoom/bounce flash head mechanically coupled to the calculator dial, a removable Vari-Sensor module, plus a complete range of accessory items for creative electronic flash applications. The zooming flash head has clearly-marked settings for camera lens focal lengths ranging from 28mm to 105mm, and tilts 0°-90° for bounce lighting. On manual, the Vari-Sensor module furnishes variable flash output down to 1/16th power. Optional system components include various power sources, shutter cords, a remote flash trigger, case, quick release pistol grip with brackets, and cable release and extension cords. Filter kits and a soft-light bounce umbrella round out the complete 285 system.

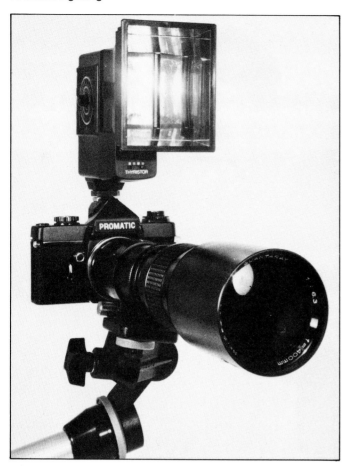

Conventional flash units produce light with a beam pattern sufficiently wide and tall to cover the field of view of a 50mm lens; some have beam widths wide enough to include the coverage of a 35mm lens. However, when you use a longer lens, usually for a more distant subject, you get no benefit from the light which falls outside the lens' field of view, and you may have an exposure problem because the flash doesn't put enough light on the distant subject. This "telephoto" flash adapter concentrates light from the flash into a narrower but brighter beam, and is recommended by the manufacturer for use with lenses from 70mm to 300mm focal length.

The Vivitar Model 2500 is a compact system flash with a wide assortment of accessories. An unusual feature is a 1/8th power non-automatic setting for use with some autowinders. Recycle time is 1/2 second; therefore, this flash will fire repeatedly in sync with some brands of autowinder which operate the camera shutter and advance film at two frames per second. In this mode of operation, not more than 25 frames should be exposed in one burst to avoid overheating the circuits in the flash unit. Nicad batteries are recommended for repeating flash.

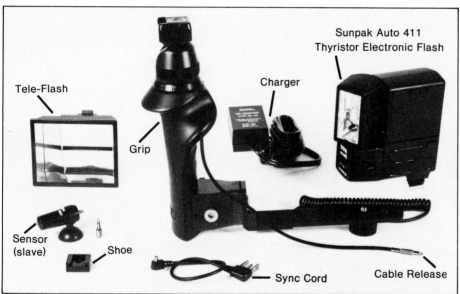

One of our favorite subjects is the amazingly rapid changes taking place in the world of electronics. These changes are obvious in computers, calculators and, certainly, electronic flash. The Sunpak 411 is a great example. Compact, powerful and versatile, it's a good system for beginner, advanced amateur and professional. The thyristor circuit saves the stored up power until called for; the auto exposure system is flexible, and you can go over to manual operation and still retain thyristor benefits—in fact, six ways. The Power Ratio Control permits manual operation at full, 1/2, 1/4, 1/8, 1/16 and 1/32 power while retaining thyristor benefits. You can trip it by hot shoe or PC cord, adjust the reflector, and select batteries or AC to suit your needs.

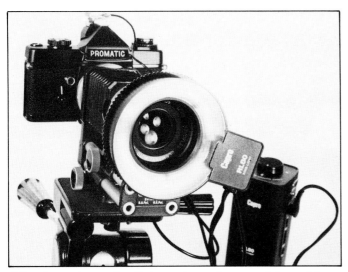

The ingenious ringlight solves the special problem of getting light on the subject of a close-up picture, without shadows. Attach the ringlight to the front of the lens and you'll be delighted with the shadowless lighting. Some ringlights are part of a larger flash system; others are sold as a unit with case, battery charger/AC converter and PC cord.

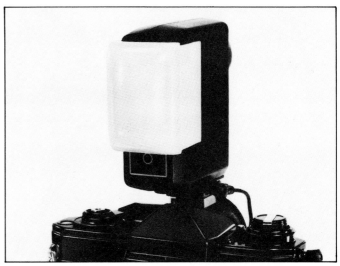

Check your camera shop for accessory clip-on flash diffusers such as this one from Sima Products. Diffused light from a flash eliminates harsh shadows and greatly improves portraits with flash.

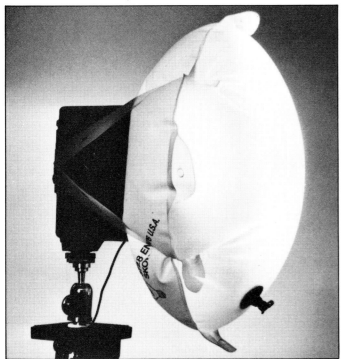

An airbag for your flash? No, an inflatable Air-Diffuser from New Ideas. It fastens over the flash with a couple of rubber bands, eliminates harsh lighting and increases the area of light coverage. A set of six filters to change the color of the light is included! No storage problem, either—it deflates!

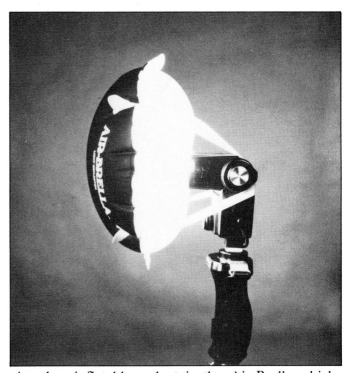

Another inflatable gadget is the Air-Brella which you blow up and attach to your flash with rubber straps. All you have to do is point the flash away from your subject so the reflector bounces light back toward the subject, diffusing and spreading the beam at the same time. This gives both softer lighting and a broader beam angle than direct flash.

The Bounce Light Kit from Smith-Victor is part of a great series of reflectors! Each consists of a 48" x 56" sheet of tough, lightweight metalized material on a polyester base, available in four highly reflective surfaces, including silver, blue, gold and soft white. Use them to improve the reflection quality of ceiling or wall or to reflect light into dark areas. Durable? Wash it, scrub it, crumple into a bag—it springs back again and again, says the manufacturer. How to hang it? On this ingenious X-frame that folds to a portable 19-3/4".

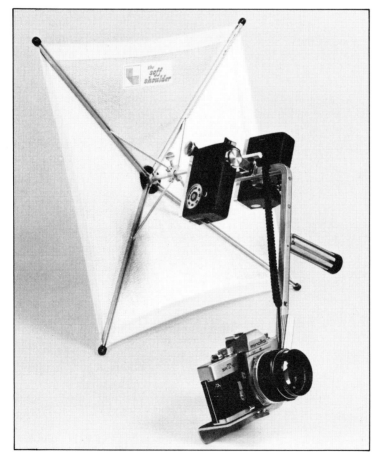

Larson Enterprises manufactures a large variety of reflectors and diffusers for both hand-held use and for mounting on stands. For use as light sources with flash, there are two types: This Soff Shoulder reflects the light back toward the subject. Another type places the flash behind the fabric so it shoots through the fabric for a different, more diffused effect.

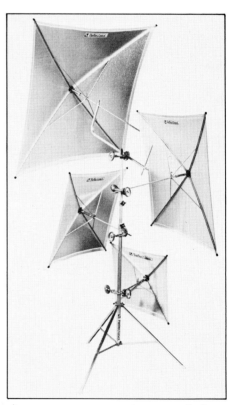

As you see, many types and sizes of reflectors are available for stand mounting to control the light in a studio or any other shooting location.

### ASA/DIN/ISO

When you go to your dealer to check out flash units—or any other photographic products for that matter—you may see a new trio of letters along with the old ASA and DIN standards. Don't let it throw you! The International Standards Organization (ISO) has a new designation which determines film speed in the same way as the ASA and DIN systems; it is just labeled differently. Thus, a film with an ASA 125 or 22 DIN speed is listed as ISO 125/22°.

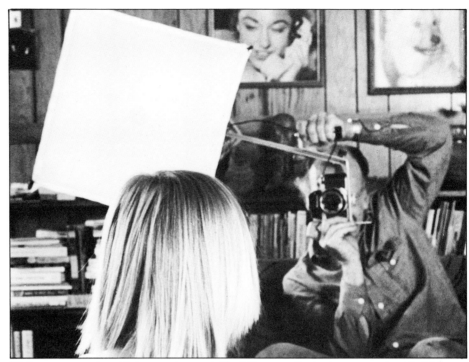

Using a portable "shoot-through" diffuser, Carl photographs Debbie.

To prevent reflections or to "subtract light," try black Reflectosol units.

The Larson Starfish is a "shoot through" diffuser with a flash unit inside the stand-mounted light source.

To attach photographic gadgets to stands, several manufacturers offer well-designed clamps that serve as an extra hand when you need it. This swivel clamp by Perfected Photo Products accepts tubes or rods from 1/4'' to 7/8'' in diameter.

When you get all set up with diffusers, reflectors and one or more flash units, how do you figure exposure? A flash meter does it the easy way. Position this Wein meter near the subject with the light collector facing the camera, pop the flash setup once, without making an exposure, and read the meter to see what aperture you should use. This meter is set for ASA 50; if you use another film speed, you spin the calibration dial located around the light collector and it tells you which stop will be the correct one.

A multiple-function flash meter, while a little more complex to use, may also prove to be an interesting gadget. This one, the Minolta Flash Meter III, solves just about any exposure problem, from continuous to pulse-light illumination, using a silicon photocell and internal microcomputer. It has its own set of accessories.

# EVEN LIGHT METERS HAVE GADGETS

The Luna-Pro System Meter by Gossen has optional attachments for a variety of specialized uses, including enlarging; repro or copying; fiber optics probe; and microscope, variable angle and flash, to name those of most interest to the amateur photographer. These accessories are instantly interchangeable on the basic light meter.

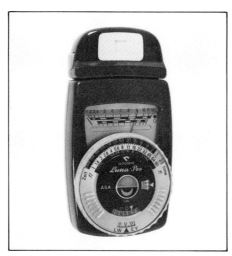

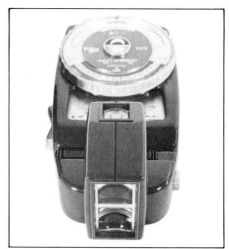

The enlarging attachment permits the Luna-Pro light meter to be used like a probe analyzer. Use it on your enlarging easel to obtain direct readings of aperture and exposure time. Another Luna-Pro component that looks almost identical to the Enlarging Attachment is the repro or copying attachment which makes readings possible for flat copy such as paintings, documents or photo prints. It can also be reversed to read light transmitted through slides of translucent material being copied.

Normally, this Luna-Pro light meter measures light over a 30° angle. Attach this variable-angle spotmeter gadget to narrow the angle and you can select 15° or 7.5° so the meter reads what your telephoto lens sees, rather than parts of the scene which won't be recorded on film. You can use this attachment as a spotmeter to read brightness of selected small areas in a scene. Just look into the top of the spotmeter attachment as though you are looking into a camera viewfinder. You'll see a red circle to show what is being measured in a field of view of 15° and a green circle to show what you are measuring if you are using 7.5°.

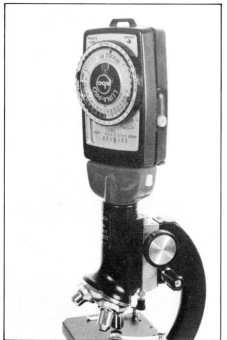

If you are going to photograph through a microscope, you may want to measure the light first to set the camera exposure controls. Sure enough, Gossen has an accessory for that, too. A series of tests is described in the light meter instruction booklet to help you calibrate this measuring setup so you get perfect exposures.

The flexible fiber optics probe attachment on the Luna-Pro conducts light from areas inaccessible to a light meter. Suggested uses are in photomacrography, ground glass measurements, density measurements on negatives or transparencies, and for luminous density measurements. The little tabs are furnished with the attachment to provide a standard target for some readings.

# INFRARED PHOTOGRAPHY

Almost everyone realizes that light has different colors and wavelengths, and that the longer wavelengths are red. When they're long enough, they become infrared.

Some films are manufactured so they are sensitive to infrared light, even when that light is not visible to the human eye. For more details, Kodak has an excellent data book, *Applied Infrared Photography* (M-28), available from photographic dealers.

An infrared electronic flash will operate in what appears to be total darkness, with the flash emitting an infrared light not detectable by the unaided human eye. A filter must be used for infrared photography outdoors in daylight, as the film is also sensitive to ordinary light.

One of the uses of infrared photography in the medical field is by the dermatologist; in the military they use it in camouflage detection, and—shades of Sherlock Holmes—to detect invisible writing. We're sure most of you have seen the marvelous pictures taken by satellite in which the colors appear to be "wrong"—that, too, is infrared, and is an invaluable way of "reading" the earth's surface.

For the amateur photographer, infrared photography can be a complex and fascinating field to explore; approached in a less scientific and more artistic spirit, one can obtain photographic effects that are quite different.

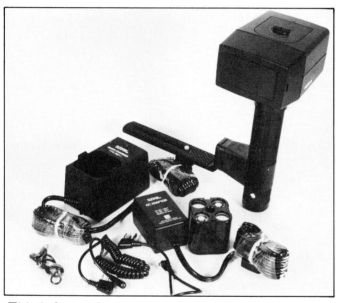

This infrared flash system is so different from most flash units that it qualifies as a gadget. It uses a very dark red filter to produce mainly infrared light. You cannot see the flash unless you're looking directly at it, and then it's only a dull red glow. This flash must be used with infrared film. Because of the special characteristics of both film and flash, it has two classes of use: Situations in which the special effects of infrared light and film are important, or cases where the flash must not be detected. The system includes infrared flash unit and handle mount; hi/lo power selector; quick release bracket with bounce capability; 5' coiled sync cord, standard sync cord, 10' extension cord, and removable ready-light cover. Power source: four nicad batteries with charger, a 510V battery pack or a 100-240V AC adapter.

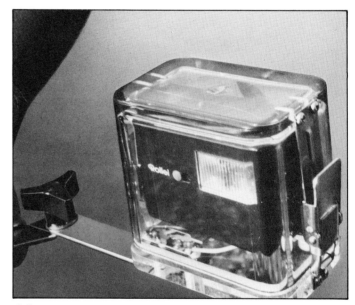

Many popular makes of electronic flash can be used in underwater housings. Because modern electronic flash controls exposure automatically and recycles without manual aid, it adapts beautifully to this enclosed housing. This entire underwater housing system is shown in Chapter 1.

# Backgrounds

## BACKGROUNDS

Nearly everybody has a collection of funny photos that are absurd because of the background—Uncle Harvey with a tree limb growing out of his ear and brother Bob with a telephone pole growing straight up out of his head. We take a great stride forward in our photographic development when we *notice* the comic or distracting results of inadvertently including a bad background in a picture. Many people don't notice such things and are perfectly content with the results. This next step occurs when we learn to observe and *control* background while making the shot—even if it means substituting one background for another.

Seamless background paper in black, white and about 50 assorted colors is available in sheets and rolls through your camera shop or graphic arts supply dealer. Sheets are usually 28'' x 44''. Rolls on a stiff cardboard core are usually 12 yards in length, and range from 53'' to 107'' wide in colors, and up to 140'' wide in black or white. You support the core with a holder or frame of some kind and unroll the seamless paper as needed. If you use it for an infinity background, take off your shoes before walking on it.

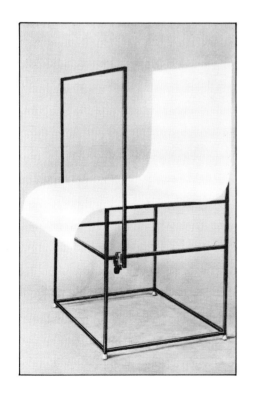

The Technal Transi-Table has a sheet of translucent white acrylic on a steel support and not only provides an infinity backgound, but also allows backlighting of the background to eliminate shadows. You can backlight with color and with varying amounts of illumination for special effects. For problem photography of glassware or shiny objects, add the tent-holder frame at the front and cover the entire setup with a white sheet. This diffuses the light and eliminates reflections on the object you are photographing.

Ordinary white or colored poster board from an art supply store makes a fine background for small objects such as flowers, glassware and jewelry, and still-life photos in general. Lay it flat on a table surface and then curve it up as shown, using tape as needed to hold it in place. Because of the gradual transition from horizontal to vertical, the background seems to be endless and is sometimes called an "infinity" background.

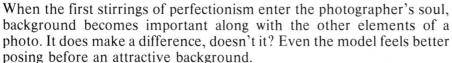

When the first stirrings of perfectionism enter the photographer's soul, background becomes important along with the other elements of a photo. It does make a difference, doesn't it? Even the model feels better posing before an attractive background.

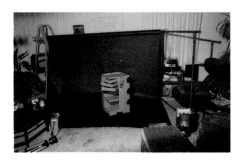

This is a setup we used over a weekend to do some product shots in our living room. The support structure is made by Welt—except for the ladder—and consists of adjustable uprights and horizontal bars for supporting a backdrop of any kind and to make a set. The Welt equipment adjusts in height from 4'3" to over 10', and the crossbar is long enough to hold seamless paper rolls up to 115" in width. A smaller model is available to hold 67" paper rolls.

You can improvise a background or a background holder, if needed. This holder is called Helen. The background is a commercially-available hand-painted vinyl-coated canvas attached to a household window shade roller. It can be hung from standard window shade roller brackets which allow you to roll it up and down easily, or it can be hung from a frame. Instructions are included for mounting on a light stand. One brand is Kalt. They are available in blue or brown. Sizes are 45" x 54", 54" x 60" and 6' x 7'. As soon as we get Mike and Rose to settle down there with Tigger, we plan to make a group portrait.

Guess what we used for a background here? Yes, a projection screen! It's portable and can be set up anywhere. It's about the right size, neutral in color and you probably already have one in your home. If you don't want to use the projection screen for a background, consider using it to support the background you would like—colored fabric or paper, for example. Use distance and depth-of-field to make it appear sharply focused, or softly blurred.

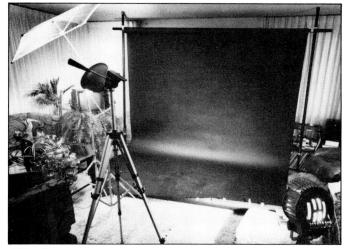

Here's another setup in our living room, using a Polecat support system for the seamless paper. The system also includes an assortment of holders for backgrounds and lighting which is versatile and relatively inexpensive. This one is made from spring-loaded Studio Polecat uprights that are adjustable to reach ceilings up to 19' high, with a crossbar to hold the paper roll.

Uprights in the Studio Polecat system press against the ceiling using springs inside the poles. The uprights are fitted with plastic caps to prevent marks on the ceiling. The U-shaped metal crossbar hanger supports up to 300 pounds.

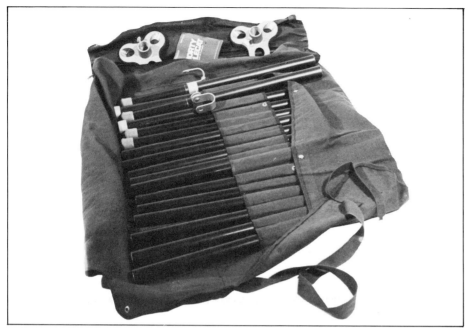

The Shorty Polecat Kit's 22 pieces fit into this handy canvas carrier and assemble into two uprights with a crossbar similar to the studio model. The two metal tripod fittings each accept three of the short poles to make a tripod base for the uprights. With the tripod bases, the holder supports itself as a freestanding unit.

Polecat Timber-Toppers, obtained separately, are just top pieces to fit on a 2'' x 3'' piece of lumber. Inside the top piece, which is padded to prevent ceiling damage, is a spring to exert pressure against the ceiling to hold the upright in place. To mount a crossbar, you can drill through the uprights as we have done here. This crossbar is the handle from a discarded broom. Polecat also makes a round Timber-Topper to fit on 1-5/8'' doweling such as used in clothes closets.

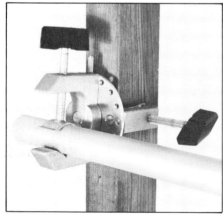

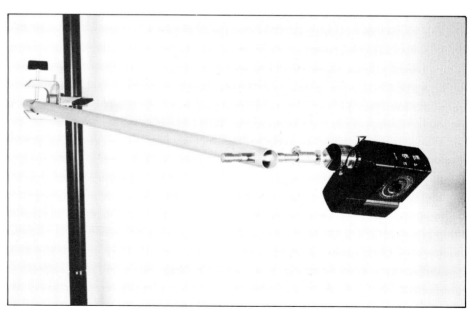

You don't have to drill to mount a crossbar. Meet Polecat's "Claw." It clamps to a 2'' x 3'' upright to support the crossbar, and has many other uses besides. It can support lights, reflectors, poles or whatever you need to attach to a chair, table, ledge or ladder. The clamp rotates and securely locks into any of 16 settings.

Are you ready for this? It's a Polecat Lite-Stik held by a Polecat Claw on a Polecat Upright. The Lite-Stik is 3' long, 1'' in diameter, and includes adapter hardware on the end to support a flash or small lamp holder.

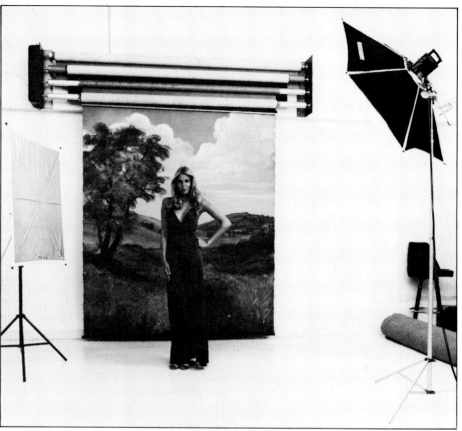

Money-saving tip: When using seamless paper over carpeting, your model will wrinkle or damage the paper by standing or walking on it. Reduce the possibility of damage by sliding a square of hardboard under the paper.

Professionals use multi-roll holders for backgrounds; however the serious amateur can own the same equipment if he chooses—and the budget permits. The advantage of a multi-roll holder is convenience, of course, and the time saved when changing from one background to another. Deluxe multi-roll holders such as this one are motor driven. You can use plain backgrounds, painted ones with no particular design or painted scenic backgounds. This one is a James Bright Background, available through Photographic Products of Hawthorne, California, along with this deluxe holder.

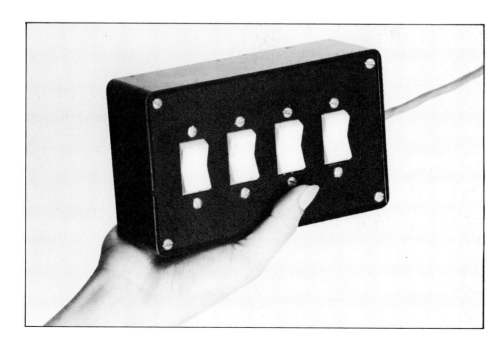

This is the remote-control box for the Photographic Products motor-driven multi-roll holder. Each switch controls one of the four rolls.

Photo by Sanford Studios

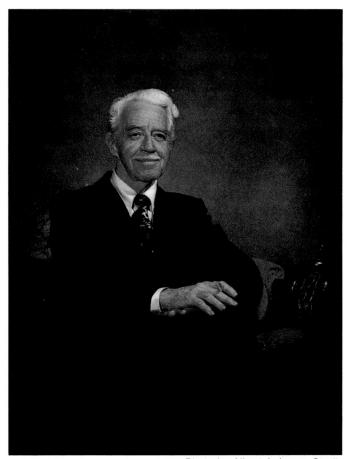

Photo by Albert & James Studio

Photo by James Bright

These photos were all made against James Bright hand-painted backgrounds. They illustrate ways to "match" the background to the model or subject. In the photo at right, the camera was deliberately positioned to show both the background and the studio wall behind the background.

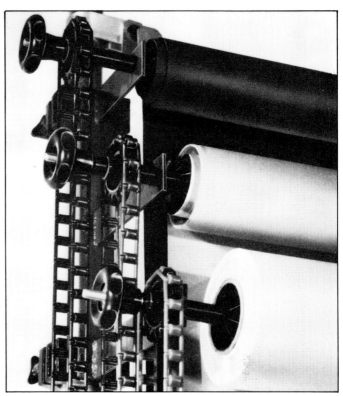

This Bogen multi-roll holder is easily assembled and is operated by hand. You can see the gears in the close-up view. While this type is not as glamorous as the motor-driven holders, it is extremely functional—and beats having to get up and down on a chair to pin the seamless background to the wall!

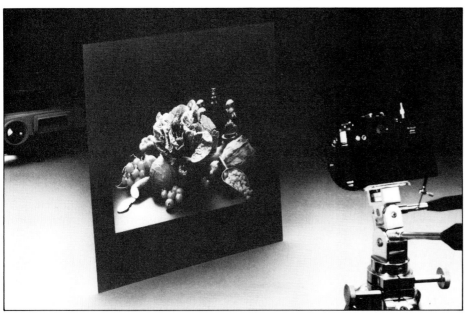

CAT—no, it's not a type of pet. It stands for *Copy And Title* and is a specially-designed rear projection panel for use in photocopying transparencies, titling, special effects, cropping, changing of backgrounds and even straightening vertical lines. The 18'' x 18-1/8'' glass panel provides uniform diffusion over a wide angle. The 18'' x 18-1/16'' PlexiCAT adds a flexible acrylic base allowing curving of the panel for special effects. It's a 3M product.

## REAR PROJECTION

Most rear projection screens have a fine-texture surface, making it possible to rephotograph the image from the screen.

Examine the image and read the meter in your usual fashion. Unless you wish to reverse the copy image, the original should be placed in the projector in the reverse manner to which you are accustomed for a regular screen.

Modify the color of the duplicate with filters, and create many other different special effects. If you plan to do a lot of rear projection shooting, ask your photo dealer for Ektachrome Slide Duplicating Film, which will give a slightly better image than regular film.

# 8
# Darkroom Gadgets

How elaborate a darkroom and how many labor-saving devices you want is very much an individual matter. Perhaps we can make a comparison between the darkroom and the kitchen: Some cooks turn out excellent meals with simple equipment and few gadgets, while others delight in having the latest labor-saving devices and special accessories.

To some extent, the same is true of the home darkroom: We *resist* saying that professionals have more equipment and amateurs have less—or that the more equipment you have the better your darkroom product will be! It just ain't so!

As a hobby, the darkroom aspect of photography can be a terrific amount of fun, so buy your equipment with an eye on what you enjoy! It can be less expensive than golf or tennis, to name a random duo of leisure-time rivals!

Darkrooms that are dark when they don't need to be, especially for black-and-white work where the sessions in the darkroom may be long, are potentially hazardous, and may be depressing. A darkroom with a darkroom ceiling light is soothing and relaxing. You may need an extra safelight up close to see detail or to judge a print, but try not to let that be your only light.

The portable darkroom is experiencing a revival, partially, we believe, because so many photo fans are seeing them used during demonstrations in photo stores. They're appropriate for either black-and-white or color use, and are available as a tent, as shown here, or a box. Both provide useful darkroom facilities at home or away, although the tent offers the additional advantage of folding for easier transportation. The light-proof fabric pulls over a metal frame on a 1'' baseboard. Included in the kit is a built-in connector for AC cord, red window with a flap to close it, and a red safelight for black-and-white work which you can turn off for color processing. It comes with a carrying case.

## DARKROOM GADGETS

In looking at the gadgets for darkroom photography, we are impressed with the changes taking place in this area. Of course, not everything is new; some have only changed a bit, but many photographers may not know about a lot of these items.

Among the older gadgets we include are portable darkrooms, bulk film loaders, cassette openers and dodging devices.

The actual dark-time needed is less and less. To print in color from negative or slide, you only have to be in the dark long enough to compose your picture, make the exposure and load the print paper in a tank. That's it.

In the light you can spend 12 to 15 minutes changing solution two to five times, depending on the process, and come out with a completed color print which can be dried with a hair dryer! We used to spend hours in the dark, even two or three days total when working with the dye transfer process. Electronic marvels, chips and transistors make the process easier now. They're used in timers, analyzers, agitators and the enlarger itself, and help us overcome some of the difficulties encountered in trying to cope with the greater precision required in some color steps than were required in black-and-white.

Some of these new products have made black-and-white easier and better. For some uses, RC paper is a logical choice because it processes and washes quickly.

Even more important, many of the gadgets and processes extend the range of what you can do, and make it more fun.

If you're a newcomer to darkroom work, practically everything in this chapter will be of interest. Old hands may browse more selectively. There's something useful here for almost everyone, such as gadgets to help you process film and dry it; gadgets to aid in the printing process, and post-printing. We also cover how to take care of prints so they'll look good.

Making a darkroom really dark has caused many problems. One of the better solutions to making an ordinary inside door serve this function is ordinary door weatherstripping and threshold seals, available at any lumberyard or handy store. These photos were made in a custom color lab, but the method should work anywhere.

At one time, changing bags were a necessity for loading and unloading cut film in the field. Today, a changing bag is an emergency device for most of us. You can check the film in your camera by placing the camera inside the bag through the zipper opening, then inserting your hands through the light-tight sleeves on the other side of the bag. If the film is not feeding properly, or if you have inadvertently pulled it off the spool inside a 35mm cartridge, you can remove the film inside the changing bag and put it in a film can.

All film cassettes used to be reloadable, like these. Then the manufacturers decided that the end caps had to be tighter and changed their procedures so the conventional cassette is destroyed when the film is removed. You can still buy *reloadable* cassettes, with space for necessary information about film type, ASA, expiration and date . . . here you can see what the inside is like!

If you use enough 35mm film, you can save about 50% by buying 100' rolls and loading your own reloadable cassettes, with a bulk film loader. The cassettes can be used more than once, and you can load short lengths of film for special occasions. Most 35mm black-and-white film and several Ektachrome types are available for bulk loading. A film loader makes the job easier and quicker than doing the whole procedure in the dark as you would have to if bulk loading by hand.

A film-leader template is a gadget bulk film users find very useful to cut the film properly for 35mm spools. Having a standard cut for the head of the film makes it easier to load some models of camera. Leica has required this cut for a long time. Of course, this process should be performed in a darkroom—not in full room light as you see here.

This film-leader template also has a guide to cut a tapered tail when loading bulk film, although most reloadable cartridges don't require this cut.

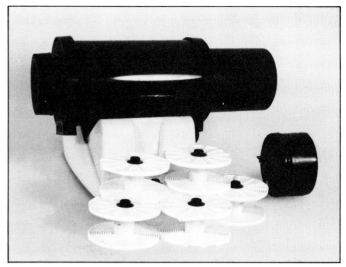

The classic tool for opening a 35mm film cassette is a beer can opener. For non-beer drinkers, pop-top fans, those who find it awkward or for whom a beer can opener is not classy enough, buy a spring-load cassette opener! Smooth and sleek, it has no sharp points to injure self or equipment. Put the cassette in the grooves at one end of the tool, squeeze the opposite ends together and one end of the cassette comes off. Then slide out the inner spool of film. Suggestion: Do this in the dark!

The Unicolor Film Drum II System is intended mainly for those wanting to develop several rolls of film at one time. The drum accepts up to eleven 110 rolls, six 135 rolls or four 120 rolls. A piston is supplied permitting adjustment of the amount of solution for the number of rolls to be processed at that time. It is insulated to maintain temperature, and fills with solution from the center of the reel. For this reason, special Unicolor center-filling reels are recommended, although Nikor-type will work with a Center-Fil Tube accessory. This tank should be used with a Unicolor Uniroller (agitator) or used as an inversion-type tank.

The Uniroller is the same one used in color print developing; the special Unicolor center-filling reels are sold separately.

As with all drum systems, it uses a minimum amount of chemicals.

Some people need help in getting film curved just right so it will fit in the grooves of a developing reel. Yes, there is a gadget to help. It's called a film loader. Feed the film through the loader and use it to guide film onto the reel as shown here.

Using a piece of scrap film, practice with the film loader and reel in the light. After you've developed some skill, try it in the dark a couple of times as a trial run.

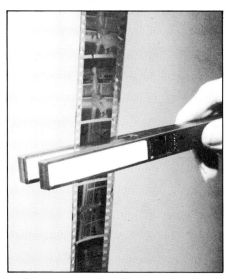

After developing film, you need some method of removing excess water when hanging it up to dry, to prevent water spotting. Of course, there are gadgets to do this, called squeegees. Some look like tongs, others look like oversize clothespins; most have rubber or sponge blades. Squeeze to open, relax to let close. We find them a little difficult to control, but others like them.

An anti-static brush removes dust from negatives, slides and lenses, and is said to keep them dust-free longer by neutralizing static. This Staticmaster brush is available in several widths, really works, and is a good darkroom gadget.

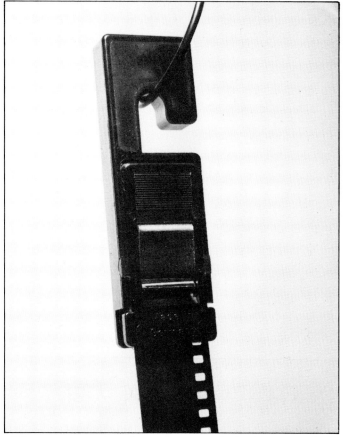

After squeegeeing, however you do it, hang the film up to dry. This well-made plastic film clip has steel springs inside to hold the film securely. It looks good and works just fine. Use another one on the bottom of the strip of film to keep it from curling up or being blown around.

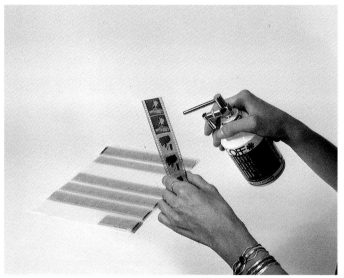

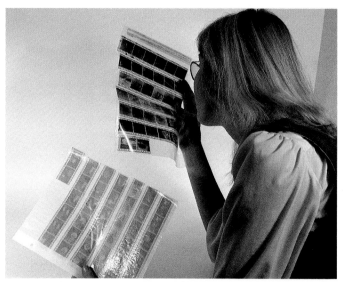

Canned, pressurized Dust-Off freon gas blows dust out of hard-to-reach areas. The pocket size is 3 ounces; junior size is 8 ounces, and there's a large 14-ounce refillable professional size shown here which is good for about 300 bursts. The large can has a reusable trigger valve and nozzle. A flexible 2' extension hose with nozzle is available.

8-1/2" x 11" negative preservers with standard three-ring binder holes will hold six or seven strips of 35mm negative film, depending on the brand of negative holder you buy. Some are made of heavy-duty vinyl, others of light plasticized paper which is transparent or translucent. Some kinds permit contact printing without removing the negative from the page. Other sizes are available to hold other sizes of film.

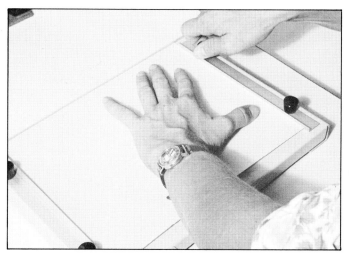

Borderless easels print right up to the edge of the paper. For the initial adjustment, hold printing paper flush against the back guide and adjust the retaining bars on each side. The paper is held in place only by friction between two edges of the paper and the bars at the sides. Each batch of paper may have a slightly different size, requiring a slight readjustment of the retaining bars on the easel. Buy an easel to fit the largest paper size you intend to use. It should adjust to fit smaller sizes.

The all-metal Speed Ez-El is designed to speed the process when you have a run of same-size prints to make. It's fixed in size and simple to use—just insert the paper at either end. Flanges hold the paper flat and thumbholes permit easy centering of the paper. The base is non-skid, and a range of sizes is available.

It's sometimes a long stretch to the enlarger controls, especially for a short-armed person. Solve the problem with a focusing handle, called—in this case—a Micro-Converter Handle. It brings adjustment of the enlarger focusing knob within easy reach by means of a three-section handle and a large adjustment knob that fits a variety of enlargers. With the focusing handle, a person working at the enlarger can now focus precisely and easily. Lengths of the three handle sections are 8" 12" and 16".

If your enlarger is aligned properly with baseboard, lensboard and negative carrier, your prints will be sharper. An adjustable alignment level enables you to do this more easily. First, level the baseboard in both directions. Place the alignment level with the label end on the baseboard by the negative carrier. This positions the level away from the enlarger body, allowing you to see it better. Next, hold or clamp the alignment level to the lensboard and level the lens.

# FOCUSING MAGNIFIERS

Somehow, focusing a sharp image in the darkroom seems to be a problem for some photographers. If a negative is dark or we're working with a great degree of enlargement, it can be a problem for nearly all of us.

Focusing aids have been around for a long time; some magnify the image cast on the easel, and this is difficult. A magnifier that focuses on the aerial image does a much better job and is easier to use in the long run. A reticle—crosshatch of fine lines—is present in the optical path which establishes the placement of the aerial image. The magnifier focuses on the grain of the film. Final checking is done by the parallax method—move your head back and forth; if the image does not shift, the focus is exact.

It is easy to focus on the aerial image without the presence of a ground glass screen, but takes a little practice to get used to it.

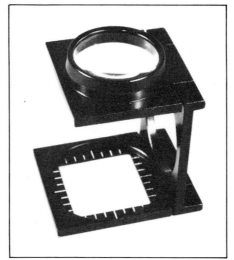

Linen testers are useful magnifying gadgets that fold up compactly when not in use. Photographers use them for spotting, checking focus or looking at small details on equipment. They're called linen testers because they are designed to count the number of threads per inch in linen fabric.

Some of you have watched a jeweler hold a device in his eye by scrunching up his face, and looking at a precious stone through it. He's using a jeweler's loupe, and it's been around a long time. Variations of this are used in photography. The Agfa loupe does not fit in your eye, but rests on a base that holds the glass at a precise focusing distance from the subject. The base is transparent, so it's easier to get light on an opaque subject.

An inexpensive focusing magnifier can do a perfectly acceptable job. Even these have a fine-ground glass and mirror for precise focusing. The image is 1-1/2'' square. In this photo, we got fancy and made a double exposure to get an image in the finder.

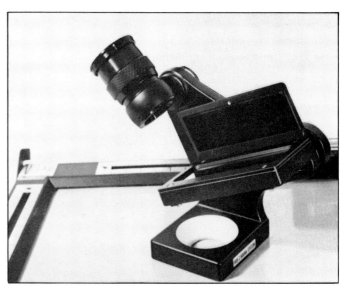

More sophisticated and more expensive, the Omega critical enlarging focuser has grain-focus aerial image technique, 10X adjustable-swing eyepiece, 86mm front-surface mirror, and built-in blue filter for black-and-white only. The eyepiece must be adjusted to your vision.

Exposure meters for use with enlargers are offered by about a dozen major manufacturers, so they are not really rare or unusual—but some beginners don't know about them yet. This Labosix model by Gossen has a separate sensor that you move around on the enlarger easel to measure brightness at different parts of the image.

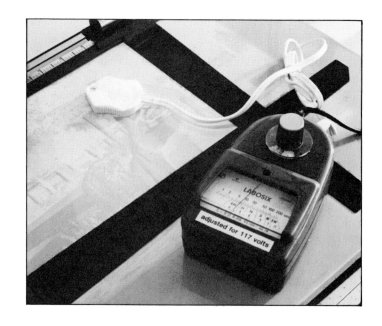

## COLOR
## PRINT MAKING

The ease with which color slides can be printed today is amazing! It used to take three days to do what takes about 15 minutes today.

Almost any enlarger, even an old one, can be used, although a color head is a convenience. Both Kodak Ektachrome paper and Cibachrome paper do a good job and both require about 12 minutes to process.

It's easier to judge the color correction necessary for printing slides than for color negatives, and there are many devices to help you. All methods for improving and modifying black-and-white prints, such as dodging, burning and vignetting, are used. Also, the ability to change the color of part of the print can be useful in color printing.

Color analyzers are important in printing both color negatives and color slides. They do the same job as enlarging meters, and more. With a little help from the user, they are also able to read the color quality of the slide or negative. This keeps you from having to reprint every time to get best results. A calculator does the same job, but you must make a print to get the results.

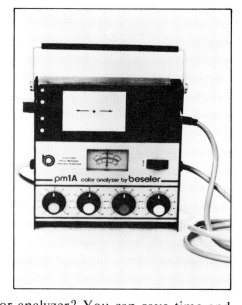

Why buy a color analyzer? You can save time and materials, and therefore money, by using one. They help you to determine filtration and exposure necessary for good prints with little waste from trial-and-error attempts. This Beseler PM1A offers spot or integrated readings on the meter, and a photo-multiplier light detector more sensitive than CdS cells.

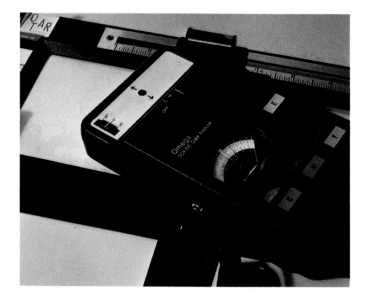

Color analyzers are getting smaller and lower in price. Designed to measure the red, green and blue components of light and comparing with a previously-known value, the analyzer then indicates the filtration and exposure adjustments required to produce a quality color print. This particular analyzer has a spot-meter probe.

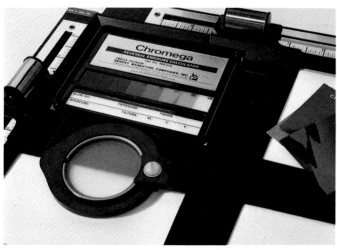

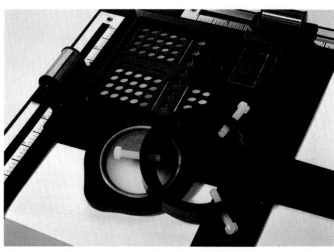

A reversal exposure calculator provides an easy method for determining the proper exposure for printing slides on Ektachrome or Cibachrome papers. It includes the exposure calculator, image diffuser, gray comparator cards and a red neutralizing filter. Cost is low.

A reversal exposure and color calculator does what the reversal exposure calculator does, but gives color balance information as well. It is far less expensive than a color analyzer.

Use a program timer to set up a mechanical program to pre-time all processing steps and control the equipment. You then have little more to do than measure out solutions and arrange chemicals in order of use. This Omega Program Timer has a timing range from 30 seconds to 29 minutes, 30 seconds, in 15-second increments. There are four timing slots for each minute on the dial assembly, with each slot representing 15 seconds. The minimum time from start is 30 seconds, however. Extra timer dials and tabs are available.

Once you have set up a program, you can remove and store the timer dial until you need that program again. This saves much time over resetting each program every time you want to use it.

It has two three-wire grounded outlets. If an operating accessory is plugged into the timing outlet, then the device controls that accessory. The other outlet works just the opposite and, for example, can be used to keep a light on *except* during the programmed timing cycle. When one goes on, the other goes off. A 6' cord is included.

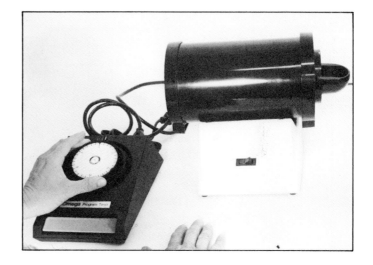

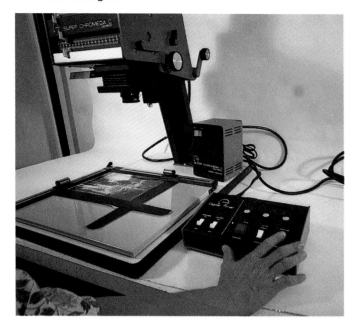

A digital timer for your enlarger is easy to see in the dark, with a pre-display of each setting—a big change from the primitive machines we used to call timers! One like this Omega really shows its worth during double-printing and dodging. As with most timers, it has a focus switch to turn the enlarger light on. Start the exposure by pressing the green illuminated button; because this is simple, it makes special exposure processes easier to do. Separate switches control time by tenths, units or tens of seconds, and another controls the electronic audible signal. In addition to the *start* switch, there is also one for *cancel*. A separate outlet for the darkroom light turns it off during exposures.

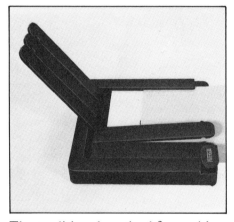

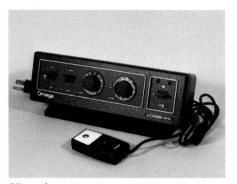

Were you ever in a hurry to finish printing and, while working with the enlarger, forgot the print in the tray? Or, worse yet, forgot the film you were also developing? All of us try these multiple steps to keep busy and get done in the darkroom. Well, this CP Touch Timer is designed to keep us out of trouble and make everything work better. It's an enlarging and processing timer, with variable brightness control on the display; and the timer remembers enlarging time and ten processing times, while audio signals warn you before the conclusion of steps you have selected. Once you set it up you will be totally free to concentrate on making better prints.

The traditional method for making a test strip is to put a strip of paper down and move a piece of cardboard in steps to give several exposures. This Paterson gadget exposes a 4" x 5" piece of paper in five even steps.

Here's another sophisticated darkroom helper, the Omega Auto Exposure Control C-5-50. Exposure controls are achieved by making one good print and locking the information into the memory. You can then produce additional prints automatically. Your only function is to select a reference spot similar to the one originally programmed. Then you can change negatives, size of enlargement or filtration without problem.

Many good pictures can be made great by judicious cropping. A photo scaler shows proportions used to mark the slide mount for cropping so it will enlarge to a standard print size. In most labs today, you can't obtain individual specialty cropping but you can get it in standard sizes such as 5" x 7" or 8" x 10". Finishing labs use metal die-cut masks to make standard sizes only.

## BURN! DODGE! VIGNETTE!

Do these words mean the same thing? No, each describes a slightly different process and result, but together they form the most generally used processes and can be the most fun, after cropping, in improving your picture. Each one darkens or lightens some area of your print, and there are gadgets to perform each process.

Burning-in implies considerable darkening of portions of the print. Sometimes this process takes so much exposure that it's desirable to remove the negative from the enlarger and darken part of the print with raw light (no image).

Dodging is the opposite of burning in; here, the idea is to lighten certain areas of the image. It can be performed with the hands or with special dodging gadgets, with cut-out cardboard, or sometimes with cardboard or cotton suspended on wire to block areas of the print.

Vignetting lightens or darkens the print all around the edge or all around a portion of the print.

It's possible to become very skillful in using these techniques so remarkable results are achieved.

This landscape photo has lovely clouds, but they are much more dense in the negative than the foreground and barn. In the darkroom, a 4-second exposure is right for that area, but leaves the sky bare—plain white.

A 20-second exposure gives good rendition of the clouds, but now the foreground and barn are just silhouettes, without any detail.

Here is the solution: Trace the outline of the horizon, trees and barn onto a piece of scrap paper and place the paper in the enlarging easel. This is then cut out to make a dodging tool matching the outline. The final enlargement is made with an exposure of 4 seconds overall, and 16 seconds additional for the sky, with the dodging "tool" blocking extra exposure of the foreground. Total exposure for the foreground is 4 seconds, with 20 seconds for the sky. When making exposures with this much time difference, there will almost always be a slight outline around the dodged area—as seen here around the roof of the barn and the silo. Photo by Jerome P. O'Neill, Jr.

The shot on the left is a nice picture, but the background distracts the viewer from the baby's pretty smile. Vignetting eliminated the background and towel. To do this, make an oval cutout the shape of the image you want in a piece of paper. During the exposure, hold it over the enlarging paper, moving the vignetter around to create a soft edge to the oval photo. Photo by Jerome P. O'Neill, Jr.

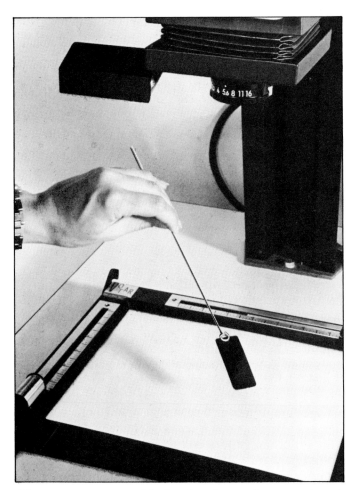 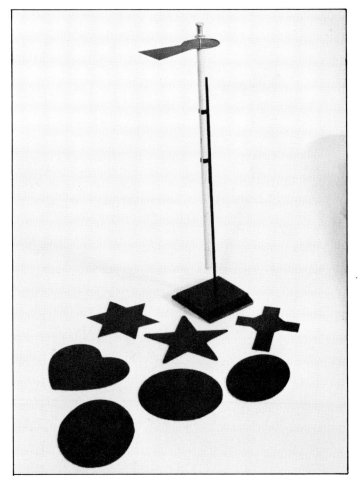

If you want to get a bit fancier than using your hand or a piece of cardboard, buy a dodging set. The simplest set consists of a metal handle that holds a variety of plastic shapes sized for various needs. The dodger shown here is part of a Lewco Dodgette set. Keep it in motion while using it.

Darken the background around a subject using one of these plastic heart, circle, star, cross or keyhole shapes which attach to an adjustable stand. Eight pre-cut shapes make up this Testrite burn-in kit.

For even more versatility, this marvelous Variable Vignetter gadget has leaves that are individually pivoted around a circular opening, with the inner edges of the leaves serrated so they don't make a solid straight line. To use, first close the leaves to make a small circular hole in the center. Working inside the hole, use your fingers to pivot the leaves so the opening takes any shape you happen to need.

For spot printing, vignetting or dodging, you can use this Lewco Visible Dodger, a gadget with seven different shapes cut out of a rotating wheel. The wheel rotates over an opening in the rectangular base of the device to select one of the cut-out shapes.

This portrait diffusion grid, part of an Omega enlarger system, diffuses the picture while *enlarging*, rather than in the camera. Some photographers say the quality is better when the photo is diffused as the picture is taken, but we can't tell the difference. To use this framed grid, an additional enlarger accessory holder must be purchased.

Even the most attractive young ladies have slight variations in skin color, which are often revealed in an unmanipulated print. At right is the same portrait printed with a diffusion grid. This evens out the variations without showing any obvious screening marks at all. It's a subtle and useful device.

## TEXTURE

Almost at the very beginning of photography, people tried to make photographs look like paintings, etchings and other art forms. Photographers and viewers became embroiled in controversy—the purists versus the anything-goes-if-the-result-pleases group.

There are several methods of modifying the print to make it look like something else. One is to physically emboss the paper, which many specialty labs do. It requires a fairly high-priced piece of equipment, and gives a distinctive appearance to the print. An example is the so-called canvas print.

Another method uses a texture screen either in contact with the negative, or over the print paper at the time the print is exposed. Texture screens are low in price and easy to use with both color and black-and-white. It is even possible to make your own—just photograph a textured subject with high-contrast film.

Some labs actually remove the emulsion from a print and laminate it to real canvas.

Single-frame 35mm negatives with texture patterns such as Tapa, Canvas, Burl, Linen, Brush, Grain, Etch, Bromoil, Relic, Lateral Brush, Gesso and Brush Stroke will add interest to your prints.

Place the texture film on top of the negative or transparency in the negative holder of your enlarger. It can be sandwiched with color or black-and-white film. Make a test print to find the best exposure.

On the left is a "straight" print, made from a slide taken at the Asahi Pottery works near Tokyo. At right is the same slide printed in contact with a texture screen. To get good contact between slide and screen, you should remove the slide from its mount because otherwise the mount separates slide and texture screen too much to keep both in good focus. Sometimes you can leave the slide in its mount if you can stop down the enlarger lens enough to bring both into sharp focus.

The Pace border-printing kit uses magnetic thermoplastic masks at the enlarger to print a fine-line natural black border on prints from negatives, or a fine-line white border when reversal printing from slides. Kit #1 is for 5" x 7" prints on 8" x 10" paper, and 8" x 10" prints on 11" x 14" paper. Kit #2 is for printing full-frame 35mm formats to 5" x 7-1/2" and 8" x 12". To use, place the outer mask over the printing paper on the enlarger easel and print normally. Then, fit the black vinyl insert into the mask. It has a narrow, clear border around the edge. Slide the negative carrier out and turn on the enlarger lamp for several seconds to print the fine-line border.

This printing mask set contains circle, oval and square masks which are made of a magnetic material to hold the paper tightly against a metal easel, assuring a sharp edge. Variations are created by combining masks.

Modern color printing uses higher processing temperatures than in the past. A small immersion heater is great if you don't have a ready source for hot water.

If you notice skin irritation or allergic reaction to photo chemicals, neutralize the chemical action with a special soap such as Neutrogena, wear protective gloves, or both! The soap can be purchased almost anywhere, and most full-line photo retailers have protective gloves. These surgeon's gloves are anti-allergenic and pre-powdered so that a snug-fitting glove goes on easily. To re-powder gloves, use a product such as Biosorb gloving powder.

Made for use on mixing faucets with hot and cold water, a thermometer well is placed between the faucet and the hose. By adjusting the flow of hot and cold and watching the thermometer, precise temperature may be maintained. A filter traps most dirt and rust particles in the water. Install the thermometer (not included) in the plastic sleeve. The well is made for standard garden hose threads, with adapters available for other sizes.

Most commercial and industrial labs use a mixer to do a thorough job of stirring chemical solutions. Here's one from Wein Products, Inc., for the home darkroom. A magnetic field turns a Teflon-coated mixing bar within the solution at speeds of 50 to 3000 rpm. The top surface of the mixer holds up to 3-1/2 gallon capacity containers, which must be made of non-magnetic material such as glass or plastic.

This sleek little Rowi darkroom signal timer has a range up to 60 minutes.

Rock this Ambico tray with a gentle nudge of your finger to create a consistent self-agitating action. The tray is contoured to keep work area clean and dry by minimizing spill-over. A curved base gives a stable, consistent movement for even, non-streaking development and fixing. This is an interesting, innovative design.

As you use the darkroom chemicals stored in this Falcon bellows-type bottle, compress the container itself to eliminate air, and extend the life of your chemicals. To restore the bottle to maximum size, fill it with warm water.

Another way to keep air out of a storage container is the Chem-Sack from Perfected Photo Products. A polyethylene bag with built-in valve fits in a cardboard box. You fill the bag, close the box and draw out the liquid using the valve. As liquid is drawn out, the bag collapses so air is never in contact with the container's contents. Chem-Sack containers are available in 1-gallon and 5-gallon sizes. An accessory 60" hose is available if you want to put the storage unit up on a shelf.

Want to add another dimension to your great photos of mountain scenery? Use Addaroma concentrate to make the print actually smell like a cedar tree! Choose from a dozen fragrances, including leather, cedar, lemon, mint and rosebud. Dilute the concentrate 1:63 in water and use it as a final rinse or just dip the print in it. More information from Merix Chemical Co., 2234 E. 75th St., Chicago IL 60649.

Pace Photographic Products developed this ConvertaBottle with several unusual features. It's a 32-ounce translucent mixing graduate for darkroom chemicals which can also be used for storage. An outer opaque sleeve keeps light out of the translucent part of the bottle, and has a window so you can read the scales along each side of the label. Turned as shown in this photo, you see a scale marked in ounces. Turn the sleeve the other way to read contents in milliliters using a scale on the other side of the label. You can write information on the label and use a scale at the bottom to keep track of the number of prints made.

A hand-held hair dryer is useful for drying an RC print in three or four minutes. In color printing, the colors change on drying so it's important to see what color corrections you need to make for the next print.

Another unusual product from Pace is this Multi-Purpose Print Squeegee Board. Set it up over a darkroom tray and use it as a squeegee board for prints up to 11″ x 14″ size. Also use it to hold wet contact sheets or prints for examination with a magnifier. It adjusts and relocks to become a handy retouching desk when you need one. It's translucent so you can put a light behind it for viewing transparencies or retouching negatives.

If you can't buy the gadget you need, maybe you can make it yourself. This wood-frame print dryer was constructed for use by students and has served well for a long time. It has removable racks and holds a lot of prints. The rack frames are covered with screening to improve air circulation through the air-dryer, and the screening is aluminum so it won't rust.

This collapsible air-dryer made by Depth of Field uses redwood and plastic-coated fiberglass screening. Prints are held flat between two layers of screening, under tension caused by lowering the tension bar in the center. The screen material completely encircles the wood frame so prints can be air-dried on both top and bottom. Capacity is eight 11" x 14" prints or 16 8" x 10" prints, and units can be stacked for more capacity. Screening material is impervious to chemicals and needs only periodic cleaning with a sponge.

Falcon's Resin-Coated Print Dryer is a roller-squeegee that removes excess water from any print or negative just by rolling between the latex rollers. The dryer comes with one print drying rack made of vinyl-coated wire which attaches to the dryer or can be mounted on a wall. Additional drying racks are available.

# 9
# Slides & Slide Shows

## SLIDES AND SLIDE SHOWS

Right here, right now, let us strike a blow to free everyone from boring, inept, poorly-planned, amateurishly-produced and seemingly endless slide shows.

Sound exaggerated? We wish it were. We wish we'd never had to sit through two hours of under- and over-exposed slides; of unedited travel narrative; of complete documentaries of someone's distant relatives whom we hope we never meet, and snapshot slides presented without continuity or plan.

A really good slide show is a sprightly, fast-moving presentation, and begins with a plan, perhaps even a written outline— and all sub-standard slides are at the bottom of the waste basket. The narrator has practiced his words, perhaps even recorded them and backed the narration with appropriate music. The slides are shown on a projector set at the correct height, on a screen large enough to be visible to the entire audience. And—the show is short! We usually plan ours to last 22 to 26 minutes, and may show 150 slides or more in that length of time. When some enthusiast says, "I wish it had been twice as long!", we accept the compliment, put away our equipment, and resist all temptations to go on another two hours (no matter how hard that may be!).

This chapter has great gadgets, and it also has great ideas, selected to help you produce a show like a pro.

You can use slide shows for personal pleasure, for fund raising

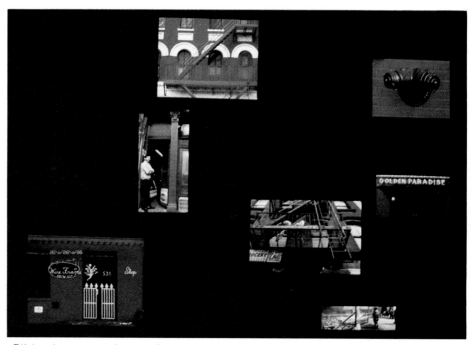

Slide shows can be as simple or complex as you want. from one projector and one screen to many projectors and multiple screens. Photo by Dennis Rizzuto, Dennis Rizzuto Associates, Flushing, New York.

projects, teaching aids and many other purposes. Recently, we had the pleasure of working with a delightful woman who sought advice on making her slide show more effective. She produced a very good slide presentation with two purposes—to inform the community about a new art museum, and to raise money for its construction. Talented photographers shot slides of the architect's scale models of the new building, of museum activities, classes and exhibitions. Volunteer speakers rehearsed her well-written script, familiarized themselves with their projectors and slides, and gave programs in clubs all over town.

This program was exciting and successful—because it was well planned and well done.

Accept the responsibility of not boring your audience, even if they are "only" relatives and friends. Consider yourself a show-business person, a director, if you please. Set yourself a time limit so you'll have to throw out some of the dubious slides you know won't project well. Try to put yourself in the minds of your audience, and strive to show what they want to see. Most often this is a close-up shot, so when you shoot pictures, vary long and medium shots with close-ups.

As you view all your slides for

one show on a large light box or editor, pull the ones that would be more dramatic if sandwiched with a color filter or another color slide, and build dramatic effects into your presentation.

Decide on a title, and make a title slide. Then, jot down an outline and from that your script will come. Select a music background, record or rehearse your script, and you're ready for the dress rehearsal. In your commentary, say something that is NOT obvious. Never—never say, "This is a mountain." If that isn't obvious, then don't show the slide. Instead, say something that does not show in the picture, such as where the mountain is, how high, why it's interesting.

As soon as you begin to think of yourself as a producer or director, improvements will follow and you'll be in demand for repeat shows.

An illuminated slide sorter is handier than you will believe if you don't own one. There are various styles and sizes, some very inexpensive. You'll use it to examine each new batch of slides to reject those that didn't come out well and to put the remainder in proper sequence to show in your slide projector. Another valuable and little-used accessory is a waste basket to contain reject slides. Be tough-minded about it! *Discard bad slides*—they don't get any better in storage and just take up space.

All three of these simple, inexpensive slide viewers operate on two batteries. The Pana-Vue at left features a push-pull changer for 36 slides. The other two accept one slide at a time and can be hand-held or set down on their built-in stands.

## SORT AND STORE

Phoebe made a survey to determine how professional and amateur photographers store slides. Most admit that their collections are temporarily housed in cardboard boxes; that retrieval is frustrating; and that they intend to get organized as soon as they have time, or next weekend—whichever comes first.

To store and file your slides you need a little help from a gadget to sort more quickly, be it slide sorter or light box, or several of each. Then, you need a filing system. We won't suggest a system for you, because you may have different requirements than we do. The best we can do is suggest that you consider how best to find a slide, and possibly how you are going to use your slides.

Do you seek them by date, by subject or event, or by the kind of shot? Example: You have a picture of a relative, taken on a

memorable trip in 1969. By date, that may have been a prolific year for shooting, and you might have a big job finding that particular one.

Suppose it's a wedding; then it would likely stay with other wedding pictures if it shows a veil or gown.

Perhaps it's a close-up portrait and you have a file for *Family Portraits*. If it shows a relative in a remarkable scenic setting, then it might be filed differently. Come to think of it, the need for different headings for one item probably led to the invention of cross filing!

When you devise a workable system for filing your slides, sorting and storing will be a pleasure not a chore.

Our best suggestion for storing slides consists of two systems—group files to hold a lot of slides in whatever kind of categories you decide on, and a smaller number of projector trays for the shows you have organized and are still using. Store the show slides right in the projector trays.

## LIGHT BOXES

The large lighted transparency viewer has always been called a light box. The less expensive units have one or two standard light bulbs mounted behind a plastic sheet that holds rows of slides. The more sophisticated systems such as those made by Graphic Technology use special fluorescent lamps that light the entire viewing area evenly, do not cause color distortion, and are replaced on a regular basis to maintain proper color balance.

The GAF or Sawyers Projector-Editor lets you view on its own screen or project onto a distant screen. Several companies have made products of this nature. The problem seems to lie between what the photo fan wishes to accomplish and the hard fact of producing the product. If a table viewer sells for one-half to one-third the price of a projector, then it's a substitute. If it approaches the price of a basic projector, it is not. In addition to showing a large image on a screen, most slide projectors can show a small image, about 8'' x 10'' in size, up close but lots of people don't know that. The image is very bright when the projector is close to its projection surface, so a white wall or white piece of cardboard will do very well as a screen. Set up in this way, your basic slide projector also serves as a viewer-editor.

This tabletop incandescent viewer uses a molded plastic 24-slide cassette which fits on top for viewing or slides into a storage box. The viewer and a magnifier are parts of a sophisticated Leedal viewing and storing system. The storage box holds six cassettes for a total of 144 slides. Slides can be viewed in the Leedal cassettes without being removed or touched, providing excellent protection against dirt, dust and fingerprints. Developed primarily for educational and industrial use, professional equipment such as this is also suitable for the amateur photographer.

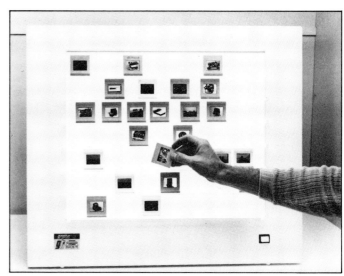

At left, the 16" x 44" viewing screen standing on edge is used to view large transparencies in the upright position; in the horizontal, it is an excellent viewer for standard size slides. At right is a modestly-priced 16" x 20" viewer with slide sorting overlay. The fluorescent lighting is even over the entire surface.

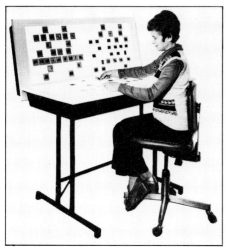

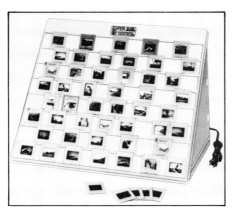

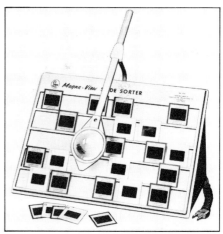

We can't resist showing you the kind of viewing system used by studios, agencies and affluent amateur photographers. The Graphic Lites transparency viewing console has an illuminated sorting table and rear-mounted display screen with slide holders, all on a heavy-duty frame. Height is adjustable, for sitting or standing operation.

The tabletop slide sorter and viewer at left holds 80 35mm 2" x 2" slides and uses two ordinary 60-watt bulbs behind a translucent styrene screen. It includes a twin socket for the bulbs, a 6' cord with on-off switch, folds easily for storage and weighs 6 pounds. On the right, Logan's combination slide sorter and viewer, the Magna-View, has a 3" movable glass lens for a magnified view of slide detail—a very useful gadget!

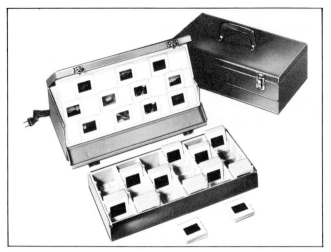

An illuminated 2" x 2" slide sorter and a group slide file combined in one compact carrying case. The sorter panel holds 21 slides and the file tray holds 750 slides in groups. Light is provided by a 40-watt bulb.

Many of us leave slides in cardboard mounts—but there are times when a glass mount is better. We recommend using glass mounts for slides used frequently in programs, and for slides you handle often which should be protected. They are widely used in schools and churches. These very thin plastic slide binders with double glass fit most major brand slide projectors, and are sold 20 to a box.

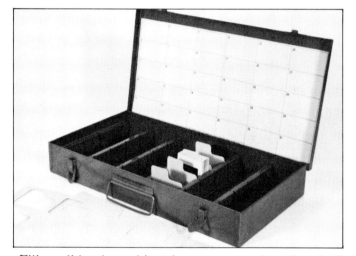

Filing slides by subject in a group rather than individually saves time and space. The 8" x 14-1/2" metal storage box on the left holds 750 slides and has die-cut dividers that fit into slots and hold labels. It also includes an index sheet with 30 spaces. Translucent plastic slide pages provide a clear view of 20 or so slides at one time; they can be viewed without removal from the individual protective pocket, and the viewing light is automatically diffused by the back surface of the plastic. The 3-ring style fits into a standard 3-ring notebook or this special holder with hinged lid and snaps. Or, you can file them in a file drawer. The storage system on the right is easy to label and index; however, some authorities don't recommend plastic holders for long-term storage because of possible deterioration of the slide. These pages are available in two styles—side-loading, which means you slip the slide into an opening in the side of each storage space, or top-loading in which the slides drop into the top of each space. We feel the top-loading type is more convenient to use.

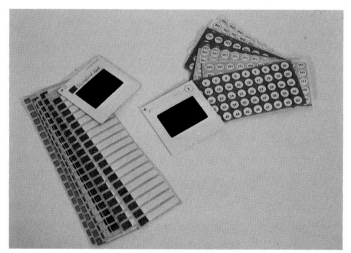

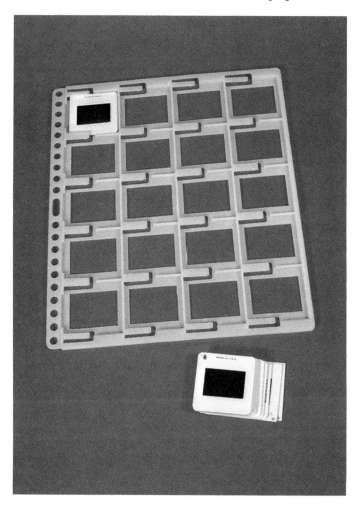

Slide numbers and color-coded labels can be very useful in keeping track of your slides, identifying them, and keeping them in sequence. A package of numbers contains numbers 1 to 1000. A package of labels has 200 labels in assorted colors.

Plastican Slide File Sheets hold 20 2" x 2" slide mounts. These are an alternate to the soft plastic pages with pockets, and are designed so the plastic never touches the film. Each slide *mount* rests on a recessed framework of plastic, and a small built-in clip holds the top of the mount. These 9-1/2" x 11-1/4" sheets fit a 3-ring binder or can be filed in a drawer or box.

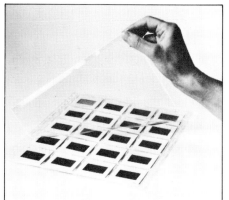

### HANGING SLIDE FILES

Now you can keep slides in a hanging file, protected by a chemically-safe slide page cover. Hanger bars, storage pages and index tabs make up this flexible Saf-T-Stor system which allows you to add and subtract slides without having to rearrange the entire system. It's compact, storing 240 slides per inch of filing space and can be used in standard filing cabinets, desk drawers, desk top files, and ring binders. And it works with any standard film format.

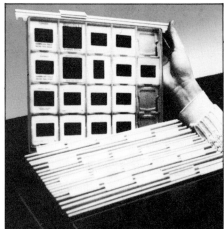

Each 9-1/2" x 11" page holds 20 slides in cardboard, metal or glass mount, each slide fitting into an individual slot. The slide page is then covered by a Page Protector, a sheet of non-contaminating plastic that is said to resist temperature variations, humidity, moisture and chemical migration.

Hanger bars slide onto the rigid plastic slide file page and are then suspended from the file frame in the drawer. Index tabs help you organize slides; the highly-visible system ends "hide and seek retrieval."

## DUPLICATING SLIDES

If you know *in advance* that you are going to need several identical slides of the same scene or subject, the very best way to get them is to shoot more than one slide when you make the original exposure. Sometimes the subject won't hold still that long and sometimes you don't know you want more than one slide until afterwards.

If you have one slide in your hand and need several more that are *identical*, you should hustle over to your friendly local photo shop and ask for professional slide duplication. Even professionally-made duplicate slides are not exactly like the original, but they will be a closer match than you are yourself.

Making copies of slides is easy to do if you don't require exact duplicates. Just put slide film in your camera and photograph the slide you want to copy using a special slide copying setup. Normally the copies will exhibit more contrast than the original and the colors will be a little different than the original. Usually this is acceptable, and the copies serve your intended purpose.

Amateur slide copying really becomes fun and useful when your intention is not to produce a duplicate, but to *change something.* You can change the composition and content of the slide by photographing it at a magnification greater than 1.0, and cropping out some of the original image. The appearance can be altered by using color filters over the light source or over the camera lens so the copy is a different color. You can also obtain special holders for making 35mm slides from 110 slides, or larger slides up to 4x5". Using color negative film in the camera, you can make negatives from the slides and then have prints made from the negs—which will show the cropping or special effects you introduced when transferring the image from slide to negative.

The ChromaPro tabletop slide duplicator is manufactured by a photographic specialty company, Sickles Inc., which began by making equipment of this type for commercial labs and finishers. However, it is within the price range of many serious amateur slide copying enthusiasts. The buyer supplies camera, lens and adapter rings; everything else needed to duplicate slides is included in the ChromaPro. The light source is a high-output quartz halogen lamp suitable for Kodak E-6 duplicating film in cassettes. Perhaps best of all, it has continuous dichroic filtration for color correction. Incidentally, the dichroic filters will not fade as gelatin filtration does.

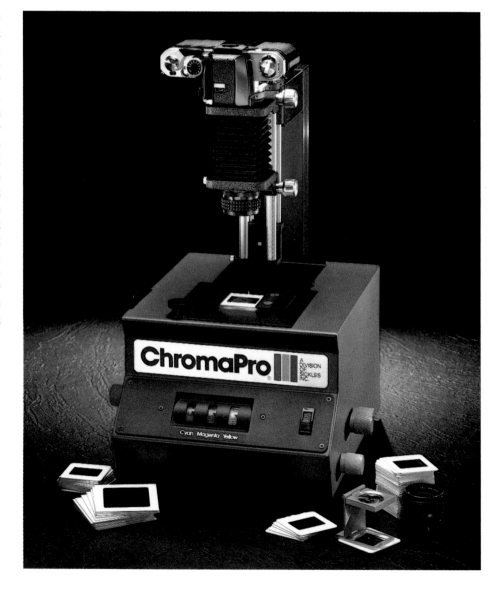

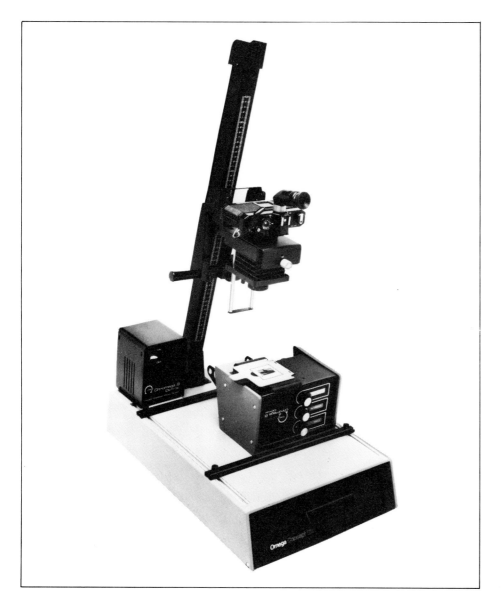

This slide copier gadget really works, and is a bargain if you already have a B or C model Omega darkroom enlarger. Invert the enlarger's Chromega B dichroic lamphouse to illuminate the slide, which is held in the slide copier. The filters in the enlarger color head let you modify the color of your slides with ease. You'll also need the bellows camera attachment and a T-mount adapter for your camera.

The zoom slide duplicator attaches to a 35mm camera by means of a compatible T-mount. It's called a "zoom" duplicator because the magnification can be changed from 1.0 up to 2.0. The rectangular slide holder on the front has a pane of frosted glass to diffuse the light before it reaches the slide. It requires no focusing adjustment, and the light source may be either daylight or electronic flash.

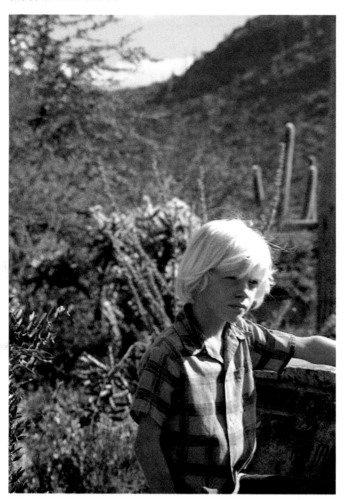

While the original slide is a pretty picture, we wanted to make it more of a portrait. Using an inexpensive slide duplicator, we cropped the image to get the shot we wanted. Notice the increased contrast, color change and loss of image quality in the copy.

## MAKING A SANDWICH

When two pieces of film are placed together, the process is called sandwiching. The purpose is usually to obtain a special effect. One transparency of a moon may be sandwiched with another of a lake—many photographers keep a file of stock shots that come in handy for just such effects. Combine two images to print on the enlarger, or to project.

Another type of sandwiching involves placing a texture film with a transparency, either in color or black-and-white, or combine a colored gelatin filter with a transparency.

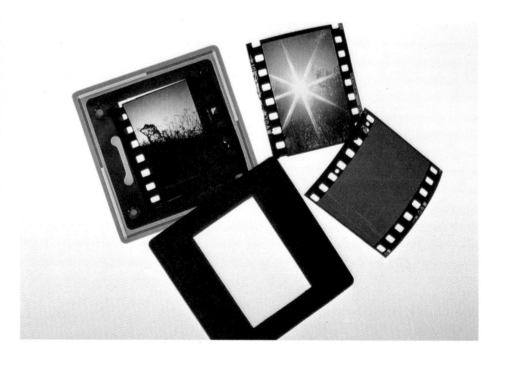

Projection Stand

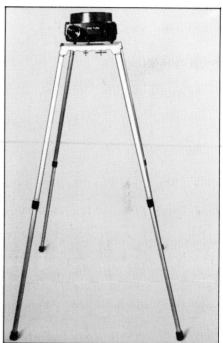

This three-layer sandwich combines the elements shown at left—a special effect silhouette of trees, a shot of the sun made with a star-burst filter, and a third transparency, showing only a blank orange card, to add color. Note that the more layers of film you add, the darker the final results will be due to the cut in light transmission when projected.

The Welt Professional Project-O-Stand can be carried in one hand! Molded carrying handle, built-on metal leg holder clips and aluminum tubing legs attach to a sturdy metal tabletop. Extended, the legs will lift the platform to 56" for overhead projection—one feature which makes a big difference. Most of us project on an occasional basis and make do with whatever is handy—usually about ordinary table height, which is too low. This stand gets your projector up where it ought to be!

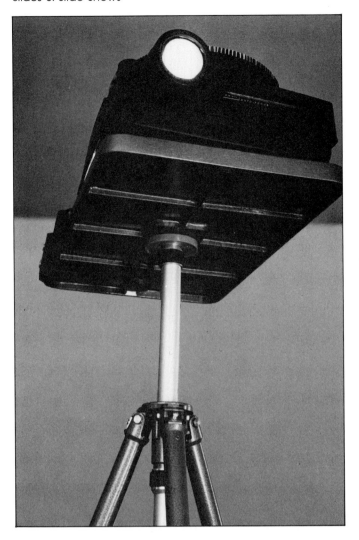

One of the most important improvements to your slide show is just better placement of the projector! A high elevation gets the light path over audience heads, and eliminates the keystoning effect, where the projected slide assumes a wedge shape because the projector is set at an angle to the screen. Set the projector higher than usual, and also set the screen higher so people in back can see over the heads of those in front. The gadget here is a Gitzo projector stand mounted on a Sturdy Gitzo camera tripod.

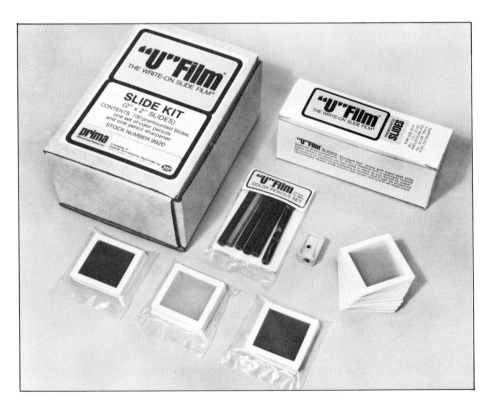

"U" Film blank slides are specially textured so you can write or draw on them to produce titles for slide shows, cartoons, maps or whatever your imagination conceives to make the presentation more effective and interesting. You can add information instantly to your slide show without having to wait for slide processing. They are available in a kit with several colors with special color pencils to mark them. Using materials supplied in the kit, you can letter or draw your own title slides and attention-getting cartoons, as illustrated above.

Letter sets are available with adhesive-backed, three-dimensional letters which are easy to mount on a card to create titles for a slide show, as a transition from one subject or location to another, and as an ending. The letters can be placed on a rock, a piece of fabric, a tree, or positioned on a sheet of glass and shot in a natural setting. Titles can also be made on location from printed material using your close-up gadget to magnify it, or even with words drawn in dirt or sand.

Title slides are more attractive and artistic if you combine letters with materials related to the subject or mood of the slide show. The kind of material you present at the beginning prepares the audience for the tone and even the location of your slide show images.

Use your own photographs for title slides! It's easy—you only need a print, a letter set and a pane of glass. Put the adhesive letters on the glass; that way, you don't mar the print, and you can position it to best effect. Don't forget to watch for fingerprints, dust or other marks on the glass which could ruin your finished title. The completed title looks professional and keys the mood and subject of your show with an impact words alone cannot achieve.

Quick shots of maps, postcards or artifacts will make your vacation trip slide show exciting. You can make a good copy in the park with a knee for a tripod, using ordinary film, no special lights, no fuss—and it's quick!

There are special high contrast films for copying handwriting or print against a white background, but amateurs don't often use them. However, when it is inconvenient to obtain or change to a special film, don't hesitate to use whatever is already in your camera. While visiting a museum in Sweden, Carl saw a letter his mother had written, in Swedish, to her cousin in Stockholm. We photographed it with daylight slide film, which was already in the camera. What a thrill it was to see the letter and get a photographic copy!

## SHOW YOUR SLIDES WITH SOUND

Setting up a slide show with recorded voice, music and sound effects has some definite benefits. For instance, if the show is ready but the speaker collapses with stage fright, a recorded narration will permit the show to go on.

The effect of music as a background, a special effect or mood builder can be really dramatic. Sounds can also be recorded in the field—bird songs, waves, storms, speeding cars—one good idea leads to another.

Best of all, if your first efforts don't meet your standards, you can do it over again until you're satisfied.

Working from a script or outline results in an amazing improvement in any slide show. Try making an outline or script before you shoot the slides—or at least before you select them.

Recording music from tape or disc as a background to voice narration can be done using any hifi system, and gives a finished, professional tone to your slide show. Also, someone other than yourself can run the audio-taped show if tape and slides are synchronized.

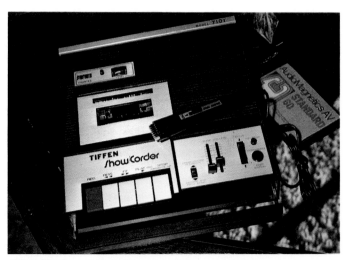

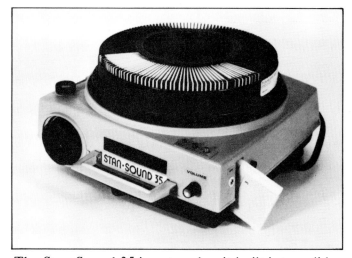

The Tiffen ShowCorder is a special cassette tape recorder designed to help you create and show your own slide presentation, with sound. Part of its capability is full console control of the slide projector—focus, forward and reverse. Record your words and the music of your choice, then show them in perfect synchronization with your slides. This cassette recorder can be used with most popular brands of remote-control slide projectors by obtaining the appropriate connector cable. The set includes the tape recorder, projector connecting cable, direct recording patch cord for radio or record player, AC power cord, 4 C-type batteries for recording on location, earphone, remote microphone with carrying case and stand, and a blank C-60 (60-minute) cassette.

The Stan-Sound 35 is a sound unit built into a slide projector housing. It's actually a Kodak E-2 Ektagraphic projector modified to include a built-in tape recorder. You can record and playback, synchronize sound with slides and project a complete sound and slide program from this one unit. The tapes are continuous-loop type and are available in lengths of 1 to 22 minutes. It also serves as a line public address system using the microphone.

## DISSOLVE CONTROL FOR MULTIPLE PROJECTORS

Dissolve controls are a step toward making your slide presentation more stimulating. Images from two or more projectors blend into one another. The effect is smooth and professional because there is no sudden darkening of the screen or bursts of light with no image, and the show just flows along.

A thoughtful selection of slides adds considerably to this feeling; change from long shot to medium or close-up, or even extra close-up, as a change of pace. This tells the story better by answering the questions that naturally come to the audience's mind. Some dissolve controls can be linked to a tape recorder or other control device so the whole show is an automatic production.

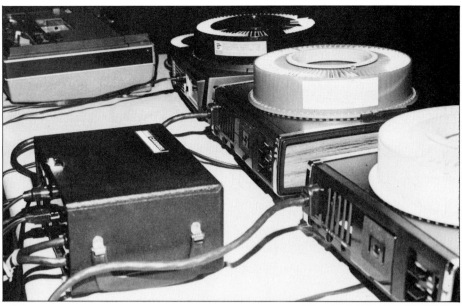

A dissolve control permits you, the projectionist, to set up the program, push the correct buttons and lean back to enjoy the show—interrupting your leisure only to change slide trays on time! Of course, the show must be set up correctly in advance, and the correct slide trays must be placed on each projector. Kodak produced this show for photo dealers, using three projectors, a tape recorder and dissolve control—all Kodak equipment except the tape recorder.

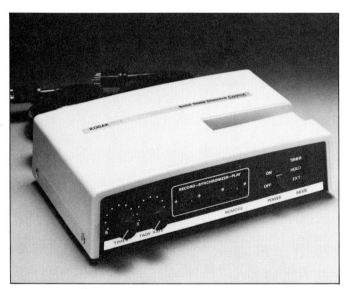

This Kodak solid state dissolve control for two projectors has variable slide timing and variable fade rate. Variable slide timing means that slides can be programmed to stay on the screen a shorter or longer time. You may have more to say about one slide than another, so you can vary the amount of time each slide remains on the screen. Variable fade rate means that the process of fading from one slide to another can be slow, medium or fast—you can choose and set the rate.

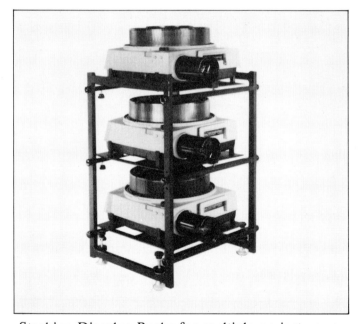

Stacking Dissolve Racks for multiple projectors are made so that, as the images on the screen change, these images dissolve one into the other. The rack permits slide projectors to be positioned so the image from one falls exactly on the same spot on the screen as the image from another. Critical alignment is important to avoid image "jump," and the Buhl rack facilitates adjustment for precise image registration. Buhl makes racks for two or three projectors.

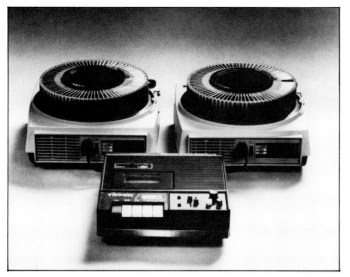

Another unit combines recorder and dissolve functions for up to two projectors in one unit. This Tiffen Sound Sync Dissolve Programmer offers cut or variable dissolve and permits record/playback of all mono or stereo cassette tapes. Accessories include a projector stand, speaker amplifier, carrying case and start-stop dissolve remote control.

The Micro Diamond programmable dissolve unit from Clear Light provides a moderately-priced entry into the world of multi-image projection—it's a fully programmable unit for use with two-projector single-screen slide shows, with a playback system for up to six projectors.

## SLIDE TRAYS, CUBES, STACK LOADERS

The type of tray or loader you buy should fit your temperament and your storage system, as well as your slide projector! Meticulous individuals may prefer an individual-load type such as the rotary or straight tray. Impetuous? Choose a cube or stack loader. Think about how you want to show and store slide shows you presently have. If you already own a slide projector, find out what systems it will accept; not every tray or loader fits every projector. Also consider if you want to keep your present equipment or buy new. What's available?

Find out what kind of slide mount each projector will accept, *before* you buy. The Kodak stack loader, for example, will not accept glass or metal-mount slides at this writing, and the instruction booklet warns against using loose mounts or taping cardboard mounts together.

The illustrations in this section should provide a good overview of major show-and-store slide systems.

Bell & Howell cubes offer a "different" method of handling slides—different from trays or the old way of feeding one slide at a time—and this is a method good enough to survive. The main attraction is the compact storage and easy handling. The projector rotates the slides around a circle with 4 stops, one of which includes a handy preview position so you can check the upcoming slide before it goes on the screen.

The Kodak Stack Loader: Most slide projection systems utilizing trays also have an accessory stack loader so you can see your slides quickly and easily as soon as they come back from processing. This device works with group storage systems as well, so you do not have to store everything in trays. Kodak has even developed a handling device so you can pick up to 36 slides with a clip which springs shut at the top of the stack and moves them to the loader or back. The storage box, shown at right, holds up to 216 slides.

Sawyers projectors started their career with a straight tray called "Easy Edit," which is no longer available. In order to keep up with competition, their projector was adapted to use this 100-slide round tray that sets on the projector vertically.

Kodak makes three trays for Carousel projectors—an 80-slide tray, a 140-slide tray, and an 80 universal tray which will take either paper or glass-mounted slides. Note the light color of the 80 tray—it's designed so you can see where the slides are.

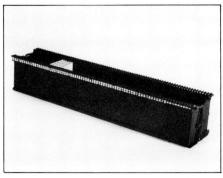

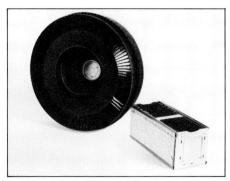

Argus projectors currently use an 80-slide tray. Note the spring mechanism on the ends which puts pressure on the slides so they won't fall out. However, when you spread the two halves against the springs and turn the tray upside down, all the slides fall out at once. It sure beats picking them out one by one!

One of the longest-lived slide trays is the 36-slide model Airequipt tray. The metal septums hold the slide firmly in place and even create somewhat of a problem in removing or changing slides! Beside it is a circular Airequipt tray which operates in the vertical mode and is more in line with present trends.

The 50-slide Rollei trays are sold in a plastic container with lid. In Europe most, if not all, projectors use the same kind of tray. Trays for Zeiss, Leitz and Rollei projectors are interchangeable.

## PROJECTION SCREENS

In addition to the ordinary stand-type projection screens, there is a variety of not-so-ordinary screens. Some hang on the wall, others from the ceiling; some are rear-projection types, some contain sound speakers.

Most specialty screens expand the use of your projection equipment because they permit you to project in other than ordinary ways. We usually project a new batch of slides on the wall or on a white card, just to see what we have. Rear projection is great to show slides in a lighted room, as are shadow boxes. Note: Load your slides backwards for rear projection.

A ceiling or wall screen solves the problem of finding the screen each time you want to use it, setting up and putting it away again.
**Screen Material**—Projector optical systems have always been a problem. One way of getting a brighter image was to have a highly reflective screen; glass beaded screens are great in this respect—the image is not too sharp, but it's bright. Remember the big deal about stereo projection and special glasses about 15 years ago? This kind of projection works with polarized light, but that light doesn't work with glass beaded screens; the beading destroys the polarization.

So aluminized screens were born. They work great—sharp pictures, good reflection except from off to the side. The viewer must be fairly close to the axis of the projector. Again a change. Today's lenticular screens are aluminum-coated screens with fine lines or lenticulations on the surface. These provide a brighter image for folks sitting off to one side.

At the same time, the optical system of projectors has been improved so much that it's hard to believe. We used to have a 1000-watt projector and could swear the present 150-watt ones are just as bright!

A wall or ceiling-mount screen is surprisingly lightweight and easy to mount, especially in the smaller sizes. It takes up far less space than the conventional screen on a stand, and it can be left in place, ready to use at any time. Placement is selected to give the best viewing to the greatest number of people in the room, and to allow the projector to be set up at the correct distance from the screen. If you rearrange the furniture, just change the location of the screen.

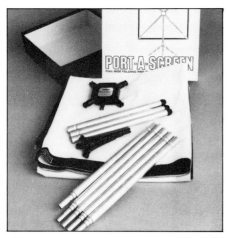

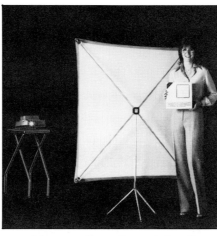

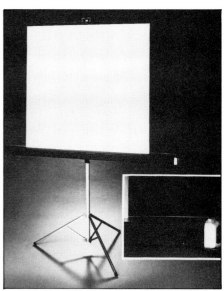

Lug-along a projection screen? No problem, when it weighs four pounds or less, and folds down to only 10" x 10" x 3"! A wrinkle-resistant, washable screen, friction-controlled telescopic aluminum tubing with spoke locks, tripod feet—that's it! Unfolded, it becomes a full-size projection screen—in 40" x 40", 50" x 50" or 60" x 60" sizes.

And if you want to put your sound where the action is, the Knox Sound Screen features a dual-speaker system enclosed within the case. It can be used with all sound projectors with mini jacks.

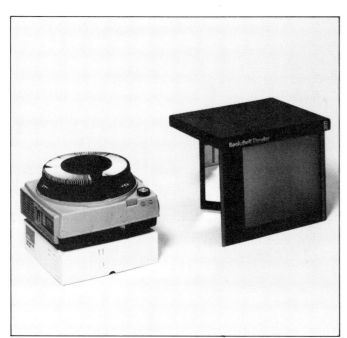

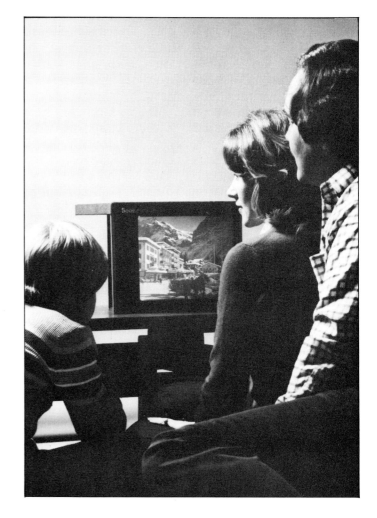

The 3M Bookshelf Theater is a small 8" x 10" rear-projection screen that folds up like a book and can be stored on your bookshelf. Behind the screen is an angled mirror to reflect the projector light beam so you can put the projector to one side. You can actually put projector and screen side-by-side on a bookshelf or on a table; then you sit up close as though you are watching T.V.

## AUTOMATIC ELECTRIC PROJECTION SCREENS

No longer limited to schools and large businesses, the automatic electric projection screen is now available in the sizes we can use and the surfaces we need, at affordable prices. Da-Lite, for instance, has screens from 50'' x 50'' to 20' x 20', and a choice of surface materials. Each type of surface is preferred for a particular use:

**Glass Beaded** is very bright, offers excellent color reproduction and a wider viewing angle than formerly; performs well in normally dark rooms.

**Silver Lenticular** performs better than other surfaces in rooms that cannot be darkened, or darkened much. Color separation is good, but colors may change or intensify; must be placed exactly perpendicular to the projector and to the audience eye level.

**Matte White** is the best surface for multiple projection or overhead projection. Picture brightness is less than other surfaces, but is uniform over wide viewing angles.

Da-Lite's Cosmopolitan screen is available in sizes from 50'' x 50'' to 12' x 12', with a walnut-grain vinyl-covered steel case. The factory-sealed motor is mounted inside the metal roller and is lubricated for life. The screens are available in glass beaded or matte white surfaces, and can be hung from the ceiling, wall mounted, concealed by a soffit or recessed in the ceiling.

## METHODS OF INSTALLATION

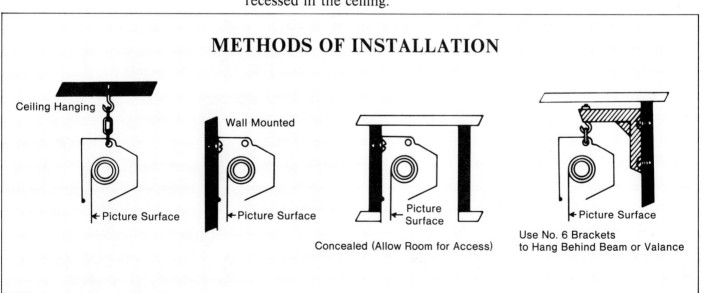

Ceiling Hanging — ←Picture Surface

Wall Mounted — ←Picture Surface

Concealed (Allow Room for Access) — ←Picture Surface

Use No. 6 Brackets to Hang Behind Beam or Valance — ←Picture Surface

If you find yourself rushing over to the screen to point out the key part of each slide, try to stop. Keep your seat or stay at the speaker's podium and use a light pointer instead. These are flashlights with a special lens on the front which projects an arrow or "V" bright enough to be seen against most projected images. Light pointers come in various sizes and shapes, from pocket-size as shown at far right to the large auditorium type on the left. They are usually more appropriate for educational or technical presentations; you can sometimes do a better job by showing an overall view followed by a separate slide illustration, a close-up of some particular detail of interest. This makes the light pointer unnecessary and gives the audience a clearer shot of the detail.

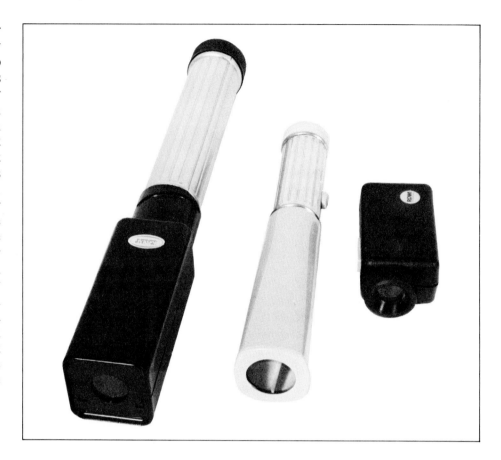

If you don't mind viewing or displaying 35mm transparencies in their original size, you can show them "as is" in the Slide Lampshade from Red Zitske Enterprises of Madison, Wisconsin. Kits are available for desk or hanging models, and include a screened matte lampshade which holds up to 60 transparencies. The manufacturer suggests that any irreplaceable slides be copied before using, although they assure us that color shift or other damage does not usually occur when the shade is used with the suggested 40 watt bulb.

Several years ago we decided to create a display wall to show mounted prints, where we could easily change the display. We paneled the entire wall, and attached molding with grooves to hold the prints.

## THE PRINT

When we were learning about photography and making prints, there was a joke about the "Potato Sack" Photographer who made prints by the thousands but never did anything with them. When they piled up and got in the way, he stuffed them into potato sacks. He made prints because he loved to do it, and for him that was sufficient—or at least he thought so.

Today, many of us differ only in that we stuff our photos in drawers or on a shelf in the closet. We have had the fun of making the pictures but we deny ourselves the continuing enjoyment of looking at them occasionally and showing them to our friends.

It's not always convenient to set up a slide projector and screen, particularly just to show a few photos. If you make prints or have

them made for you, and if you then make it easy to display them, you'll begin to get full benefit from your picture-taking activities. There is a great satisfaction in looking at images you made in the past and reliving the event. You don't have to shoot negative film to end up with prints. Slides can be made into prints very easily, either in your home darkroom or by a commercial photofinisher.

To show and share your prints, there is a most important step between drying and mounting them—and that's spotting. Many prints are not complete without being spotted. Dust images and other imperfections must be removed, and there are easy-to-

use sets to help you disguise those imperfections in black-and-white or color.

Trimming your print is the next step. A paper cutter is standard equipment, and there are some innovative ones on the market today.

Matting sounds so difficult that many photographers never try it. The process is an exacting one, but there are now a lot of gadgets to help you develop this most satisfying skill.

Then you mount the print. This chapter shows several ways, including some shortcuts.

You can also frame a print almost instantly in a variety of modern ways, including a plastic

box that doesn't look like a frame at all!

Matting, mounting and framing certainly add to the appearance of the print, and show that you value it. The trend today is to display prints—your own, or those you have purchased for your collection—in home and office. Some interior designers now specialize in using photographic prints as dramatic elements in room design.

A print can be an important gift, especially if you photograph, develop, print, mount and frame it yourself. In addition to giving the picture itself, you are giving your insight in making the image and the skills you've developed in photography.

This is a fresh print which requires spotting. It can be salvaged with careful attention to detail.

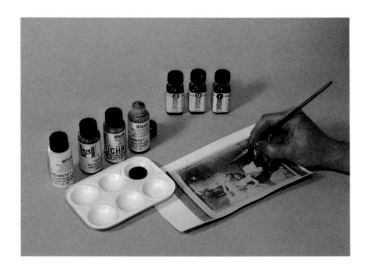

For spotting black-and-white prints, you can use Spotone or Berg Touchrite. The basic 3-bottle Spotone set has three tones—blue-black, neutral black and olive. Spotone acts like a dye and penetrates the emulsion, leaving little trace on the surface of the print. The Berg Touchrite basic set has 3 tones—the same as Spotone, plus white. Touchrite White is opaque for retouching highlighted areas on the black-and-white print, or for opaquing negatives. Touchrite toners stay on the surface of the print.

Color prints can be spotted, too. Spotting colors are dyes which can be mixed or thinned, and they're very flexible. A small dish or piece of glass makes a good mixing palette. Good spotting brushes are a necessity, and may be purchased when you buy your spotting colors.

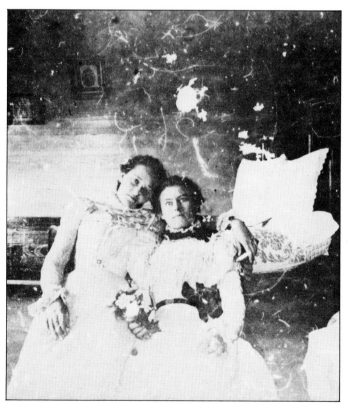 

To restore an old photo, first copy it, making a print large enough to work on. Then get busy to cover blemishes and blend them into the print. Noticeable improvement! A complete job may require several steps of copying and printing, working on each print in turn. You can also make a paper negative from this print, work on the back or front, and then use it like a negative. A paper negative is a print on single-weight or light-weight printing paper made by contact from a print. If the negative is 35mm and your first print is 5'' x 7'', then the paper negative would also be 5'' x 7''. When you have done more spotting and etching on this, it can be contact printed on photo paper for a final print.

## TRIM AND CUT

To prepare a print for display, trim it so the white margin is equal on all four sides of the print—or not equal if you prefer it that way.

When shopping for a cutter, look first for safety features; some of the cutting edges are so sharp that you definitely need protection. Next, determine the size limitation of the cutter so you get one that will cut the size mounting board you need.

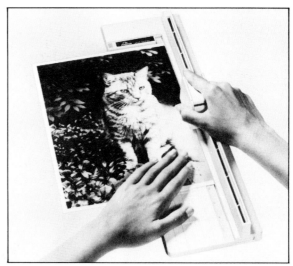

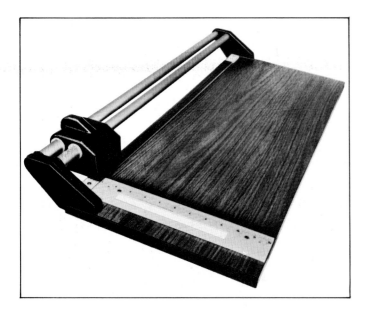

This Falcon print trimmer uses a standard low-cost single-edged razor blade. Fully enclosed, the blade cuts only when pressure is applied to the housing. The trimmer handle cuts up to 14" and is designed so you always see exactly what and where you're cutting, *before* you make the cut! It's a real lightweight at only one pound, and hangs on the wall for handy storage. The unit comes with a package of five super-sharp blades.

There are many trimmers and cutters now. Roller cutters such as Edric Imports Rota-Trim model at left have desirable safety features. The Sheffield steel rotary blade will cut paper, plastic, film, photos, tissue paper or mount board. Some cutters will handle only paper and light cardboard, while others will even cut thin metal.

## MOUNT BOARD

Quality mount board (cardboard) is cured and seasoned to prevent warping, and is available in white, ivory, buff, grey and black. White is the preferred salon mount, often the only kind accepted for exhibition. It comes in several thicknesses, often stated in terms of ply—for instance, 2 ply is thin and 4 ply is thick.

The best board is acid free and is the only kind used for valued print collections in galleries and museums. *Conservation* and *archival* are terms sometimes used for this fine board—but always verify that the board is acid free.

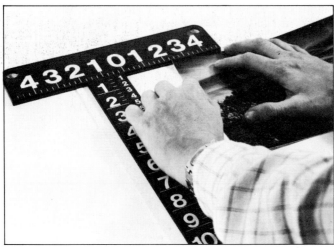

You can place any size print on any size mount board and professionally position it, ready for mounting, without making a single pencil mark! The Falcon Print Mounting Positioner looks like a translucent T-square, but it's really an ingenious device with specially designed numerical divisions to eliminate all the guesswork from positioning, in under ten seconds! A print positioner is enthusiastically welcomed by anyone who has ever accidentally mounted print off center.

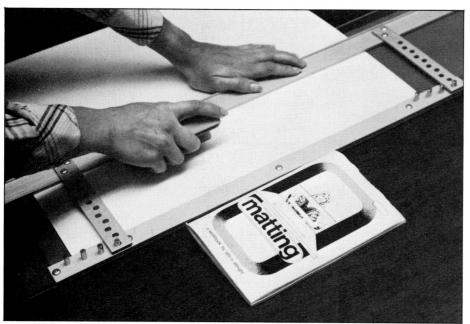

## MATTING

There has always been room for individuality and personal preference in print display—the matter of a border, for instance. You can choose to go without a border, with a white border or a black border; to mount flat with or without a black paper showing around the edges; or, most advanced of all, you can use the cut-out, beveled matte.

Matte board with the opening already cut out can be purchased in standard sizes such as 8" x 10" and 11" x 14", in either vertical or horizontal format. The classic salon mount is 16" x 20", which gives a uniform appearance to a salon display.

Cutting a matte used to require heavy, expensive gear and lots of skill. Today, the equipment is reasonably priced, but you still need practice to do a good job. This EZ/Mat matte maker includes base, straight edge for marking, hold down, cutting edge, measuring system and cutter for beveled edges. The instruction book is exceptionally informative.

## MOUNTING THE PRINT

The main problem in mounting a print is laying it down without wrinkles. Glues and cements are messy, and if they're not intended for photographic use they can eventually damage the print.

It's possible to mount murals on some kinds of mount board by using a paste such as wallpaper paste; however, it's a difficult job and requires skill. Translation: You'll probably botch the first couple of tries.

Adhesive mounting methods include the use of paper or mount board with pre-applied adhesive and peel-off backing, or spray adhesive. No expensive equipment is needed here.

Another adhesive method utilizes paper with adhesive backing, and an applicator which looks and acts like a little hand-crank roller. This gets the adhesive-backed paper and the print together the first time through.

There is also a new and interesting mounting adhesive, Seal Fotoflat Removable Dry Mounting Tissue, which is made to be used with a low-heat press and, says the manufacturer, it allows removal and remounting or prints years later simply by putting them in the press and reheating.

Dry mounting with tissue and a press is the favorite method today.

It allows use of a regular household iron as the source of heat to bond the print to the mounting board; but if you mount a lot of prints you'll want a tacking iron and a dry-mount press.

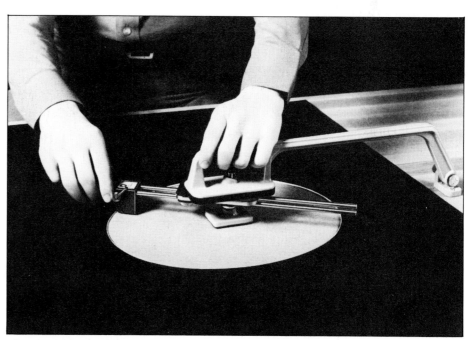

Oval and circular cutouts in mattes require special equipment such as this cutter. The cutout portion of the matte has been removed so you can see how it works.

## ADHESIVE PRINT MOUNTING

For quick print mounting, choose from several adhesive methods. One type can be bought in rolls and the adhesive paper is cut to size; another, in pre-cut sizes; a third method is adhesive spray. A neutral pH factor means that the spray or adhesive won't eventually cause acid discoloration of the print—that's why it's important to use only a product made for photographs.

Positioning the print exactly right, the first time, can be tricky. If you're all thumbs, look for the kind of mount system which allows you a second chance!

This print was mounted with Falcon Perma/Mount 2, a two-sided self-stick adhesive card. One side of Perma/Mount 2 sticks to the back of the print, the other side to the mounting surface, which can be matte board, cloth, wood, fiberboard or just about any other material. Perma/Mount 2 is available in packages of six cards in three sizes—8" x 10", 11" x 14" and 16" x 20".

It's repositionable! Spray your work with this adhesive, position it—and move it around if you didn't get it exactly where you want it. The adhesive doesn't form a permanent bond for several hours. Use it for matting, for albums, and for color or black-and-white photos. It's said not to become brittle with age.

To dry-mount without heat or moisture, use the transfer adhesive with the name to remember, Gudy-O! The only tools you'll need are a pair of scissors to cut the paper to size and a cloth to smooth it after application. When the backing paper is removed, the adhesive area is ready for your print. It can be used on almost any kind of mount board.

## DRY MOUNTS USING HEAT

A common way of mounting print to board is the dry-mount method which works in this way: Assemble the print, the mount board, dry mount tissue, a tacking iron and a dry mount press. Place the tissue against the back of the print, which is placed face down. Touch the tissue at the corners and in the center with the tacking iron; it will form a bond at those places, because the tissue is heat-sensitive. Turn the print over and place it face-side up. Insert into pre-heated dry-mount press and follow instructions.

There are a number of special mounting tissues available, in addition to the all-purpose dry-mount tissue. There is a laminating film for sealing prints protectively; an easily-removable tissue; a tissue made for RC (resin-coated) print paper; and a tissue for texturizing and mounting in one operation.

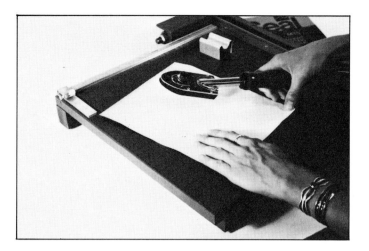

When using heat-set dry-mount tissue, first cut the tissue to fit the back of the print. Then use heat to lightly tack the tissue in place. The gadget shown here is a special tacking iron.

## DRY MOUNTING WITHOUT HEAT

A manually-operated applicator speeds the mounting of prints with Scotch Positionable Mounting Adhesive. That means the hand-crank supplies the power! Use 8'' x 10'', 11'' x 14'', even 16'' x 20'' Positionable Mounting Adhesive (PMA) sheets in the applicator. Roll out the amount of PMA you need, and cut the sheet to size.

Transfer the adhesive to the back of the item being mounted by putting the adhesive and the photo through the applicator. Align the photo on the mount board—it can be positioned again and again until it's just right. Put the photo and mount board through the applicator again, and the bond is permanent. If you don't have an applicator, a roller or squeegee will also work.

# HOT PRESS MOUNTING

This Scotch mounting adhesive is made to be used with a hot press, can be tacked with the hand alone rather than a tacking iron, and permits repositioning even years later just by reheating in a hot press. It's called Pro-Mount No. 572 and is available coated on release backing in rolls 50' long by 24'' wide. Position the photo face up on the ProMount adhesive surface and cut the adhesive with its paper backing to size, leaving about 1/2'' of border. Now turn the photo with adhesive face down on a separate sheet and burnish or rub the back with a plastic squeegee.

Trim the adhesive by rubbing along the edge of the photo, rolling the excess off in one piece. Peel the release paper away and position the photo face up on the mount board. Press with your hand to tack it into place. The photo can be permanently bonded to the mount board by placing it in a press, preheated to 180 degrees. Protect the top of the photo with a piece of paper called the release sheet. The low temperature helps protect RC and Cibachrome prints against heat damage. The process is completed in 45 seconds; the work can be repositioned for up to 5 minutes, or years later by reheating in the press.

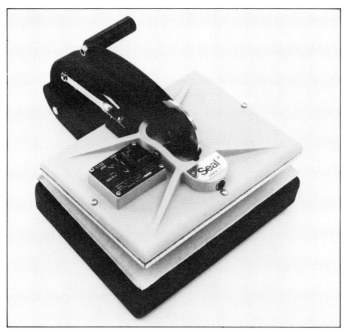

Heat-setting dry-mount presses are in demand for home, school and commercial use, and even for mounting murals. After tacking the print to the mount board, place it in the press and follow instructions for temperature and time. Heat causes the tissue to form a bond between print and board that lasts for years. It's possible to mount any size up to twice the depth of the throat of the press. Heat control is almost a necessity, so select a dry-mount press with a thermostat.

For many years the classic salon mount was a necessity for the serious photographer submitting prints to the photo salons. We still like it. The mounts are 16" x 20" and are available in white, cream, gray and black. Prints may be any size this format will accommodate.

Your prints are not finished until they're properly mounted and displayed on the wall. Plaques with a self-adhesive mounting surface provide a quick and inexpensive way to mount them. Just position, smooth down and trim your print if necessary.

Pre-drilled holes permit vertical or horizontal hanging. The mount itself is made of warp-resistant plastic-lined particle board. Standard sizes are available in photo stores, and special large sizes can be ordered. What better decorations for home or office than pictures you have taken yourself?

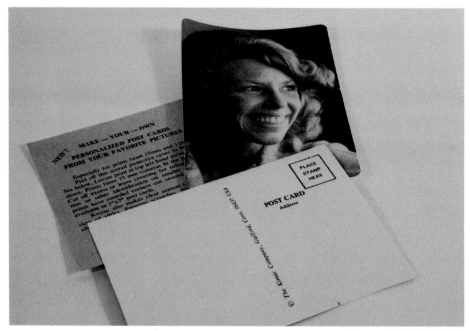

The postcard mount is a guaranteed eye-catcher! Peel part of the protective paper from the adhesive backing, position your 3-1/2" x 5" print, peel the rest of the paper off and smooth your photo print onto the postcard. It's all set for name and address, stamp and a message that will catch the attention of the recipient.

Another instant-mount idea—the transparent borderless frame. Set your print on the white cardboard liner box. There's no adhesive, so you can change prints with ease. Slide the clear plastic exterior box over the print and hang the frame on the wall! The liner box has holes positioned for horizontal or vertical hanging, and the box construction gives depth to the photograph. The plastic exterior protects prints from dust and incidental damage.

## FRAME IT!

Once upon a time, picture frames consisted of either narrow black wood strips or ornate, heavy gold frames. When those two stand-bys began to fade from popularity, photography started to become an important part of modern decor.

Now, many treatments are acceptable, such as rustic wood frames; the elegant clean lines of well-designed and well-made plastic frames; frames with mattes accommodating 6 to 12 prints—though we wish these were of better quality; the salon mount, without any frame; and the classic gold, silver or aluminum metal frame. Your imagination and artistic eye can take it from there!

An important accessory to the well-framed photo is no-glare glass. It costs more, and does more—it reduces light reflections that detract from the enjoyment of a photographic display.

Rustic wood frames can be attractive and informal.

Smoked plastic forms a floating frame and is made in both wall and stand mounts.

Dax manufactures a variety of multi-picture frames—this one has 18 spaces, and can display an entire family tree!

The metal box-frame holds the photograph yet does not detract from it in any way. It's classic, for museums and galleries.

A handsome desk accessory combines four oval inset picture frames with a pencil holder. It's made of solid wood and rests on a swivel base.

## DISPLAYING PRINTS

Office, home, lobby; large, small or a variety of prints— photographs are the perfect wall decoration today. Think of the conversation piece as you mention where you took the enlargement that covers half a wall!

Many people seem surprised when told that their negatives or slides will make prints as large as 20'' x 30'' or 30'' x 40''. However, when you think about print size, consider the viewing distance, just as you do when hanging a painting. At a reasonable distance, a 30'' x 40'' print from a 35mm negative will look as sharp as a small print viewed up close.

The framed picture above looks like a fine example of the time-consuming art of *decoupage*, in which the photo is covered with many layers of clear varnish. But this plaque is made the easy way, with a product called Decopour, an easy and striking way to mount photos on a wood plaque as shown, and on coffee tables or other wood pieces. Mix these two fluids according to instructions, and pour over your print in place on the backing surface. When dry, the hard, glossy, transparent plastic forms a coating that resists dust, moisture and impact. The instructions are written in an exceptionally clear and logical fashion and are well illustrated. Redwood plaques are available in 4'' x 5'', 5'' x 7'', 7'' x 9'', 8'' x 10'' and 10'' x 12'' sizes. Also available is quick-drying sealer for sealing plaques prior to pouring the plastic.

To make a display wall for your mounted prints, shop for molding with a groove to hold the edge of the mounted print. Attach the molding to the wall in two strips with the grooves facing each other. This allows you to slide the mount into the top groove far enough that the bottom of the mount clears the edge of the lower strip of molding. Then, release the mounted print and it will drop downward into the lower groove but still be retained by the upper groove. Space the two moldings apart so they will hold a standard size of mount board such as 11'' or 14''.

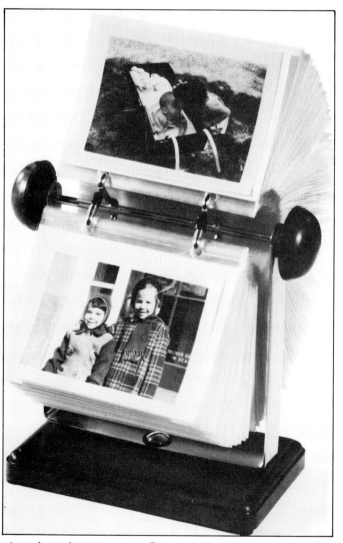

This print holder by Gepe solves two problems. Placed on your coffee table, it makes it easy to show and enjoy your photos. Store the negatives in the drawer below and you'll never lose them. Then, when Aunt Minnie wants a copy of that great photo of Aunt Minnie, you have the negative immediately at hand and can have a print made.

Another clever way to file and display your prints is a Roto-Photo—a set of clear plastic sleeves on a spindle so you can quickly spin through them to find the one you want.

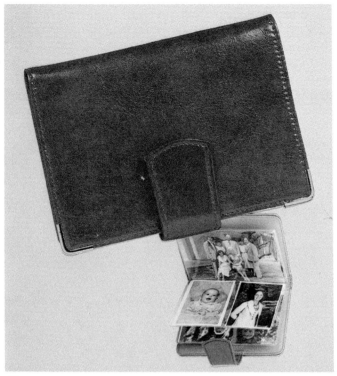

Everyone wants to show photos to friends and family, and if you're not at home, you usually carry them in plastic sleeves in your wallet, right? Well, here's another way to carry those small prints around with you, in the Photowallet.

And if you want to go one step further, you can let your snapshots do the talking! That's what Voxcom offers, with this ingenious little device used extensively in the educational field. You just affix sticky-backed magnetic tape stripes on the back of the photograph and record, using the Voxcom Card/Cassette Recorder. The recording is made at the slow speed of .4 inches per second, which gives you three or four sentences on the back of each 35mm print. The tapes can be applied to any format, conventional or instant.

## HANDLING PRINTS

Even if you're not a student, you may want to take your prints somewhere. If you are a student, you have the constant problem of transporting mounted prints without getting them soiled or bent. Whether you get an expensive and elaborate print carrier or a simple one depends on your budget and frequency of use.

One tip: Put a sheet of tissue paper between each print. A special acid-free interleaving tissue is available, although this is really a specialty item for museums or print collectors.

## STORING AND CARRYING PRINTS

Students and collectors usually know about the standard drop-front storage boxes, but few are aware of the exotic custom storing and carrying cases which are made to order by photographer-craftspersons attuned to using materials such as wood.

A heavy-duty vinyl print portfolio holds ten or more 16" x 20" mounted prints. It makes a strong, inexpensive protective cover when carrying prints around, and can be purchased from your local camera shop or art materials store.

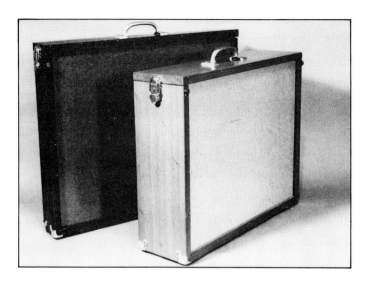

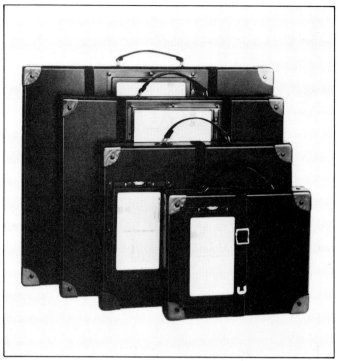

For rugged protection, a reinforced fiberboard case is good for storage or as a shipping case. Just figure out what size you need, and how many prints you want it to handle. They are stocked at some camera stores, and any shop can order them.

Going first class with your prints? Portfolio boxes made to order are constructed of redwood or mahogany in the size and depth you want. The inside of the box is sealed against wood vapor for print protection. The exterior is varnished and hand rubbed, and is fitted with brass hardware. If you treat your prints with this much care, perhaps others will value them, too!

# 11
# Miscellaneous

Ever forget what kind of film you have in the camera? Some models are made with a memo holder on the back cover to hold the end flap of the film box so you can't forget to remember. If the maker of your camera forgot to install the memo holder, ask your dealer for a Cam-De stick-on holder made by Cel-u-dex Corp. in New Windsor, New York. They come in two sizes—one for 35mm film box ends and the other for 120 film boxes.

## MISCELLANEOUS

They say that necessity is the mother of invention, and of course it's true. In the preceding chapters you have seen gadgets for solving a lot of different problems as seen by the inventors of the gadgets. It must have occurred to you that people encounter some mighty strange necessities that motivate them to invent something.

One would think that those different categories of gadgets would provide a place for everything photographers can conceive. Not so, apparently. This chapter has the ones we couldn't fit anywhere else.

If you don't remember the old stereopticon viewers, your mother does—well, maybe your grandmother. Anyway, in the good old days, people sat around in their parlors looking at scenic views in three dimensions, as in the real world. You can still do it today and your three-dimensional views can be in full color. For example, Pentax offers this stereo adapter to fit over 49mm and 52mm filter thread lenses. It makes two separate images on one frame of film—one for your left eye, one for your right eye. Put the slide in the stereo viewer and each eye sees its own view of the scene, producing the three-dimensional illusion.

Here's another amazing item for the forgetful photo fan or the serious photographer who needs to record essential data. Fotonote books contain blank forms to record all the information about each shot, including film and exposure data. Fotolog books are simpler, for the photographer who just wants to record subject and general information. Both come with a set of duplicate stick-on numbers. Here's how to use them: First, stick a number on a page in the book. Stick the duplicate number on the film cartridge and load it into the camera. Record all data about that roll of film on the numbered page. When you send the film in for developing, peel the number off the film cartridge and stick it on the receipt you get for the film. When the film comes back, match the *printed* number on the receipt to the *printed* number on the address label. Then transfer the stick-on number to the film box. Now you know that the photos in that box are the same ones you took notes about on the page with the same stick-on number. It certainly is a lot easier to do than it is to explain!

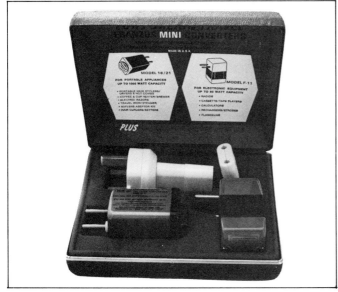

Traveling to faraway places? Franzus Miniconverters will convert faraway voltages into 110-120 volts for use with U.S. appliances such as chargers for the nicad batteries in your electronic flash. Franzus also supplies adapter plugs to fit wall outlets in several countries.

Turning pro? If you take pictures and sell them for money, use them in advertising or trade, or make any other use that requires a model release, you should have a pad of model release forms. Your photo dealer can get them for you.

You might want to pick up a copy of *How to Make Money With Your Camera* by Ted Schwarz, also published by HPBooks. This publication, and many others from HP are available at your local dealer.

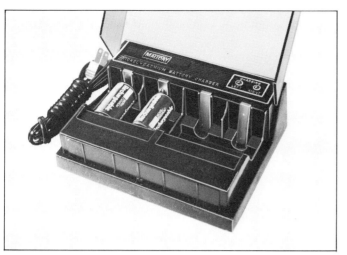

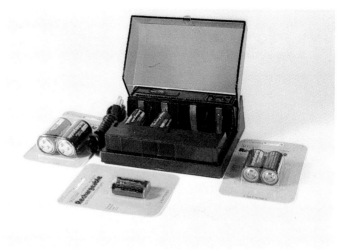

The Mallory Nickel-Cadmium Battery Charger takes AA, C or D-size rechargeable batteries, designed to replace the non-rechargeable batteries in photo equipment such as the autowinder, strobe or camera. Before initial use of the rechargeable batteries, charge them for 16 hours. After that, charge them 16 hours a month when left idle, and more frequently according to use. They can be recharged up to 1000 times. Be sure your equipment will accept nicads—check your instruction manuals!

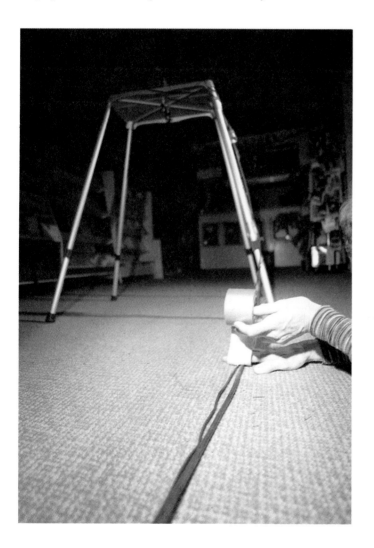

Oh—lest we forget, one other gadget should be in your camera bag at all times. It's Gaffers Tape, also known as duct tape—that end-all fastener which will save you time and time again from searching for a specific kind of clamp or other device to temporarily hang or attach your equipment. It works on floors, ceilings, walls, trees—anything you could conceivably have to attach a piece of equipment to. And it's great when you have to run wires across a heavily traveled floor, too. To coin a phrase, "Don't leave home without it!"

# Index